Aug. 2013

To my friend Road Dog.

May we always be friends.

Always your friend
MAC

Phil Cross
Gypsy Joker to Hells Angel

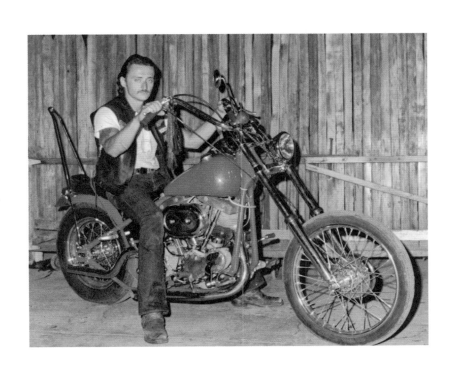

First published in 2013 by Motorbooks, an imprint of MBI Publishing Company, 400 First Avenue North, Suite 400, Minneapolis, MN 55401 USA

Motorbooks titles are also available at discounts in bulk quantity for industrial or sales-promotional use. For details write to Special Sales Manager at MBI Publishing Company, 400 First Avenue North, Suite 400, Minneapolis, MN 55401 USA.

To find out more about our books, visit us online at www.motorbooks.com.

ISBN-13: 978-0-7603-4372-2

Library of Congress Cataloging-in-Publication Data

Editor: Darwin Holmstrom
Design Manager: James Kegley
Designer: Karl Laun
Cover designer: John Barnett

Printed in China

10 9 8 7 6 5 4 3 2 1

PHIL CROSS
GYPSY JOKER TO
A HELLS ANGEL

PHIL AND **MEG CROSS**

PHOTO EDITED BY MARK SHUBIN

motorbooks

CONTENTS

INTRODUCTION

My name is Phil Cross, and I've been a Hells Angel for forty-three years. Everybody has their own story as to what led them to become a member, but we all have one thing in common: a love of both motorcycles and the camaraderie of the brotherhood. This is my story.

I have been a Hells Angel longer than many people predicted I would be alive. I'm not kidding; I was somewhat reckless in my youth and was told more than once or twice, or a dozen times, that I would not live to see thirty, or probably even twenty-one. You get the picture. Well, it turns out that they were all wrong . . . really wrong. I even survived a liver transplant when I was fifty-nine and stage four cancer five years later. So I guess you could say I have been lucky, or maybe I was just meant to live a long and interesting life (and that I have). And it all started when I was born in San Francisco, California.

San Francisco has always been an interesting place, right from the start. Before it was called San Francisco, the Bay Area was home to the Ohlone Indian tribe to the north and the Miwok Indian tribe to the south, and you have to agree they were pretty interesting people. Then the missionaries came and built Mission San Francisco in the late 1700s. The next big deal was the gold rush that started in 1847, which made for big growth in two industries in San Francisco: prostitution and gambling—this was the Barbary Coast. In 1906, the big quake hit and the fire that followed wiped out the entire Barbary Coast, which meant no whores and no gambling . . . at least not for a while. San Francisco played a big role in World War I, but nothing like it did during World War II. Being a port city, San Francisco was vital in the war effort. The shipyards located there and along the coast worked with machine shops, metal fabricating shops, and woodworking shops to become one giant ship-building industry. That's what my dad did for a living; he helped build those ships that were so badly needed by our armed forces, and that's where I come in.

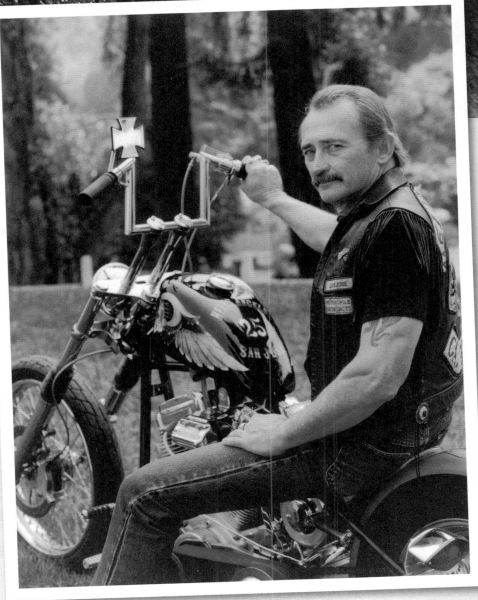

Me as a twenty-five-year
member.

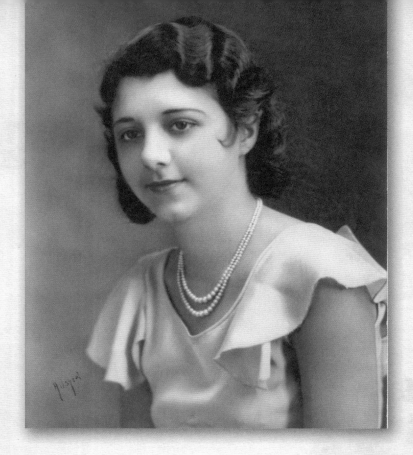

My mom as a sweet sixteen-year-old.

I was born in San Francisco, California, on August 11, 1942. We were an average middle-class American family: Mom, Dad, my kid brother, the family dog Corky, and me. Unfortunately for my parents, we had to leave San Francisco. When I was two years old, I got sick and just couldn't get seem to get better. The doctors found a spot on one of my lungs and told my folks that I needed to live in a warmer, dryer climate, so we packed up and headed for Coyote, California (to my grandmother's ranch). My parents went from living in one of the most important and urban cities in the world, with a population of 635,000, to a place no one knew existed, with a population of about twenty-five farmers.

It was probably difficult for my parents at first, but it was a good place for a rambunctious kid like me to grow up. I have wondered what my life would have been like if I had grown up urban rather than rural. Maybe I would have been a pharmacist!

Before I jump into my growing up years in Coyote, here are some of the highlights of 1942 that I find interesting.

Franklin D. Roosevelt was president of the United States, Angelo Joseph Rossi was mayor of San Francisco, the Hells Angels were a U.S. Army Air Force Bombardment Group, and we were right smack dab in the middle of World War II.

So I guess it could be said that I came into a world at war, and I have spent most of my life fighting—either for something, or against something, but fighting nonetheless.

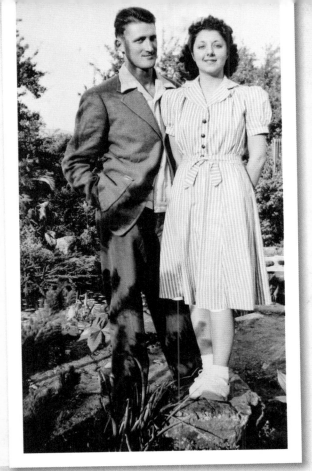

Mom and Dad right after they were married.

Dad and I on a visit to Grandma's ranch when I was about six months old.

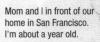

Mom and I in front of our home in San Francisco. I'm about a year old.

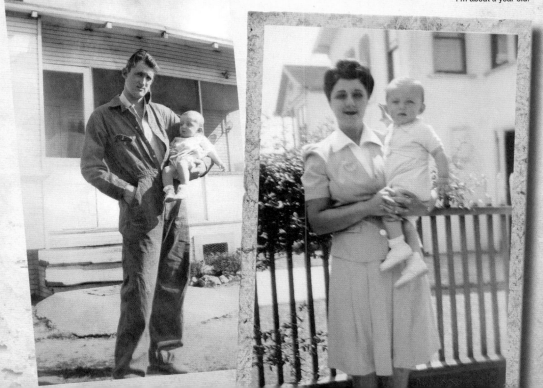

COYOTE

SO NOW WE ARE LIVING in the grand metropolis of Coyote, on Grandma Orlando's ranch. You may not have heard of Coyote—no one has. At the time, it had a population of about twenty-five people, mostly my family and other ranchers. There was no actual town, just a post office, and I don't think the town really ever got any bigger than those twenty-five people. To give you some reference, Coyote was just between San Jose (a pretty decent-sized town) and Gilroy (a small farming community). Now it's gone; it's all Pacific Gas and Electric towers along Highway 101 just before you get into Morgan Hill.

My grandpa, Joseph Orlando, died when my mom was a teenager. This left my grandma to run the ranch on her own (which she did as well as any man). We called it a ranch, but Grandma was really an orchardist. She had about twenty acres of plum, cherry, and walnut trees, and she had cats . . . lots of cats. They weren't pets; they lived outside and caught their own food. They were the rodent patrol. I always thought they were pests too. After I left the ranch, I would never allow a cat in my house—not until my wife moved in (now we have three cats, two dogs, a tortoise, and two fish, and I have no comment).

Grandma's house was a sturdy three-bedroom with a big covered front porch. Without a doubt, the most important room in that house was the kitchen, with its big country kitchen table. My mom's family all lived in Gilroy, and Sunday dinners at Grandma's were an all-family event with various aunts, uncles, and cousins. This was a 100-percent Italian family, so imagine what those dinners were like. There would be opera music playing in the background, good food, homemade wine, and conversations (and hands) flying everywhere. They were good times.

The front porch was second to the kitchen in popularity. In Coyote, it got hot just as soon as spring took hold and stayed hot until fall grudgingly let go. It would be too hot to be inside, so if there was going to be any sitting around, it was done in the cooler shade of the porch. To this day, I have a fondness for large covered porches.

The ranch was a healthy, wholesome place for a boy to be raised, but it was also a place where he could get bored and consequently get into a bit of mischief. It's also where I learned to become a crack shot . . . at a real early age. So good, in fact, that when I went into the navy, I scored expert in marksmanship.

I learned to hunt on my grandma's ranch, and I have to say that shooting and killing animals didn't bother me much because it just seemed natural. I grew up in a hunting family, seeing most of my relatives hunt. My dad hunted, and yes, my mom hunted. I have to say, too, that all of my uncles were remarkable hunters. Everyone in my family hunted, fished, or at least camped. But the hunters didn't do it just for sport or trophies; what they killed we ate.

My mom had two sisters and five brothers. One of her sisters died very young, so I never knew her. Growing up, I would say that I was really close with only three of my uncles. Not that Aunt Rose wasn't great, but we just didn't hang out a lot. Uncle John died when I was still pretty young, but I have good memories of times with him, Aunt Juanita, and Cousin John. Uncle Pete owned a ranch and was a commercial fisherman as well as an amazing cook. That's what I always think of first when I think of Pete. Uncle Sam (Salvatore) probably was the uncle I most wanted to emulate. He had a certain way that he carried himself; you could tell that he was in control. It seemed that he had an interesting past, and as a kid I really wanted to find out what it was. I never did find out what Uncle Sam's secret past was, except that he got into a lot of fights when he was young (sometimes my Uncle John would be with him). The other thing that I remember about Uncle Sam was that he loved to drive fast, I mean

I was never a big fan of those cats that were always hanging around the ranch.

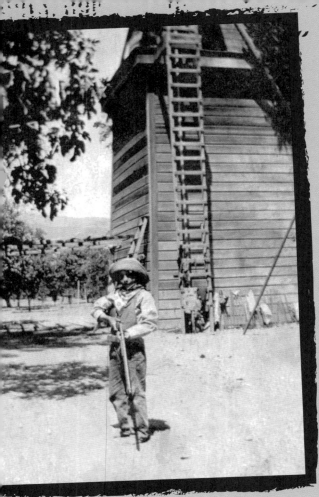

The great white hunter with my .22 rifle. That's our water tower behind me.

really fast, like one hundred miles-per-hour fast. I suppose you could say he was a bit of a nonconformist. No wonder I looked up to him.

Even Grandma did some quasi-hunting, at least when it came time for picking a chicken for dinner. That old gal would go outside with the feed bucket, call for the chickens, and start casting the feed around. All her chickens were free range, and when she called, those birds would come a-running. Then she would stroll between them, still casting feed, and when she found the right one, she would reach down, grab it by the neck, flick her wrist, and snap its neck, all without ever breaking her stride. The other chickens never even knew what happened. They never knew that Grandma was the chicken grim reaper. Grandma was smooth.

I started shooting BB guns at about five or six years old. By the age of seven, I was hunting with one. I got so good at shooting birds that Uncle Dominic started paying me one cent for each bird I got. Now you have to realize that birds were considered a menace because they were eating the cherries, and cherries were money. Well, I got real good at bagging those cherry-eating menaces, and one day I showed up with a big sack of birds for Uncle Dom. There must have been about fifty birds in the sack. Anyway, that cheap bastard didn't want to pay me. That was the day that I learned about someone welching on a deal and that I didn't like it. Uncle Dom did finally pay up, though (probably once Grandma got after him), the cheap bastard.

I moved on to a .22 the next year, and once I got that gun, I loved to shoot even more. That's when I got really good too. I learned to shoot so well that by age ten I could hit a beer can at seventy-five yards with my .22 rifle. Remember I said Coyote could be a bit boring, not a lot to do? Well, I did a lot of shooting in those years, a whole lot. I would rather go shooting than pretty much do anything else in those days. It was something you could do alone and keep getting better at; for me that was important. I also had a whole lot of uncles, so I had plenty of beer cans to practice on.

My kid brother David was always tagging around with me in those days. He was sort of like my second shadow. Now he's only a couple of years younger than I am, but back then it was enough of a difference to make his constant presence get on my nerves. In truth, I probably wasn't very patient even then. This one day he did something, I don't even remember what he did, but I got real mad and I hurt him bad. I threw a board at him, and it hit him square in the head. Man, there was blood everywhere, and Dave had to go to the hospital to have stitches and whatnot. I felt really terrible, and not just because I got

in so much trouble—big trouble, I mean the belt kind of trouble. Seeing what I did to my little brother (who really was a good kid) and realizing how wrong it was became the beginnings of a different path, one where I would always try to protect the people I was close to. I guess you could say it was the first faint stirrings of allegiance in my young soul. It didn't, however, put an end to my sometimes-violent responses. After all, I haven't been close to the people who I have fought over the years, at least not most of them, at first.

Even though it seemed that Dave was always following me around, apparently I did have some time to myself. I remember at least one day distinctly (maybe he was recovering from that hit in the head I gave him). It was the day I was wandering on the ranch and I swear I met a ghost, or at least what I thought was a ghost truck.

There was this old 1920s truck on the ranch. Obviously, it didn't run. This thing was totally rusted, except the spokes of the wheels (only because they were made of wood). This particular day I must have been bored, so I decided to go and sit in the driver's seat (which was nothing but springs). The key was still in the ignition, so I turned it and the engine turned over like it was trying to start. It startled me so much I jumped out of the truck. I ran about twenty feet away and just stared at it for a while. Then I decided to hell with that truck. I don't think I ever got back in after that.

Like I said, I loved hunting, but I stopped at about age fifteen. I suppose you could say I had an epiphany one day while I was hunting, and it changed the way I felt. I was camping up by Licks Observatory with a guy whose

My uncle Sam. Even in this photo he looks like he has a secret.

Uncle Pete, with his constant companion (a cigar), moose hunting.

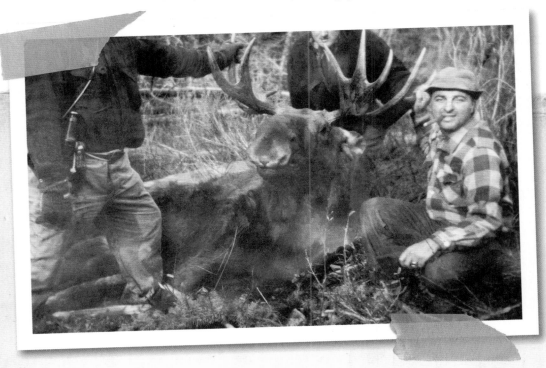

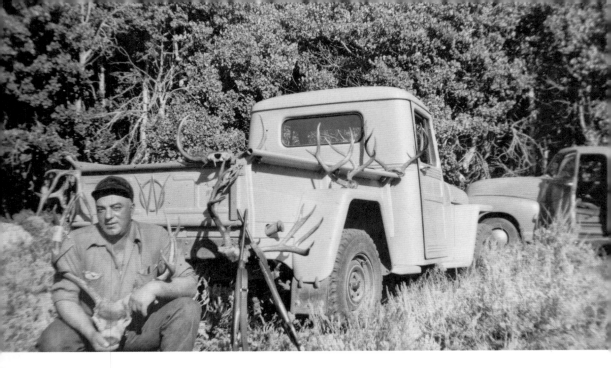

Uncle George on one of our hunting trips. I wish I had that 1950 Willys truck now.

last name was Brown; I don't actually remember his first name. I saw a deer running down a hillside. It was a big buck, and, boy, I wanted it bad. Now he was about 125 yards away from me and he was running really fast, but I knew I could get him. So I took my shot. I saw that buck stumble, but he disappeared into some trees so I couldn't be sure if I got him. I had to know, and there was only one way to find out. So I went sliding down that hill, and as my feet hit the ground, I looked up and a mountain lion was hitting the ground not eight feet from me on the other side of the dead buck (no wonder that deer was running so fast). I raised my rifle, we faced each other off, and he paced back and forth, back and forth, his eyes moving between the deer and me. I was ready to shoot, but something stayed my trigger finger; to this day I honestly can't say what it was that kept me from shooting. Then in one graceful leap, the lion jumped to the bank, about six feet above me. He gave one last look at the deer and one last look at me, and he was gone. That buck was mine! I won the day! But the next day I saw what I am sure was that same cat with his mate and two cubs (now you have to understand that this is a very rare thing), and suddenly I was really, really glad I didn't shoot him. I just never had the desire to hunt after that. But I still really, really liked to shoot.

Even though the town was small, hunting was not the only education that I got in Coyote. It had a nearby school, and that is where my formal education started. I have to say that I hated school. I hated elementary school, I hated junior high school, and I hated high school! My fighting career started in the first grade. I fought the same kid all the time; it seemed like I fought him every day for three years. His name was Joey Sasso. Joey Sasso was overweight. He was a "Butch the Bully" and I never beat him, but I never backed down and I never stopped trying.

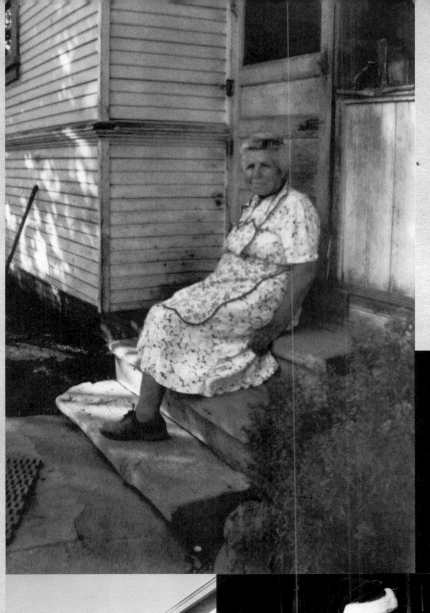

Grandma on the back steps in 1944. There were usually a bunch of cats hanging around those steps too.

Dave and I in the yard. Check out that trike. I always did like striped shirts.

"I've been a very good boy, Santa, so I want a Harley and a tattoo for Christmas."

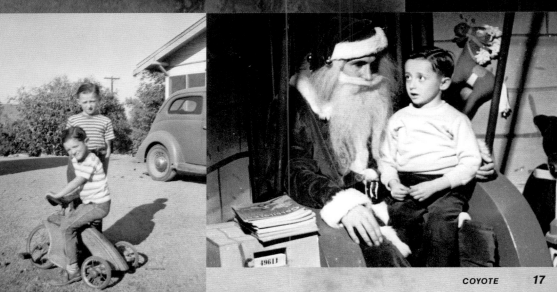

ATYPICA
TEEN

E MOVED TO SAN JOSE when I was about
old. I guess my parents felt it was time for the
their own place, and my dad probably wanted
wasn't particularly happy about the move. I loved
have been perfectly happy staying right there.

tty sure this was the only time Dave and I wore the Hawaiian shirts that Mom got for

Our house was on a street called Genevieve Lane, and it's gone now. In 1964, Highway 280 was rerouted. Our house was located in a neighborhood right in its path, so the state bought all the houses, whether the owners wanted to sell or not, and we moved again.

Now I had a bigger school and a larger population to go after me, so I never really stopped fighting the whole time I was in school. But once I got good at fighting, people stopped messing with me. Now they wanted to prove themselves against me, or they pissed me off, so I pretty much fought my way through my school years and that trend continued right on into the navy. If the schools weren't fond of me (and they weren't), you can only imagine how well the navy took to me with my ways.

I joined the navy straight out of high school. I have to backtrack a little here because joining the navy is a time when most young men get their first tattoo. Not me. I already had one, a big one. I got my first tattoo when I was fourteen years old. I still have the same tattoo: a panther and snake fighting on my left arm. I had it done by a guy named Curt Quintell Bruns down on Post Street in San Jose, and it cost me $12 (which would only be something like $170 today).

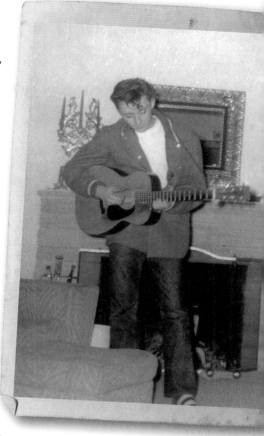

I got my Martin guitar when I was fourteen and I still have it.

My parents split up when I was seventeen years old, about the time that the Genevieve house was being bought by the state, so I guess it just seemed like a good time for them to go their separate ways. I was pretty much a loner in those days. I didn't really pay a lot of attention to what was going on at home, but I could tell that after the split my mom seemed happier. She bought a place right on the San Jose/Campbell border and, of course, my brother and I went to live with her. Even though they were divorced, my parents got along well; in fact, they got along better than before. We always spent holidays and birthdays together, and sometimes even just a Sunday dinner (but if my dad screwed up and started acting like a jerk, she could run him off). Of course, those family gatherings only happened if my dad wasn't currently married. He got married pretty easily, three more times that I'm aware of, maybe more. I only say maybe more because I didn't even know about one of his marriages until he happened to mention that he was getting a divorce. He didn't stay married for very long either. My dad was pretty tight; maybe he thought getting married was cheaper than getting a housekeeper.

High school was something that I didn't take too seriously. I suppose I just kept going because it was what you were supposed to do and that's where my friends were during the day. I didn't play any sports in school; I just never got into it, not even watching them. I liked solitary hobbies like coin and stamp collecting. It sounds like I was some sort of bookworm or something, but I wasn't like that at all. I just wasn't much of a joiner, and I was always comfortable being on my own. I went to the movies whenever possible, usually with my brother. I loved going to the movies, especially the action-packed ones, and I still do.

I had to take a bus to school, and I hated riding that damn bus. One day, in my sophomore year, I noticed this car parked by the bus stop with the key in it. Without even really thinking about it, I jumped in and drove it to school. I parked it down the street so that none of the teachers would see me driving it. After school, I took the car back to the bus stop. The next day, there was the car, with the key in it again, so I took it again. After school, I had my own key made in case the owner was ever so inconsiderate as to not leave hers. Yeah, I had decided to drive to school every day from then on. I drove that car to school for most of the rest of the year. I always made sure that the gas gauge registered in the same area so that the owner wouldn't notice it.

I finally had to give up "my car" when I was late getting back to the bus stop one day. I had been hanging out with some friends and lost track of time. I parked it a few blocks away from the bus stop and walked away. I tossed my key too, just in case. I was back on the bus.

I got my first bike when I was a senior in high school. It was a 1955 500cc BSA, and it was a real piece of shit. I went down the first time I rode it too. I got on it and rode down the street, went into a right-hand turn, took it way wide, and slid under an old man's car. I got up, and the old dude got out of his car and looked at me and then looked at the bike just lying right there under his car. I was able to pull the bike out from under his car by myself. The whole time, that old guy never said a word. There's nothing like breaking it in right. That bike cost four hundred dollars, so I had to sell part of my coin collection to get it. I kept it a secret from my dad for as long as I could because he really hated motorcycles. He was really mad when he finally found out I got it, and he got madder when I wouldn't apologize. As he was yelling, his face got redder and redder, and I began wondering if a human head could explode. What's funny is that a few years later he got himself a dirt bike, and we did some hill climbing together. That and working out at the gym were really the only bonding we ever did, and that period of time didn't last very long. We never really had anything to bond over again until my daughter Amanda was born thirty-five years later.

While I was in high school, I worked for Keeble Construction during summer vacations. It was the same company that my dad worked for. Seeing as how my dad and I weren't really close, you would think that working where he did would have been a terrible experience. It wasn't, though. Although he didn't have much patience, for some reason he didn't ride me at work the way he did in my personal life. I don't know why—maybe because it would have been unprofessional, or maybe he didn't want the other guys working there to think I was a jerk (or worse yet that he was). Don't get me wrong; it wasn't like we were pals or anything. He just sort of left me alone. Fine by me. I just wanted my paychecks so that I could go out at night and have some fun.

Fun mostly meant going out with my friends and occasionally some girls. I didn't want some girl messing with my life and nagging me like I had seen with some of my friends. The last thing I wanted to do was go to a football game or a school dance, and that's what the girls always seemed to want to do. So I pretty much just went with the girls who got around. It was easier that way. I never did go to a high school football game, or any other school event. I didn't even attend my graduation. The school wouldn't let me, and it just sent my diploma in the mail.

I couldn't go to the graduation ceremony because I got drunk at the senior sneak day. The sneak day took place in Santa Cruz, at the boardwalk. Some of my friends who were already out of school were there. They were all drinking, so, of course, I got drunk with them. After that, it seemed like a good idea to take my bike up onto the boardwalk and ride it up and down. The teachers saw me and started running around trying to catch me (I can still remember the looks on their faces). They didn't catch me until I took the bike out onto the sand, but even then they had to work for it. I got a special ride home with one of the teachers that day and an invitation to stay away from school if I wanted to graduate at all. The friends who I got drunk with took my bike home for me.

I was actually surprised that I hadn't already been given the boot from graduation because I had recently scared one of my teachers. He was always riding me and ridiculing me in front of the class. So one day when the class ended, I waited until the other kids were gone, closed the door, and he and I had a little chat. I got right in his face and told him that I didn't care if he liked me or not, but that I was fed up with him treating me like he did. I made it clear that if it didn't stop our next meeting would end badly—for him. I never had any trouble from him after that, and I have to give the dude credit because he must not have ratted me out either.

I know I got into more trouble than I can remember in those days, and I'm sure it worried my parents. When I enlisted in the navy, they must have thought that all of that stuff would be behind me (or that the navy would get me ship shape). Well, they were wrong; being in the navy was just the beginning.

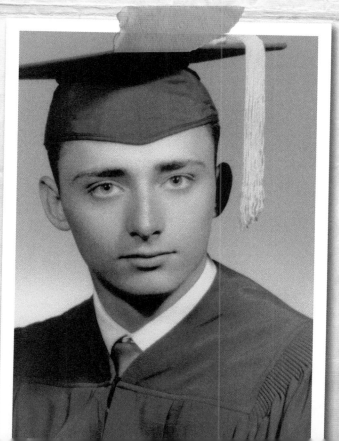

My graduation photo. I got the photo and diploma but didn't get to go to the ceremony.

SEE THE WORLD, JOIN THE NAVY

I WENT INTO THE NAVY straight out of high school. When you enlist, you put down your first three choices of location for duty. My choices were: overseas, overseas, and overseas. I didn't care where I went; I just wanted to see the world.

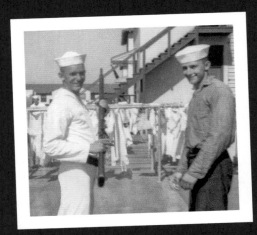

I'm surprised I have this photo from boot camp. Cameras weren't allowed.

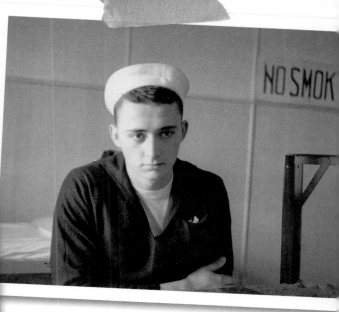

I joined the navy at the same time as my buddy Clark. Clark and I went through boot camp together, but he didn't go overseas with me. When I got to Japan, there was a letter waiting from me from Clark. He wanted to let me know not to feel bad about my girlfriend breaking up with me, and that he thought my ex-girlfriend was a lousy lay anyway. The only problem with Clark's letter was that I didn't know she was my ex-girlfriend (but I sure figured it out quick). I don't think highly of that ex-girlfriend, and I still think Clark is a dirty motherfucker.

After boot camp, I went overseas on the USS *Aludra*. Life onboard ship can be a little bit tedious; I nearly went crazy. A bosun's mate, the sailor in charge of the ship's PA system, played Patsy Cline's "I Fall to Pieces" over the PA system all the time, all the way to Japan and all the way back, for three tours. Man, to this day I still can't stand that damn song. But I finally did get it to stop playing.

My mom loaned me two hundred dollars so I could get a slush fund going onboard ship. The slush fund worked like this: I would loan five dollars for a payback of seven dollars, and ten dollars got me fourteen, etc. Eventually that bosun's mate got in debt to me, which is how I was finally able to get some relief from that God-awful song.

One night in the Formosa Straits, I wasn't bored at all. It was during a hurricane, and I talked the bosun into letting me out of a ship-wide lockdown. I went forward, one deck above the captain's bridge, and tied myself to the rail to watch the show by the light of the full moon. The waves were so tremendous that the fo'c'sle (the bow of the ship) would plummet completely underwater, covering the ship almost to the bridge, and then it would come bursting out of the water sixty to eighty feet high. It was like riding a giant breaching whale. What a trip!

Junior Richeson, my buddy in the navy, and I hung out when we were on liberty. Junior didn't get into the kind of trouble that I did, but he and I did get into some shit together. Take China for instance.

On deck, aboard my ship, the USS *Aludra*.

From the look on my face, that damn Patsy Cline song must have been playing again.

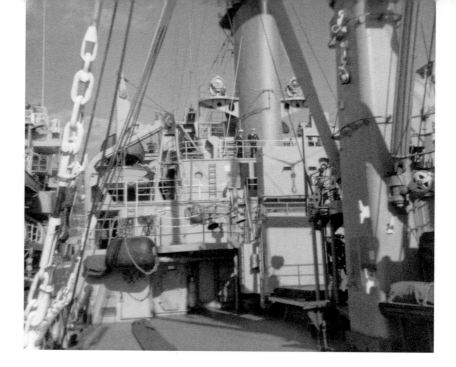

The USS *Aludra*.

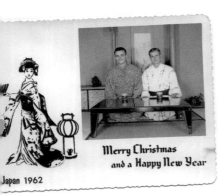

Merry Christmas
and a Happy New Year

Japan 1962

My navy buddy Junior and I had this Christmas card made in Yokosuka, Japan.

We were on liberty in Hong Kong, and there was a bar that Junior and I wanted check out. We saw this little Chinese guy pulling a rickshaw, so we decided to take the rickshaw to the bar. The driver took us down all these little side streets and alleys, and eventually we ended up in front of a whorehouse. It was obviously a set up, so we told him we weren't going to pay him. He started screaming at us in Chinese, and a huge crowd gathered around. Things got out of hand, the crowd turned into an angry mob, and they wanted us. We took off on foot with the mob chasing us down the alley. We knew we needed to distract them, and we could only think of one way. We reached into our pockets and pulled out our loose money, and we threw it back over our heads. We were able to stop and look back to see the crowd scrambling all over that alley, fighting for the money. Junior and I loped off, grabbed a taxi, and got to the bar after all.

I mentioned earlier that my fighting career from school continued into the navy. While I was serving my country, I had something like twenty-five captain's masts (a disciplinary action presided over by officers at your station). All of them were for fighting. Needless to say appropriate punishments were handed down.

My nose got smashed in a fight in the Philippines. I got into it with a couple of guys from an oiler, the USS *Cimarron*. I don't even remember why we fought. A bunch of their shipmates were in the bar, and a whole bunch of them jumped me. I was at the bottom of a pile, getting it pretty good. After a bit, some of them started being pulled off of the pile and flung to one side or the other. I thought someone was helping me because I was getting really beat up. No such luck. The guy didn't want to help me; he was trying to get to me so that he could punch me—which he did. He hit my nose so damned hard that he smashed it something terrible. I actually saw stars on that one.

After I got out of the bar, I still had to get back to the ship. We had a midnight curfew, and I barely made it back to the gate in time. My white jersey was covered in blood, so I made my way to the center of the crowd of sailors making their way through the gate. I got through the gate, but I wasn't so lucky getting onboard ship. Once I was spotted, I was taken to the USS *Ticonderoga*, an aircraft carrier, for medical treatment. The *Ticonderoga* was the only ship with an X-ray on board. I got one of my captain's masts, and a new nose for that fight.

Yokosuka was the place where I got a temporary promotion to lieutenant while I was waiting for one of those disciplinary actions. I was working on the cleaning crew in a detention area, waiting for trial for one of my fights, when I noticed a row of lockers. I started opening them and . . . BINGO! A nice fresh lieutenant's uniform was hanging there just waiting for me. Luckily the uniform was a good fit. After I was dressed and looked the part, I stashed the dungarees that I had been wearing and walked right out of that detention center and through the main gate of the base (I was even saluted) without a backward glance.

The first place I went was to the house of a Japanese girl who I had been going out with. Her name was Yukiko, and she was what was referred to as a bar girl. Her job was to get men to buy drinks. Bar girls weren't exactly virtuous; they were fun time girls, not really hookers, but if they liked a guy well enough, they would provide the service.

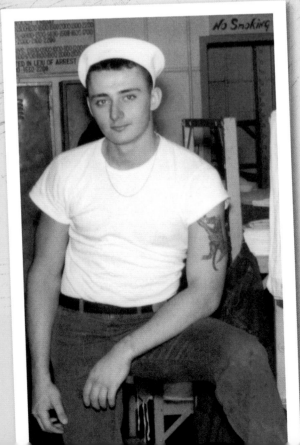

Waiting in a detention center. I was there because I got into a bar brawl in Yokosuka, Japan.

Notice the sign that is behind my head in the detention center.

MEN ASSIGNED TO DISCIPLINE DORMS WILL MUSTER AT THE FOLLOWING HRS IN THE UNIFORM OF THE DAY.

ARREST AND RESTRICTED STATUS
MON. THROUGH FRIDAY

SAT.

SUN.

RESTRICTED IN LEIU OF ARREST

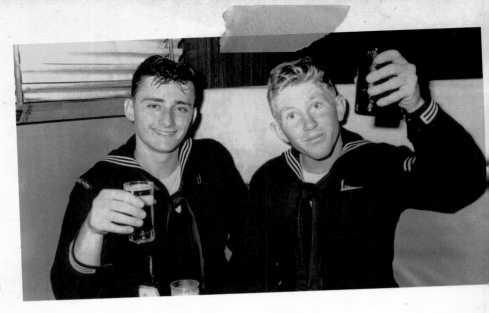

A fellow sailor and I doing what we did best: hoisting a few.

I walked all over Yokosuka in that uniform. It was surprising how differently I was treated while I had it on. One night when I was in a bar fight, the MPs who came took one look at my uniform and told me to leave before they started to round everyone up. It's true what they say—rank has its privileges.

I stayed with Yukiko for two weeks and then decided that I'd better get back. After all, I couldn't stay in Japan forever (although if it hadn't been for my family, I might have).

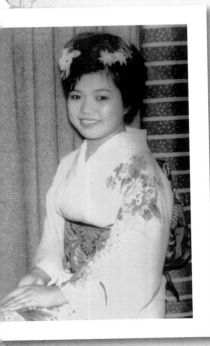

Yukiko gave me this photo of her. It was taken before she became a bar girl.

I walked back onto the base, got my dungarees that I had stashed away, found a safe place to change, and dumped the lieutenant's uniform. Then I picked up a mop and started working. After about an hour, one of the guards came up and asked me where I'd been. I said, "Mopping." With that, I was escorted to the detention center. Of course, I got caught for my little field trip, but I never did get caught for impersonating an officer. It's one of the few times I didn't get caught doing something while I was in the navy.

Like all brigs, the brig in Yokosuka was pretty tough, and more than a few times I wound up in a detention area. This is a cellblock with no windows or heaters in the cells. The only heater is at the far end of the cellblock. The door leading into the cellblock had a small open window in it, so you couldn't keep the heat in, and of course I was there during a cold, snowy winter.

One of the guards, Sergeant Pandavella, was the guy who told me that he didn't think that I would live to see the age of twenty-one. He wasn't trying to be a hard ass. He was a pretty decent guy; he was just trying to give me some advice, in his own way. I bet he'd be surprised to find out that I'm seventy years old now.

In many ways, I really liked the navy, but it didn't seem to care much for me. I decided not to have a naval career after an incident that happened one day while dropping anchor. The anchor was running out way too fast, so a bosun and I were pulling on

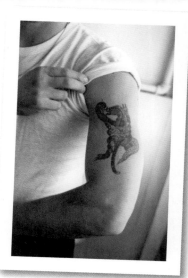

the chain brake trying to stop it. Anchor chains are painted differ-
ent colors along their length to let you know how much is left in
the chain locker. Red is the last color, and when you get to red, that
anchor better damn well stop or you are screwed. After red, the
chain can pull out of the chain locker and rip the fo'c'sle apart and
you right along with it. This is why we were instructed to get the
hell out of there if we saw red and the brake wasn't working. OK,
so we were pulling on this chain brake with everything we had,
and the chain came up red. That was bad. Very bad. When I saw
that, I started to take off, just like we were instructed to. I thought
the bosun would do the same, but I looked back and saw him still
holding on so I went back and grabbed onto the brake again. The
chain locker was filled with rust, so when the end of the chain
came out, the rust was flying everywhere. I couldn't even see that
man standing next to me. The noise was so outrageously loud that
it was like the ship was screaming in pain. We couldn't hear each other, but
I'm pretty sure the bosun and I were thinking the same thing: "We're done."
Obviously, the brake finally worked, but literally it was just in the nick of time.
A few days later, the bosun was awarded a medal for his heroic efforts in saving
the ship. (I guess I wasn't there after all.) I felt that I was overlooked and that
ordinary seamen were just discounted; that's what soured me on the navy.

Surprisingly, after all the fights and trouble I got into, I did get an honorable
discharge, though, so I guess the navy and I are even.

Everybody wanted to get
tattoos overseas. Here I
am showing off the one I
got when I was fourteen
years old.

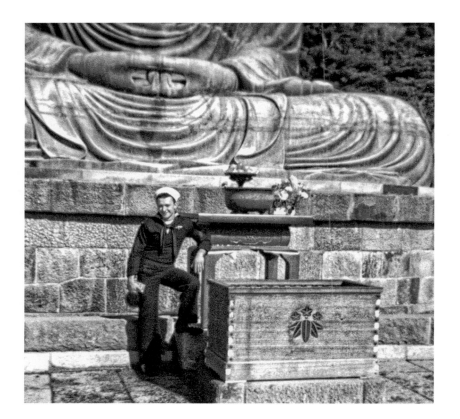

This giant Buddha is in
Kamakura, Japan. When
you go inside it, there is a
little Buddha in the head.

IN TRANSITION

AFTER I GOT HOME from the navy, I decided to pay a visit my friend Junior. That meant making a trip to Oklahoma. There were two problems with this idea. One, I had almost no money, and, two, I had no vehicle, not even a bike. I did have a perfectly good thumb, though, so that's what I used to get there.

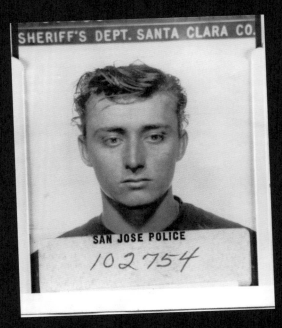

My first mug shot. The girl I was dating got in a fight with
another girl and we all got arrested. My charges were dropped.
Of all my mug shots, this is my wife's favorite.

Since I didn't have much money, I couldn't afford to waste any of it on motels so I had to sleep outside, even though I didn't have sense enough to bring along a sleeping bag. I slept in campgrounds, parks, or just off the road if I had to.

It took me quite a bit longer to get to Oklahoma than the amount of time I ended up spending there. Even though it was good to see Junior, I wasn't real impressed with Oklahoma, so I headed for home after a couple of weeks.

On the way home, I decided to treat myself to a night in a hotel in El Paso, Texas. Even though it was a cold night, it was a waste of ten dollars. Not only was the room ugly and dirty and full of bugs, but also the damn window was broken out. Plus, I hardly got any sleep because during the night I kept hearing what sounded like eerie baby cries, but I couldn't figure out where they were coming from. After much deliberation, and once one flew in my window, I realized that the sounds were coming from pigeons that were roosting all over that joint. Man that place just kept getting better and better. If I hadn't had to pay up front, I would have skipped out on the bill.

In the summer of 1962, I got a job trimming trees. The work was in Arizona and Texas. I got on my rigid frame and headed to Phoenix. I could only go fifty miles between gas stops because I had what we called a peanut tank. Peanut tanks only hold about a gallon and a half of gas, not great for a long-distance trip. I wanted a sportster tank because they held just over two gallons, but I didn't have the money to buy one. Harley's stock big twin tanks held three and a half gallons, but they weren't considered cool. I could have bought one of those for about twenty-five bucks, but I didn't want one of those ugly-ass

My first Harley. I rode it to Arizona and Texas looking for work.

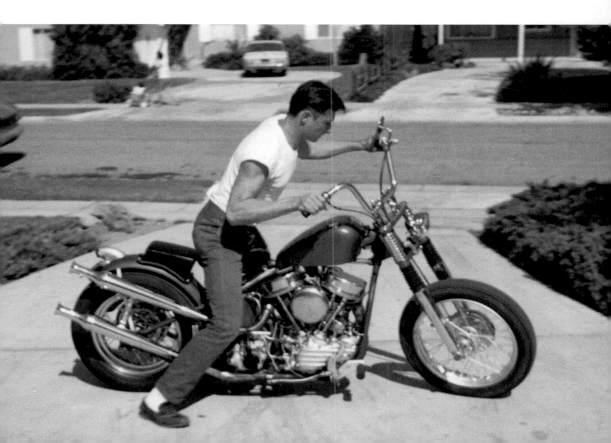

Me and my Grandma Orlando after I got home from Texas.

My friend Whitey. He was a wild one. He still is.

things on my bike. After the first couple of hundred miles, I would have put one on with bailing wire . . . if I'd had it. I learned right then and there that there's a time to be cool and a time to be practical.

When I was about seventy-five miles outside of Phoenix, my spokes punctured my tire and I had a terrible flat. I pulled off the highway into a dry creek. I took the tire off and hid my bike in an eight-foot culvert that ran under the highway and thumbed a ride into town.

While my tire was getting fixed, it had started to rain, and by the time I got a ride back to my bike, it was pouring. Every culvert we passed was flooded, and I thought for sure I had lost my bike. Hot damn, my luck held; my culvert was dry, and I mean it was the only one. I fixed my tire, but it was too wet to ride so I spent the night in that culvert. I wasn't alone, though; I had the tarantulas and scorpions to keep me company.

In Arizona, I worked trimming giant palm trees. This is incredibly hard, hot work. First you climb up sixty or so feet in 115-degree heat, and then you start hacking the dead fronds away with a machete. There are all kinds of things living in those dead fronds: rats, lizards, spiders, you name it.

One time as I was hacking away, I pulled off a large frond and hundreds of spiders fell out of the tree and stuck to my sweat-soaked body. Right about that time I decided I was due for a change. Texas, here I come.

On the way to the job in Texas, I was riding down a country road late at night and crested a hill. Right as I hit the top, there was a pack of coyotes gnawing on a carcass. I didn't have time to swerve out of their way, so I just powered right on through (no way in hell I would have stopped). Luckily, I didn't have any problems. I never lost control going through their pack, but one of those old coyotes didn't fare as well. I hit that old boy, and you should have heard the yelp. I could hear him complaining for quite a ways as I rode off.

I liked Texas. The trees were a lot cleaner—plus I got a dog there. I was working for a company called Blume Tree Service. We'd stay in one town for about three weeks, work the area, and move on to the next town. When I was in Junction City, Texas, I stayed at the foreman's place. Everyday after work, I would walk from his house to the bar, about half a mile. On the second day, a dog followed me, keeping about fifty feet away. He followed me to the bar every day, and each day he'd get about ten feet closer, until he was walking right alongside me. He started sleeping outside the house too. Dog (that was

the original name I gave him) saw me off every morning and was waiting for me each day when I came home from work. If I'd had a car, I would have taken Dog with me when I left Junction City, but it just wasn't meant to be. The foreman liked Dog too, and he promised me that he would take care of him. It was a good deal for Dog.

Tree trimming in Texas could be dangerous, both for the guy doing the trimming and for things living in the tree.

People living in that area were poor, real poor, and a lot of the trees we trimmed were pecan trees. These folks made extra money off of those pecans, so they were very protective of them. I was trimming this old boy's pecan tree one afternoon when he came running out of his house yelling and screaming and waving a shotgun. I immediately saw his point, climbed down out of that tree, and left. I told the foreman that if he wanted that tree trimmed he could do it himself. He didn't do it either. Wise man.

That same foreman was not a nature lover. I startled a bat once, and it flared out. Well, that startled me, so I swatted at it, knocking it out of the tree. I didn't mean to hurt it, so I climbed down to check on it. When I got to the ground, it was stunned but recovering. I had never seen anything like it, though; this bat was twice the normal size. But what was really unusual is that it was striped, black and white, sort of like a zebra. I put my hard hat over the bat, so it wouldn't get away, and called over to the foreman, saying, "Hey man, you've got to see this; it's amazing." He walked over, I lifted my hard hat, and then he looked down at the bat, lifted his foot, and stomped right down on it. That surprised the hell out of me. I couldn't believe he did that, but OK, so much for zebra bat.

There wasn't a lot to do on your days off in Junction City, so one afternoon I packed up my tree-climbing gear to do some spelunking in the mountains. What were considered mountains in Junction City we called foothills in California. I had been told about a couple of caves located up at Lover's Leap. The entrance to one cave was at a steep angle into the ground, about fifty yards from the cliff face; the other one was located right in the cliff face, fifty feet below the leap. The drop from Lover's Leap was about two hundred feet to a small, rock-filled river. The actual leap was marked with a large cross sitting on the rock projection that extended way out beyond the entrance of the cave. I tied my rope to the cross, lowered down to the cave opening, and started swinging back and forth. I finally got enough momentum to grab the opening, but lost my grip instantly. Apparently my sudden appearance spooked the inhabitants—bats, thousands of them—and they all came flying out at once. I could feel them fluttering and flapping all around me, hitting my face and neck, and all the while I was cartwheeling out of control. One second I could see sky, the next I was looking at the river. Finally, after what seemed way longer than I'm sure it really was, the bats were gone and my spinning body came to rest. I hung there for just long enough to decide that I didn't give a shit about that cave after all, and I started climbing back up.

After reaching the top, option two was to take my flashlight and head into the other cave. When I got a ways down, the climb got steeper and the walls got slick. I needed both hands; time to lose the flashlight. Even though the descent was only fifty feet, it was slow going in the dark. When I reached the bottom, I sat down, got my flashlight out, and slowly panned it around. The

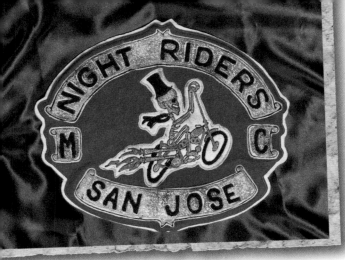

My patch from my first motorcycle club, the Night Riders.

whole cavern was pulsing, like a living being. Man, I thought the bats were bad. This cavern was filled with spiders, I mean millions of them. They were everywhere—on the walls, on the ground, and on me. They mostly looked like daddy long legs, and I mostly wanted to get the hell out of there.

Option three for the day was to go to the bar. It was at that bar that I met some guys who worked painting high water towers. After telling them about Lover's Leap and the bats, they said I should check out their company because I could make a lot more money painting water towers than I did trimming trees.

So I had a new career. These water towers are one hundred to two hundred feet tall, and painting them is dangerous work. I liked it. I liked taking all the short cuts around the towers, sliding down the legs and ropes (all the stuff we weren't supposed to do).

Water towers have catwalks that circle the tower. When the water towers need painting, a trolley is hooked to the rail of the catwalk. This trolley hung below the catwalk so that we could paint the underside of the catwalk and the lower half of the tank. Underneath the tank itself is a series of support rods that stretch out to the legs. Planks were put across these support poles so we could paint the bottom of the tank. When we wanted to move from the underside of the tank to the catwalk, we would launch ourselves off the planks, straight into mid-air to catch hold of the trolley, throw a leg up on the trolley, and climb up it to the catwalk. It was sort of like trapeze work at 150 feet with no net and not exactly OSHA-approved. I loved that job.

It was getting close to Christmas, and I found out that my grandmother was sick so I decided to head home. When I got to Arizona, it was so bitterly cold that I had to use layers of newspaper wrapped around my chest and legs underneath my jacket and pants as insulation. When I left California, it was summer and I never thought that it might be winter when I came back. Lesson learned: plan for the unexpected.

It was after I got home that I met my friend Whitey. He and I were hanging out one day, and he said he had to go see a friend. I had met the guy, so I went to Gilroy with him. We took an old dirt driveway that went through an orchard; it had a small house at the end. We pulled over and went up to the house.

We heard a lot of screaming and yelling coming from the house as we went in. There was Whitey's friend, fighting with his wife. He was a big dude, about six foot, two inches tall and stocky. He had beaten his wife bloody; she was completely unrecognizable, and her face was nothing but blood and pulp. I never thought she was too good looking in the first place, but this didn't help. When we walked in, she was on the floor. He was standing over her with a .357 magnum pointed at her, and then he turned it on us.

We were only a step or two away from him, talking to him, trying to keep him from beating his wife more, or using that gun. It didn't work; he lifted the gun and threw off a round right between Whitey and me, only inches from

my ear (my ears are still ringing from it). Before he had time to think, I turned and bolted for the door. I needed a weapon. I ran around that house a couple of times looking for a shovel, a two by four, anything to use on that crazy motherfucker, but I couldn't find a thing. So I had no choice but to walk back in. I figured that together Whitey and I could get the jump on him and take him. He had the gun on his wife again, so we made our move. We took his gun and beat him up, and while we were beating him up, his wife was crying and saying, "No, no don't hurt him. Don't hit him anymore." What a crazy bitch.

We took the gun and left both of them in the house. They deserved each other. I didn't think much of Whitey's friend.

I joined my first motorcycle club in 1963. It was called the Hells Angels. It was a bogus club (as I was soon to find out) made up by the club "president" Lupe Provenzano. Lupe's father was a district supervisor, a well-respected man in the community. His son, however, was an idiot. I mean he just came out of the womb wrong. This kid couldn't do anything right. Anyway, after I found out about Lupe's scam, I left and the fake club disbanded soon afterward.

In 1964, I joined the Night Riders. For this club, we even went so far as to get patches. The club lasted for about a year after I joined it. The club really didn't have it together enough, and it didn't have the leadership to amount to anything.

The three guys I remember best from that club are Johnny Straiter, Portagee Bob, and Indian. I got along with real well with both Johnny and Portagee Bob; they were good guys. Indian was another story. I never liked him, and unfortunately he was our president.

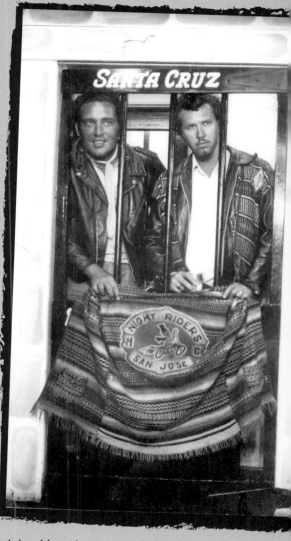

Rich and Dirty Ernie at the Santa Cruz Boardwalk with Rich's Night Riders patch.

Johnny was our sergeant at arms and was considered the old guy in the club (he was probably all of twenty-nine years old). He was a big dude, a retired professional boxer, and a man to be reckoned with.

Portagee Bob was about five foot, ten inches tall with a wiry build, and he had an odd quirk. I've seen this in other guys, but not often. Bob had no problem fighting; he just would not throw the first punch. You could sit and watch some asshole get right in his face, and Bob would wait until the other guy threw the first punch, and the second punch, and the third punch. It took three punches, every time, but after those three punches, Bob was ready to go to work.

I always thought it was too bad that Johnny and Portagee Bob didn't become Gypsy Jokers after we folded the Night Riders. They would have made worthwhile members.

THE RISE OF THE SAN JOSE GYPSY JOKERS

My good friend Theo Rumbandis and I started the San Jose Gypsy Jokers on November 29, 1965. It was the most action-packed three and a half years of my life, or so I thought. Then I became a Hells Angel . . .

My friend Theo after starting the San Jose charter.

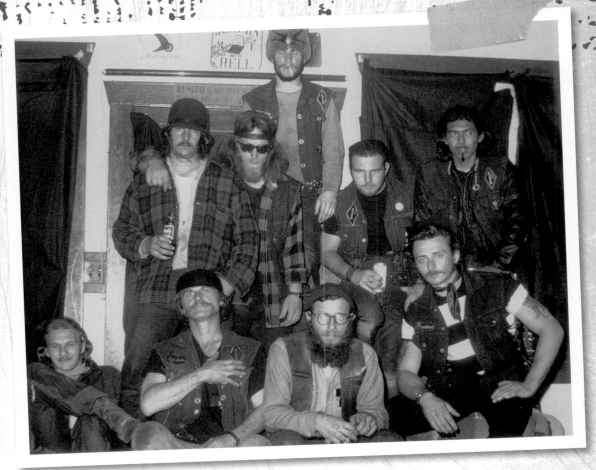

Most of the members of the San Jose Gypsy Jokers.

Theo had decided that he needed to make some connections in San Jose, so he came to a Night Riders meeting. During the meeting, Indian, who I already didn't like, really pissed me off. After the meeting ended, everyone was sitting around, drinking, bullshitting, and getting to know Theo. At the time, Theo always drank this wine called Arriba, and he had a bottle of it with him. Well, Indian finally said some stupid fucking thing that pushed my button, and I beat the crap out of him. I stuffed Indian's head in an antique wringer-style washing machine and was holding him down in it. As I was reaching for the switch (I wanted to wipe the smirk off his face), Johnny Straiter, our sergeant-at-arms said, "Knock that shit off." After I let Indian go, Theo walked over to me, lifted his wine bottle, and with a big grin said, "Arriba"! Theo had thought Indian was an asshole too, and I did what he'd been itching to do. That's how Theo and I became friends.

After that, a bunch of the Night Riders patched over and started the San Jose Gypsy Jokers, the first outside club of the Frisco Gypsy Jokers. Because of San Jose, the club spread into all the other local chapters: Merced, Santa Clara, and Stockton.

Besides me, the eight other charter members of the San Jose Gypsy Jokers were Theo and Hutch, who both came from the Frisco charter; Fat Rich; Johnny; Dirty Ernie; Bob Lee; Don; and Larry.

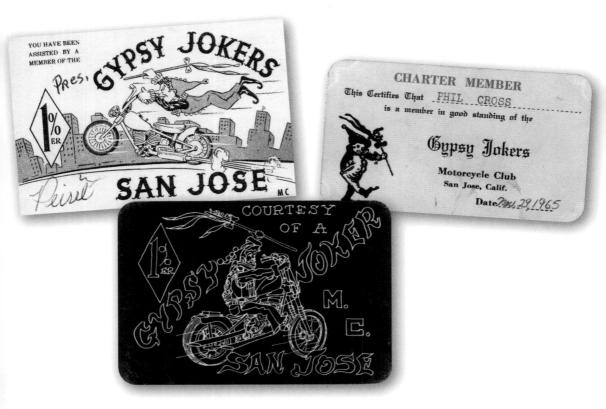

ABOVE: Even though they looked good, nobody liked the black courtesy cards because you couldn't sign them without a special white pen.

TOP LEFT: The first San Jose Gypsy Jokers courtesy card, designed by yours truly.

TOP RIGHT: My Gypsy Joker membership card, dated November 29, 1965.

Back in the day, all real motorcycle clubs had courtesy cards. They sort of happened simultaneously throughout the outlaw motorcycle world. Because the cops and press were having a field day with us, the cards were created for public image. We had a slogan that addressed that image problem: "When we do right, no one remembers; when we do wrong, no one forgets." The idea behind the courtesy cards was that if someone was having trouble, a flat tire or something like that, and you helped them, you gave them a courtesy card, so they could say, "Hey, I was helped by the Hells Angels" or "I was helped by the Gypsy Jokers" and so on. I designed the first courtesy card the San Jose Gypsy Jokers had. It really surprised me that everyone liked it on the first go round.

Right about the time we started the charter, I got a new (at least to me) bike. It was one I had fallen in love with when I had seen it two months earlier in the front of Filthy Phil's garage in Frisco. When I went to pick it up, it was at the back of a cluttered garage that was two garages deep. It was behind about a dozen bikes and a whole bunch of parts. After I paid for the bike, I was thinking, "It's going to take forever to move all this stuff and get my bike out," but Phil and Bill Azzolino (then president of the San Francisco Gypsy Jokers) walked to the back of the garage and picked the bike up. Phil and Bill were both really big guys, huge guys, and they carried that bike through the garage like it weighed nothing, around all the obstacles, and put it right down in front of me. The interesting thing about Phil and Bill was that in spite of fact that Phil was a Hells Angel and Bill was a Gypsy Joker, they were best friends, even during all the wars. They were great guys, the both of them.

In those days everyone was too poor to own leathers or rain gear. We wore what we called "greasers." Greasers were Levis that never got washed. We let the road dirt and grease and oil from our bikes build up on them. Eventually they would get to the point where they would shed water. We wore our greasers over our clean (or cleaner anyway) Levis. When you took them off they could practically stand on their own. My mom thought she was doing me a favor one day and washed my greasers. She told me that the only thing that was left when she was done were the buttons, zipper and rivets.

The bike I got from Filthy Phil. He and Bill Azzolino carried it from the back of Phil's overcrowded shop.

Kelly's Bar on First Street was a favorite hangout of the Jokers. Kelly's was an interesting place, with hundreds of bullet holes in the ceiling, a boxing ring where we had sparring on Friday nights, a heavy bag, and such regular drive-by shootings that we had to post gunners of the roof. We even had two bartenders murdered (good help is hard to keep). If it was ordinary or mundane, it didn't happen at Kelly's.

Mike Goodson, me, Harry Headgasket, and Gypsy Jack. The bike is Jack's.

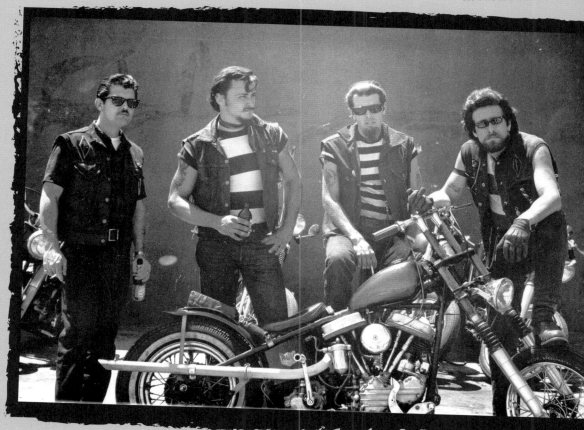

One night, a guy at the bar (not one of mine for a change) leaned back on his barstool, pulled out a gun, and took a shot out the open front door. The bullet ricocheted off a truck across the street and hit a homeless guy in the ass. The cop who eventually came to investigate didn't seem all that concerned; he just wanted to know who "shot the bum in the bum." Case unsolved.

Black Bill became the owner's least favorite customer one night (we were both Hells Angels by then) when he drew a target on the bathroom door after the owner went in there. Then Bill proceeded to fire six rounds at the target. When we opened the door, the owner was on the floor curled up around the toilet, hugging his head. His dignity had been killed, but otherwise he was unharmed.

I almost got my head blown off at that bar. Mark Leal (another Joker and a great friend) told me that there was a shooter out front. I went to check it out, and as I opened the door, I was staring down the barrel of a shotgun. As I pulled my head back, I pushed the door further open so the door took the blast. I did get a head full of splinters, though. The door was made of two-by-twelve planks, and the blast tore a substantial hunk out of it. Unfortunately, the shooter got away. It was after that incident that we posted guys with rifles on the roof.

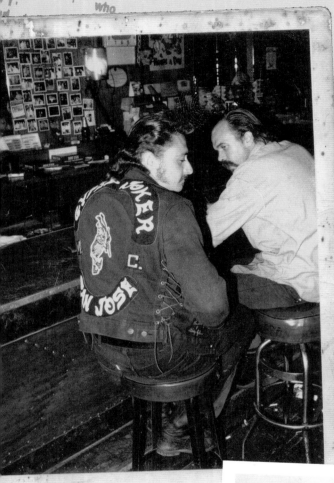

ABOVE: Gary "Can Man" Fahien and I having a few in Kelly's Bar.

RIGHT: My good friend Mark Leal.

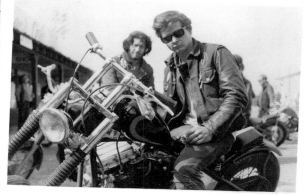

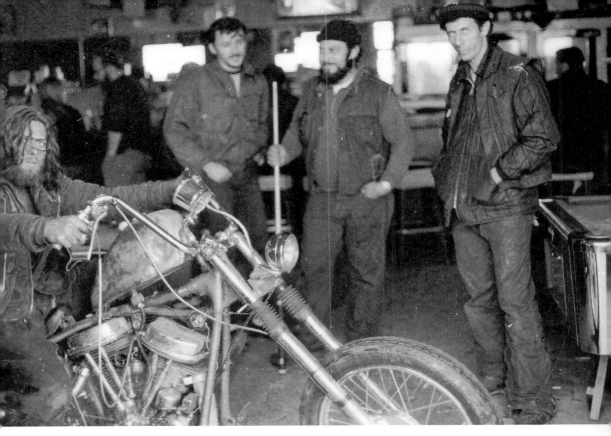

Inside the Chateau Liberte with Chico, Dago (on the bike), and Frenchy.

Two plainclothes vice cops used to come into the bar every couple of months—not for any particular reason except that the place was so notorious and just to make their presence known. Their names were Ralston and Brown. Ralston was huge, really huge. He was easily six foot, six inches tall and close to four hundred pounds. He also packed a personal arsenal. He once showed me four guns that he was packing, and when he claimed to be carrying four more, I didn't doubt it. Ralston always did the talking; Brown never said anything, literally, not one word in three years. I have to admit that they were an impressive pair.

Camus, the pig hunter, and Larry Cook. Camus gave me a boar head mount. His mom did the taxidermy.

Kelly's Bar closed about a year after Theo, Mark, and I folded the San Jose Gypsy Jokers I believe the city bought it and tore it down just days after the purchase. I don't think the city had any grand plan for that lot because it stood empty for years. I think officials just wanted to get rid of that notorious old outlaw bar.

There use to be a leather shop on South First Street where we would take our stuff for repairs and just generally hang out a bit. The store was run by a guy named Charles Manson, but Charlie never got famous for his leather work, so he turned his talents elsewhere. Years later, I met one of his friends, Squeaky Fromme, at Terminal Island, my home away from home for four years.

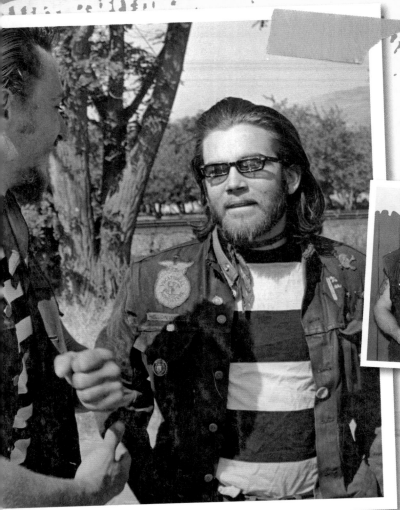

After Kelly's closed, I started tending bar at a place in the Santa Cruz Mountains. This bar was really rural, way off the beaten path. It was called the Chateau Liberté, a rather elegant name for a really rough joint. The

ABOVE LEFT: Dirty Doug (not pissing on Alice Cooper's drummer).

ABOVE RIGHT: Frenchy and me at the clubhouse.

first time I went there, just as I was heading to the front door, a guy came running out followed by another dude, who shot him in the leg. A lot of the patrons at the Chateau had guns, so when I was behind the bar, I always had one. Usually, I wore it in my belt. Sometimes I had to make someone check their gun. I didn't like guys getting too loose with them in the bar; they could take that shit outside. One time a guy who had been out hunting pig came in with a bunch of hound dogs and a rifle. I told him the hounds could stay, but he would have to check the rifle.

The weekday crowd at the Chateau was mostly mountain folk, but on weekends the bar had some really good music so the flatlanders would come up. People came from all over; they liked to check out the Chateau's badass reputation. Some of the bands that played there were the Tubes, the Doobie Brothers, and Alice Cooper, all before they were famous. The night Alice Cooper played the Chateau, he invited anyone in the audience to come on stage, if they would do something really raunchy. Well, Dirty Doug Bontempe had no problem with that. He got right up there, opened his fly, and proceeded to piss on the drums. The crowd roared; really, they loved it. The drummer . . . not so much.

During the Chateau days, Theo wanted nothing to do with drug dealing. Whenever someone would ask him if they could buy drugs from him, I could always tell. I could see the crowd start to part, like the Red Sea, and I knew someone was in for it. I thought it was funny every time I saw that, so when some guy would come and ask me if I had something for sale, I'd send him right over to Theo.

For a while, some of us were living in an abandoned house at the Chateau. We were at war with the Hells Angels at this time, so everyone had a gun. After a long night of partying, we were all pretty loaded. We were in the living room of the house lying on the floor (it had no furniture), and Frenchy said, "I want to see the stars." There were general mumblings about that being a good idea, but nobody wanted to get up and go outside. So Frenchy said it again and pulled out his gun and shot a hole in the ceiling. Instantly everyone pulled their guns and started shooting. There was a lot of smoke in that room, but after it cleared, we had a nice view of the night sky. This was how we installed skylights, via too much booze and LSD.

Haight Ashbury. It's true what they say: "If you remember it, you weren't there." My first experience with the Haight was in 1960. I first went there on leave from the navy, and after I got out, I just sort of gravitated there. I lived there for about two years; there really wasn't anything else to do. The people I hung out with then weren't hippies; hippies didn't exist yet. The people I hung with were part of the beat generation. That's right, they were beatniks, with coffeehouse music and poetry, Jack Kerouac, berets, the works. I didn't look like them or dress like them. I wasn't like them; basically I hung out with them because that's where the women were.

DANCE FEBRUARY 3
HELL'S ANGELS 507
DONATION $1.00 CALIFORNIA HALL
 625 POLK

The ticket to get into the California Hall. Theo and I each paid a buck to get the crap beat out of us.

ABOVE: It took more than a head injury to keep me off my bike.

LEFT: The aftermath of the Hells Angel Dance. Theo and I after we both got out of the hospital.

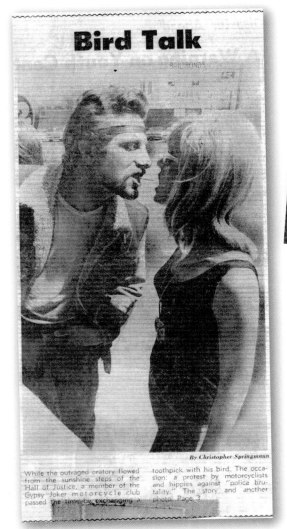

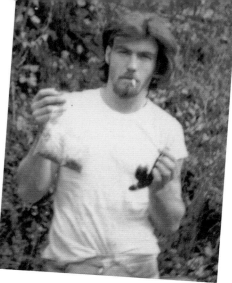

Bird Talk

By Christopher Springmann

While the outraged oratory flowed from the sunshine steps of the Hall of Justice, a member of the Gypsy Joker motorcycle club passed the time by exchanging a toothpick with his bird. The occasion: a protest by motorcyclists and hippies against "police brutality." The story and another photo, Page 3.

ABOVE: Newspaper article showing Gypsy Jack about to kiss Dave Agee's girlfriend. Oops.

ABOVE RIGHT: Dave Agee and his bag of weed.

One of those beatniks really pissed me off once. This kid was about my height and weight and we got into it in the street. After I started getting the better of him, he took off running, but I wasn't ready to let him go just yet. I was always pretty good with knife throwing, so I pulled my knife, threw it, and hit him in the shoulder. The little bastard never even slowed down, he just ran off with my knife still stuck in his shoulder.

Then in 1965 I started going to the Haight again to party with the Frisco Jokers. Now we're talking hippies. The hippie generation was a lot more fun. They were a more relaxed group and the girls were looser. This was around the time that the birth control pill became popular, which made free love a lot less complicated. It was pretty much like everybody says: free love, free drugs, and if you needed it, a free place to crash. I don't have a lot more to say about the Haight because I really was there so I don't remember a lot. It was just one big party, and a whole lot more fun than the old beatniks.

I even I went to see Alan Ginsberg at San Jose City College once. He had a little chime and he'd hit it, just one note, and he'd lose it and drift off with that note in his head. I'm sure he was high that night. I think once he started doing acid he was always high. Ginsberg wasn't a bad guy; he was just different, but shit, we were all different.

In 1966 I got into a hell of a wreck at the intersection Dry Creek Road and Leigh Avenue in San Jose. I had been to visit my Mom and was riding down Dry Creek Road, heading to the Loser's Bar. As I was crossing Leigh Avenue I looked to the left saw a car run the stop sign. It was hauling ass and I knew I wasn't going to get out of the way. I stood up on my right leg and pushed off as I stuck my left leg out in front of me. When the car hit my bike I went straight up in the air the car and my bike went right out from under me. I was so high in the air I thought I'd break my neck when I landed. I didn't,

but when I did land I was really mad. The car and my bike stopped twenty or thirty feet away from me. My knife had fallen out of its sheath and I saw it about six feet away from me. I was crawling to the knife, when a guy came up and kicked it away. He said, "You've already had enough trouble for one night. No point in stabbing the bitch too." That's when I found out it was a girl, and a young one at that. The funny thing was she was headed to the Loser's Bar too. She didn't know I was heading there, and when she showed up and saw me, she left . . . quickly.

On February 3, 1967, Theo and I went to a Frisco Hells Angels dance at the California Hall. The dance was a benefit to raise bail money for Harry Henry. Big Brother and the Holding Company (yes this was during the time that Janis Joplin was with the band) and Blue Cheer played. Gut Turk, a former Berdoo member and manager for Blue Cheer, designed the poster for the dance.

There was a bar across the street, and a whole bunch of Hells Angels were in there. Theo thought we should go over there. I didn't want to, but Theo convinced me. He said, "Let's show some class." Theo went over to talk to Fat Freddy. He thought it would be OK because he and Freddy had always gotten along well. Some other Hells Angel came over to Freddy and said something to him, and Freddy hauled off and punched me. That punch started a fight that spread like wildfire, out onto the street and right into the dance. Theo and I fought, and we fought hard, but we were seriously outnumbered and being rat packed.

I just got out of jail after doing ninety days. Larry is on the right, Buzz is on the left.

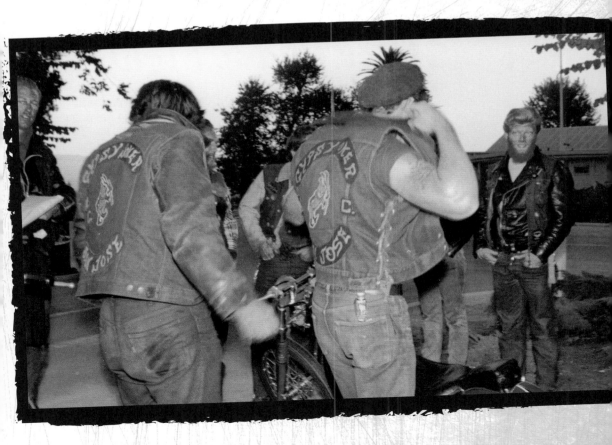

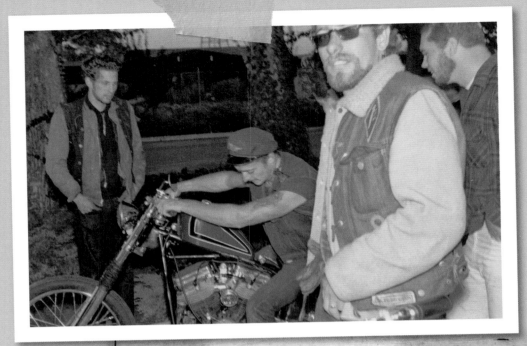

Getting ready to go on the ride where I "met" Officer Perez. Jack and Armond are on the right; Greasy George is on the left.

Jail Motorcyclist After Chase, Fight

A Gypsy Joker motorcyclist was booked into County Jail Thursday night on an array of charges after he sped through the streets and wound up fighting with officers.

Philip Raymondo Cross, 25, led police on a high-speed chase for five miles which resulted in a fist fight on Almaden road.

He was booked on charges of felony battery on a police officer, resisting arrest, reckless driving, showing false identification and giving false information to police.

According to officers, Cross and two other cyclists were riding three abreast in Coleman avenue southbound lanes and were blocking traffic.

Officer Tom Perez said he approached the trio and centered his attention on Cross because he was straddling the center line.

Cross reportedly glanced backward and then sped away on Market street on his "chopped hog" motorcycle.

He was followed as he blasted through the downtown area and on toward Almaden road, all the while running stop signs, according to police.

Finally, the 'cyclist lost control of his vehicle and dashed off on foot when Perez attempted to apprehend him. In the melee, the officer and a colleague, Tom Anthony, received assorted cuts, bruises and lumps.

The article says that I lost control of my bike. It neglects to mention that it was because Perez rammed me with his squad car.

I still have a dent in my skull from that fight. Zorro picked up a barstool with angle iron legs, and he hit me in the head with it while another guy had me in a choke hold. I got out to the street, and a big Asian guy was kicking me. Andy Holley, a San Francisco Hells Angel, walked up and told him to quit. Andy actually stood next to me and said, "There ain't nobody touching this guy no more." I was really thankful. When it was finally over, Theo and I didn't feel too classy, and we both ended up in the hospital. I never held anything against Freddy, though; I always liked him. Zorro, not so much.

In August of 1967, I was in jail for assault with a deadly weapon. My friend Dave Agee was at the farm then too. On August 12, we got the newspaper, and right there on the front page was a photo of Gypsy Jack kissing Dave's girl-friend. Dave was so pissed. He was waving the paper around and yelling, "I'll kill him; I swear I'll kill him." This not the best thing to be yelling in jail, but it was pretty damn funny.

On September 7, 1967, I got out of the farm after doing ninety days. Buzz, Mark, and I had just left the clubhouse and were heading to the Loser's North Bar. We were on Coleman Avenue riding three abreast when we passed a cop going the other direction. He spun around and followed us. This cop's name was Perez, and he followed us for a long time from street to street. When he finally turned on his lights and siren, all I could think of was having to do another ninety days. So I took off. He pursued. I ran red lights and stop signs and even rode on the sidewalk, hoping to make it to the Loser's parking lot. The place was always packed, and the lot had a lot of cars in it. My plan was to get to the parking lot and snake through the cars to a walk-through gate that led to the back of the bar. If I could drive my bike through that gate before Perez saw me, I would be home free. It was going good. I had just run another red light and managed to make it through the intersection without getting hit when my bike started slowing down; the clutches were slipping. Now I was going slowly enough for that asshole Perez to catch up and ram my bike with his car. I went down, and when I got up, I was fighting mad. As Perez walked up to me, I charged him; he hit me with his flashlight and I started pounding him. His official report said that I hit him twice, ripped his shirt, and broke his watch before another cop named Anthony came and pulled me off. In reality, I had him on the ground and was beating the shit out of him.

Perez took the whole thing personally. After they arrested me, they took me to the hospital, and when I was sitting cuffed to a chair, Perez walked up to me and maced me.

Twelve hours after I had been released from the farm, I was back in jail, and ultimately I had to do another ninety days at the farm. Shit, I really should have just pulled over.

I was out on bail and at our meeting on September 16, 1967, I was voted in as president of the Jokers. Three months later, I started serving my next ninety days for assaulting an officer.

If you've done time, you already know this, but for those who haven't, it's boring, boring, boring. Mostly, you just want to do your time and get out. There was this one guard at the farm who seemed to have a personal mission to catch anybody doing anything wrong, but his real pet peeve was weed. This guard's nickname was Whitey (yep, he had white hair), and he would take radical steps to catch people. I think the wildest was when he'd hide in trees, and when

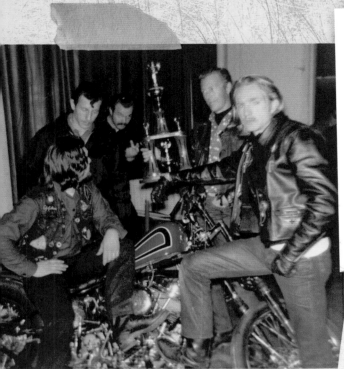

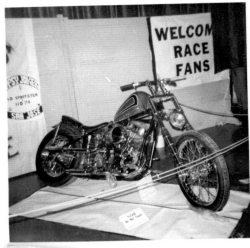

WELCOM
RACE
FANS

Phil Cross

PLEASE
Do Not Touch

San Jose Rod & Custom Show

VALLEY PRESS · SAN JOSE
1-14-68

ABOVE: Jack, Frenchy, Can Man Gary, Buzz, Tom, and the first-place trophy.

ABOVE RIGHT: My bike, entered in the San Jose Rod and Custom Show by Gypsy Jack.

someone who was smoking weed walked by, he'd drop down behind them—busted. Finally, the inmates got smart; they started smoking in the center of a giant lawn where they could watch from all directions. If they saw Whitey or any of the other guards coming, they would just put the joint in the grass, get up, and walk away. Even if the guard found the joint, they couldn't prove whose it was. Surprisingly, Whitey wasn't one of those guys who hated me. We actually got along OK. Well, good enough that he wasn't gunning for me.

While I was doing time for beating up Perez, Gypsy Jack and some of the other Jokers entered my bike into a three-day show in January of 1968. At the farm, there were always three to four hours after the bedtime head check until the next one. I decided that was just enough time to hop the fence and go to the show, so I arranged for a car to be waiting outside the jail for me on the last night of the show. I was glad I did too because my bike won. After collecting my trophy and handing it off to one of the guys, I broke back into the farm.

Probably my most unusual visitors at the farm were some of the novitiates from the Santa Cruz Mountains. Some of us had started going up there and partying with them because one of our guys knew one of their guys. They had a gazebo up there, and sometimes we'd all sit around up there and talk. We all drank the wine that they supplied, and we'd usually smoke some weed, which we supplied. Occasionally a few of them would join in.

Most of the time, we went to see them. It was nice up there, and it was relaxing to hang out. We pretty much knew that we weren't going to be getting in any kind of physical confrontations with those guys.

Even though we usually went up there, once in a while they would come and see us. They even came to our clubhouse to watch me perform a biker marriage. I thought that was pretty cool.

Even with all the fighting, partying, evading the law, or spending time in law enforcement's less-than-stellar accommodations, the one constant in my life was (and is) working out; it's a must. I have been lifting weights, which I started doing with my dad, since I was thirteen.

I started boxing at Babe Griffin's gym in downtown San Jose when I was about twenty-five. Babe had been a pro fighter in the 1920s and 1930s. When he retired, he opened his boxing gym, and he was also a successful fight promoter. My trainer there was a man named Gus Spencer, and he was really good. I could fight, but Gus taught me a lot about technique and control that really upped my game.

Since Babe was pretty famous in his own right, he had some famous people come through his place. One time I even sparred with Ernie Shavers there. Ernie was preparing for a fight and was training at Babe's gym. This was right at the start of his career, but I could tell Ernie was a pro. I just didn't know what a great fighter he was going be. I got to spar with a number of pros over the years. I was good enough to stay alive anyway.

Babe had a bar too, and one day I was in his bar drinking and a couple of Oakland Raiders came in and sat down at the far end of the bar. These were big dudes. They ordered their beers and then started having their fun. They never got up out of their stools; they just started messing with people. They were treating them really badly. First they started with the guy right next to them, and when they ran him off, they moved to the guy next to him and on down the line. Well, I knew my turn was coming, and I knew two other things for sure. One, I wasn't going to put up with their shit, and two I couldn't beat them. I had a buck knife on me, so I got it out and palmed it.

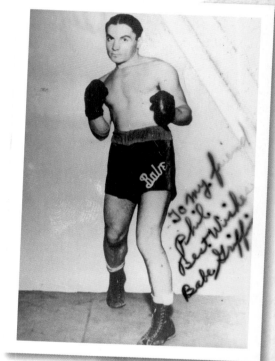

My friend Babe Griffin in his boxing prime. This photo was used for his induction to the World Boxing Hall of Fame in 2007.

My turn did come, but I took the offensive and got up and walked toward them. I got about ten feet away, and I had that knife palmed and ready to go when one guy tapped the other one on the shoulder and pointed. I thought he was pointing at me, and then next thing I knew they both jumped up really quick and zoomed out of the bar. You know this sparked my curiosity, so I walked down the bar to where they were sitting, sat down, and started drinking one of their beers. I looked down the bar, and Babe Griffin was about halfway down tucking away a shotgun. There was no way that I was going to get hurt in that bar.

If Babe was your friend, you had a friend for life. I stayed in touch with him right up until his death in 1996.

Over the years, a lot of people have either made assumptions about me or have been given bad information about me and then they passed it on. That naturally kind of pisses you off, but you sort of expect it. What I never expected from complete strangers was the exact opposite.

It was at Babe Griffin's bar that I spent about a half hour talking to a guy who was friends with Phil Cross. I was sitting at the bar, and this guy walks in and takes the stool next to me. He said something really intelligent like, "So, you're a Gypsy Joker." Was the patch his first clue? I wasn't going bother talking to this bozo; he just seemed like the type who was going to get himself in trouble. But his next question surprised me. "Do you know Phil Cross?" I said, "Yeah, I've heard of him." Then Bozo said, "He's a really good friend of mine." Didn't I say I had a feeling he would get himself in trouble? I said, "No shit?" Bozo said, "Yeah, he's a really great guy, the best." OK, Bozo might get to stay upright. We talked for another twenty minutes about what a great guy I was before I finished my drink and left. I should have just knocked him out, but he had a lot of nice things to say about me. The bartender there knew me; I wonder if he told Bozo who I was after I left.

I also took up martial arts around that time. I studied (along with Mark and Theo) with a guy named Bob Babich in San Jose. It was at Bob's place that I met another future Hells Angel, Ted DeMello. The four of us studied with Bob for quite a few years. I also met Armond Bletcher there. He'd heard that I was a pretty good street fighter and that I worked out there. So one night he came in to watch me, which I wasn't too sure I liked. He hung around for about ten minutes and left. I guess he figured I wasn't a big threat. No one was really a big physical threat to Armond; he was gigantic and incredibly strong. Later on, we got to know each other and became really good friends.

Bob Babich at his home at cocktail time.

After karate we'd go to the restaurant across the street to have a few beers. The place always put appetizers out, and we'd load up on them so we didn't have to buy dinner—more money for beer.

One night a guy came in and robbed the place at gunpoint. The owner's wife was working the register and just pulled out the drawer and handed it to him. When the owner saw what was going on, he made this funny squeak sound (Eep!), ran through the restaurant, grabbed the drawer, and kept running. The robber was so stunned he didn't know what to do, so he left. It was pretty damn funny.

As I said, Armond and I were good friends. There are a lot of Armond Bletcher stories, but the one I always think of from my Joker days is the time Armond went with me to visit a guy I knew. Armond and I had been hanging out, and I told him I needed to stop by this house for a minute. It was going to be quick; I just needed to ask the guy a question. I got out of the car and went to the door, and Armond came with me. When the guy opened the door and saw Armond, he went as white as a ghost and his eyes literally bulged out. The dude slammed the door, and Armond busted through it. I could hear shit flying all over inside that house, so I didn't bother going in.

I figured screw it, he's on his own. That guy must have really screwed up. A few minutes later, Armond and I were back in the car and heading off. I never did ask him what the fuck it was all about.

Armond was a strong guy. The Jokers were riding down the street one afternoon, and we saw Armond coming the other way. We all stopped and he asked us where we were going. When we told him, he decided to join us and without getting off his bike, he just lifted it off the ground and spun it around right underneath of him. He was six foot three inches tall and pushing about 400 pounds. He could make a Harley look awful small.

I met Bill Thompson when I was a Gypsy Joker in 1968. Bill was a private investigator. I was in jail, charged with rape, and my attorney, Paul Mansfield, had called and asked Bill if he would do a background check on the girl I supposedly raped. I had an alibi, but the cops didn't give a shit; they just figured that anyone I was with would lie for me. Bill hadn't even had time to get to the jail to meet me yet when he got a call from a friend whose daughter, Mary, had been raped. Mary told Bill that she met a guy at a bar; he bought her a bunch of drinks, took her back to his place, raped her, and then took her back to the bar. She told Bill that the guy's name was Phil Cross. Bill said, "Well, we a problem here because Phil Cross is in jail." Mary agreed to show Bill where the rapist lived. After dropping Mary at home, Bill staked out fake Phil's house. When he got back there, fake Phil was home and he wasn't alone. Bill got set up in some low trees and waited. He still hadn't met me, but he had a photo of me. After a few hours, a guy and girl came out of the apartment. Bill said the guy looked remarkably like the photo of me. They both got into the guy's red 1949 Ford convertible and drove off, and, of course, Bill followed them.

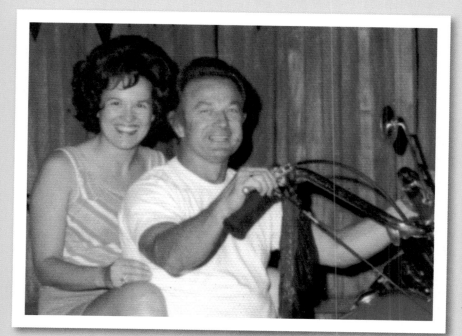

My friends Bill and Donna Thompson.

Once she was alone, Bill talked to the girl, Sandra, and she told him that she had just been with Phil Cross and that he had taken her back to his apartment and raped her. Bill told her that she was wrong, that I was in police custody and had been for quite a while (it seemed like I lived in their custody in those days).

He and Sandra went to meet Mary, and he showed both of them the photos. They both agreed that I absolutely was not the rapist, and that the dude in the other photo was.

Next, Bill met with Paul and explained everything to him. Then Paul and Bill went to the district attorney's office for a sit down with the prosecutor who had my case and the police department's lead investigator on the case. After they had been looped in, they sent an investigator out to pick up both girls who were questioned extensively. Both of them said that I didn't rape them, but that the other guy did.

Then they put both of the girls into a squad car, and they all drove to the dude's apartment. When he opened his door, both girls were standing there and immediately identified him as the guy raped them and the apartment as the place where it happened. The authorities said OK and started to leave. Bill asked, "Aren't you going to arrest the son of a bitch?" The prosecutor replied, "No, not until we get everything straightened out." Paul told them that they had to cut me loose immediately, but I still had to go before a judge before I was released.

Fake Phil, the rapist, was in the courtroom when I walked in. I know the cops and the prosecutor didn't haul his ass in there, so it had to be Bill and Paul who got him there. When the facts were presented to the judge, he banged his gavel and I was released. You should have seen the look on the prosecutor's face. He was pissed. When the prosecutor turned and walked past fake Phil, who looked so scared you almost felt sorry for him (almost), he asked the prosecutor, "Are you going to arrest me?" The prosecutor said, "Nah, we don't want you; we wanted him." What an asshole!

I finally met Bill for the first time after I was released. We were both pissed that the real rapist was never arrested and that the authorities didn't really care about those girls. So we paid that asshole a visit. I wanted him to be really clear on two things. He was never, ever to use my name again, and he was never to rape another girl. If I found out that he did either, he would live to regret it . . . but just barely.

Bill has joked over the years that working on my defense was darn near a full-time job.

Shortly after the whole mess with the rape charge, I went to lunch with Paul. We met at his office and took his new Cadillac to the restaurant. During the ride, Paul kept asking me how I liked all the details of his car. "How do you like the color? What do you think of the radio? Do you like the seats? Is the ride good?" After I answered yes about six times, I finally said, "Paul, it's a great car; I like it." Paul laughed and said, "That's good because you paid for it."

I rented a house in Redwood Estates for a while, and I had a party one night with a few other Jokers and my karate instructor, Bob Babich. It was really late, and there were only about five or six of us left, but everybody was really drunk. I had a .41 magnum and decided to pull it out and shoot a picture of the Zig-Zag man off the wall. So I threw off a couple of rounds, and this must have unnerved Bob Babich because a couple of minutes later he got up and

graciously excused himself and hightailed it out of there. The party (meaning the drinking) went on until we all passed out. The next morning I woke up to knocking at the door. When I answered it, there was a young girl standing there. She had two black eyes and was holding a bullet in her hand. She stepped in and threw the spent bullet on the kitchen table and said, "I know you guys party hard, but you got to cool it." I picked up the bullet and gave it back to her and told her, "You better keep this as a good luck charm." Without a word, she took it and left.

My place was on a hillside and hers was below it. Apparently when I fired off those two rounds, one of them went into her attic, rattled around in there, and then went down into her bedroom and landed right between her sleeping eyes. I never heard from her or saw her again. Of course, after our first meeting, I couldn't blame her for not wanting to get acquainted.

From the time that I started driving I started getting in trouble and I just kept getting in trouble. Finally my license got taken away for good. Once my friend Walt loaned me his license for the night. We looked similar and he didn't have any warrants, so I thought it was a good deal until a traffic cop stopped me for speeding. When he ran the license, he arrested me. It turned out that there was a guy in Daly City who had exactly the same name as Walt, only he had a bunch of warrants. When I got to booking in San Jose, I had a serious problem.

Walt in the foreground and Snoopy Doug.

The cop who came in to do the fingerprinting and pat down knew me. "Hey Phil, you ready?" Oh hell yes (I was acting like John Q. Citizen, arms up, legs apart. See how cooperative I am for the pat down? Here's my right hand; you can take my prints now).

The cop filling out the paperwork so that I could pay all the fines for asshole Walt from Daly City was about ten feet away and said, "Walt, you got the money for these fines?" Damn straight (John Q. again; I can't wait to give it to you; it's burning a hole in my pocket).

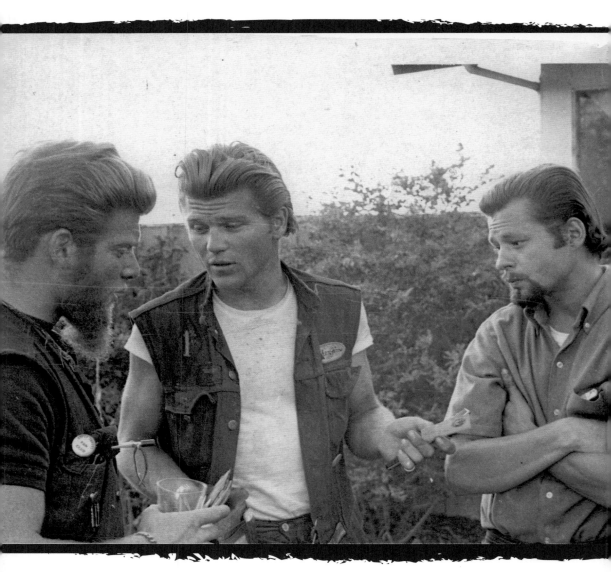

Larry, Jimmy, and Dave.

I was moving from cop to cop trying to keep them from talking to each other and trying to get things wrapped up fast. I needed to get out of there before one of them heard the other call me by the wrong name. That one was a little bit touchy.

It wasn't until I got out of prison, almost eighteen years later, that I could drive legally.

At one of the concerts at San Jose State College, we were raising funds by charging money for giving rides to people. They were short rides, basically just a big circle. My friend Dave decided that he wanted to contribute to the cause. He hopped on the back of my bike but I started off too quick, he fell off the bike, and his leg got caught up in it. Back in those days my personality was such that I just had to drag him around a little bit. I thought it was hilarious. Dave, not so much, but he wasn't hurt and got over it quickly.

I had a second incident where I dragged someone in Los Banos. There was a raised sidewalk in front of the bar we were at and the bar had swinging doors, like in the old west. I met this guy from Mexico who was a professional bullfighter. He wanted a ride on the bike and I said, "Hang on. I'll bring one on in." I rode my bike up over the sidewalk, through the open doors, and spun a doughnut on the dance floor. The bullfighter got on the back and I took off fast. I thought I was really going to impress this guy. Unfortunately, one of the guys who was supposed to be holding the doors open panicked and he let go. The damn door hit my hand, the bike did a wheelstand, the bullfighter fell partially off, and I dragged him out those doors, over the sidewalk and into the street. The guy wasn't mad, but I don't think he was the same for a few days. I doubt I contributed much to international relations.

The Red Barn was a bar on South Monterey Road. It was a big joint with a long, long bar. About twenty of us pulled in there one Friday night. The place was loaded, wall-to-wall people. When we walked in, right off the bat a bouncer came up to me and said he didn't want us in there. He had some backup from other bouncers and patrons. I could see that this was going develop into something pretty nasty. This bouncer was really big, about 235 pounds, so I figured I needed to get the first shot in. I palmed him under his nose. The shock from it took him right off his feet, and he landed on a table, out cold. Then the fight broke out in earnest. All hell broke loose. Everybody in the joint was fighting, and shit was flying everywhere. I even saw one of the barstools fly the length of that bar, from one end to the other.

Then the bouncer came to, and he woke up really pissed and swinging hard. He was looking for any Gypsy Joker he could find. The fight moved into the parking lot, and when it had slowed down, my guys started firing up their bikes to go. Just as we all started to pull out, that bouncer came out with a barstool in his hand and swung it hard, hitting Apache square in the chest. Apache flew backwards off his bike, and the bike kept going without him. We all stopped, and a couple of guys took care of the bouncer while Apache got his shit together. I'll bet that bouncer didn't wake up so quickly the second time around. It would have been better if he had just served us a drink.

THE FALL OF THE SAN JOSE GYPSY JOKERS

I WAS GOING INTO the Three Star Bar one night when one of my guys came and told me that he and a couple of the other guys had seen a Hells Angel walking down the street alone, so they grabbed him. We decided that we might be able to get some information from him that we could use to our benefit in the war, so we held him in a house for three days and just talked to him. We never beat him up or anything, just asked him questions. We figured that maybe he'd been out of state or something because he seemed so clueless, like he really didn't know much about the war that was going on. We cut Gino loose on the third day and sent him on home. To this day, I don't know if Gino was really that clueless or if he was just a good actor. Either way, we got nothing.

Bones using his dog Athena as a pillow.

I met Gino again ten or twelve years later when I was visiting my old friend Bones in Hawaii. It turned out that Gino was a friend of Bones and a good guy.

Speaking of Bones, he and I loved to ride the hell out of the streets of San Francisco, and I did it on a rigid.

We would go down a steep hill so fast that hitting the cross street would cause us to get airborne (up to thirty or forty feet) for the start of the next downhill run. We thought this was a blast and did it all the time when we were there. Once when we were doing this, a cop was pulling out of an alley when Bones and I sailed right over the hood of his car. I looked down and saw his neck craned so that he could look up at us through his windshield. He didn't even bother to take chase. I really did like doing that kind of shit.

I had another interesting ride there, when I was racing one of the Frisco members. We crested a hill and I thought there would be another one. I looked over at my friend and he was slowing down; I figured he was quitting. Well, there was another hill all right, except the road didn't go up; it went down, a long ways down. That was the longest jump I ever took, and I had a girl on the back of the bike. Her ass came so high off the bike that it was up at my shoulders. She had a death grip on my collar; it was the only thing that connected her to that motorcycle. We landed hard and the bike skipped left and right, and that old gal stayed on. It was a good thing that it was a long road; a short one and we would have been dead for sure. Luck was on our side that time; we decided not to go again.

Mount Hamilton was another ride we all liked a lot. We'd go about two thirds of the way up and spend the night. We went up there at least twice a month. The road going up there tested your riding skills; it's treacherous, just sheer cliffs. The speed limit is like fifteen miles per hour, and they mean it. We'd go up there and camp (no tents), build a fire, guys would shoot off their guns, and we'd drink. We always went after the bars closed, but nobody ever got hurt. The area where we stayed is all fenced off now. They did that to keep us from going back there. It worked.

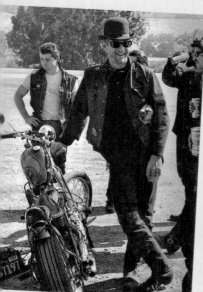
Buzz was always dapper, even without the derby.

Money was a rare commodity for all of us in those days, and we didn't take anyone backing out on a debt lightly. Buzz was owed some money, and the dude had been putting off paying him for way too long; it was time to collect. This dude was known as something of a bad ass, and also known to carry, so Gypsy Jack and I went along with Buzz as backup.

We headed over to the dude's house only to find that he was throwing a party. When we went in, the party wasn't in full swing yet, and the guy wasn't even there. One of the guests told us he was out getting something (ice or booze or drugs, who knew) and that he was expected soon. Buzz was pissed because he figured it was his money paying for the party. We decided to wait, and so we rounded everyone up and herded them into an empty bedroom (it was about twelve-by-twelve feet). As more people showed up, Buzz opened the door and let them in, and I escorted them to the bedroom.

Gypsy Jack was responsible for keeping an eye on the partygoers in the bedroom, so he decided if he had to babysit, he was going to have some fun. He was in there with his thumbs stuck in the front of his belt, and he was pacing around the room with his chest all puffed out. He looked like a rooster strutting around the hen house. He had a great old time putting on the performance of a lifetime. At least the partygoers were getting some entertainment. We could hear Jack's instructions in the

Classic Gypsy Jack Nye.

other room. Shit, it sounded like something from a Jimmy Cagney movie: " Nobody fucking moves, see? Everybody does what they're told and nobody gets hurt, see? Anybody who doesn't listen to me, well, you . . . do . . . not want to make that mistake!" It went on and on like that. Honest to God, I don't know how he did it without laughing because Buzz and I thought it was the funniest damn thing we ever heard.

Finally the little asshole that owed Buzz the money decided to show up to his own party (about damn time). When he walked in the door, we grabbed him. He had a sawed off double-barrel shotgun in his coat. After Buzz and I had relieved him of his weapon, Buzz got his money. Then we told everybody they could come out, it was party time, but not for us. We left.

The going rate for a babysitter in those days was about one dollar an hour, but that night Gypsy Jack was priceless.

During the war with the Hells Angels, we were going down to Monterey and stopped at a bar on Highway 1. We pulled up to a bar, parked our bikes, and went inside. There was pool table just inside the door, on the right. The first thing we saw was a lone Oakland Hells Angel playing pool.

There was a lull in the war at that time, but some of the guys were still pretty hot under the collar and wanted to go over and beat him up. I had heard that Boomer was a pretty good guy, and I didn't think it was the right thing to do. I took the small group of instigators aside and told them to leave him alone. They listened to me. I knew I needed to keep an eye on things, so even though I wasn't much of a pool player, I went over and shot a game with Boomer. He won and left. I found out just how right I was about Boomer after I became a Hells Angel and got to know him.

BELOW LEFT: I redesigned the San Jose patch, making the wording larger.

BELOW: We made our mark (San Jose Moose did, actually) in Porterville.

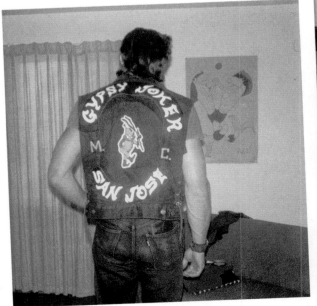

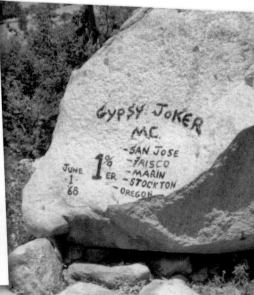

We went on a Hells Angel run during a lull in the war too. The run was at Bass Lake, and a few of our charters decided to go. I have no idea why we thought this would be a good idea; maybe it was Theo being classy again. When San Jose got there, we went down to the campsite, parked our bikes, and stayed one full day and through the night.

There were a few sporadic fights while we were there, but nothing serious. I guess it didn't look too welcoming though because one of the Gypsy Joker charters pulled up to run site, looked around, and took off. They never even got off their bikes.

The Hells Angels had a cute little trick they liked to pull on other club members. They would hand you a beer and ask, "Do you want a hit?" You can probably guess what came next. When it happened to me, I managed to come out of it not looking like a fool. As I was taking a swig, I saw what was coming. When the guy hit me in the stomach, he asked, "How do you like it?" I just kept drinking his beer, and then I said to him, "It's OK, but it's a little light." He had two guys with him so it could have gotten ugly, but he took it in stride and just walked away.

One thing you didn't do in those days was sleep by the campfire at a run. If you slept there, you were setting yourself up for trouble. If you had to sleep, you found a secluded spot, far away from the campfire to do it. I guess one of our guys was tired and cold, so he set up his sleeping bag right by the campfire, crawled in, and went to sleep. Big mistake. Some of the Angels zipped him up like a cocoon, kicked him around, and threw him in the lake. Nobody really felt sorry for him. In those days, it was just plain dumb to try to stay warm.

Massive tension broke out between the Hells Angels and the Gypsy Jokers. The San Jose Gypsy Jokers was a powerful club, but we didn't have a lot of really strong fighters. There were only a handful of us that could fight to the bitter end. Most of the other guys were willing; it was more of a lack of training that kept them back. We did have a couple that always seemed to scoot out if they saw real trouble coming. It seemed like the same group of us were always the ones left standing and fighting the Hells Angels. Finally during a confrontation in a San Francisco gas station, Andy Holley told Theo that they (the Hells Angels) were tired of fighting the same bunch of guys and they wanted to fight

Jim Blackmore,
a.k.a. San Jose Moose.

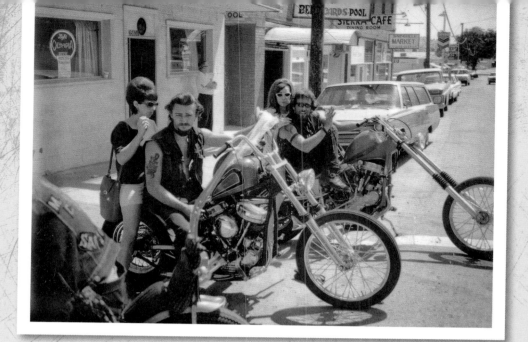

Jack and I made a trip into Springville to hit the bar.

the whole club. Andy basically said that the club wasn't strong enough and why didn't we just get out. I think hearing that from Andy was the beginning of the end for the San Jose Gypsy Jokers.

On Memorial Day in 1968, we headed out on a run to Porterville, California, and I have to say that town did not like us. There were a lot of us on this run, close to one hundred, because a local club from Porterville, the Madcaps, joined us there. Well, the local police along with some highway patrol came and "escorted" us to the Kern County line. Kern County didn't want us staying in the area either, so the officials had the exits blocked in order to keep us on the highway and out of the area. After about the third blocked exit, I thought, screw it, took the exit, and rode right on through. We found a place to camp for the night and lit our campfire. Maybe one of the reasons the locals were so pissed at us is that we were using their fence posts for our fire.

The cops woke us up the next morning, and they were rather rude about it. Jim Blackmore, a.k.a. San Jose Moose, said that he woke up to a cop kicking him and saying, "You are in Kern County now son, but not for long."

There was suspicion that some bikers had raped a couple of local girls. The only name the cops had was Moose. When the cops came around asking questions, one of our member's girlfriends told the cop, "We don't know nothing about nobody named Moose." Then she turned and looked at Moose and said, "Right, Moose?" She was a sweet girl, but not exactly part of the brain trust. Moose was immediately taken in for questioning, but he was released when the girls told the cops they were there willingly and that Moose wasn't one of the dudes they'd had sex with; he'd only given them a ride on his bike. It was rumored that the girl Moose gave the ride to was the daughter of the captain of the highway patrol.

We got yet another "escort" back to Tulare County and then onto the Fresno County line. Crap, all that escorting added a lot of extra miles and time; it was exhausting.

The biggest trouble I got into on that run was when I got home. I was giving a ride home to a girl for some reason; I don't remember why. She probably got left behind. There was a lot of TV news coverage of us riding home, and I was predominately featured in it because I was leading the pack. My girlfriend back home saw the news, and the girl on the back of my bike, and man was she pissed. I think it was after that we instituted the rule that if you bring someone up, you take them home.

There was always time for beer.

Even though our biggest problems were with the Hells Angels, that didn't mean there weren't other clubs that we had to deal with. Black Bill was president of another smaller motorcycle club called the Unforgiven Ones. His club was causing all kinds of trouble for us, and we were always fighting its members. It got pretty ugly.

Finally I thought enough was enough, and I decided to pay Black Bill a visit. Gypsy Jack and I drove to his house late one night and went into his bedroom. Bill was asleep in bed with his wife right next to him. I shook Bill and he woke up, looking at me and my gun and Jack and his gun. I explained to Bill that the shit had to stop, or else. Jack and I left as quietly as we had come in, and Bill's wife never woke up.

Black Bill didn't take my advice, though, and we had a huge fight on a one-way street in downtown San Jose. The good part about that was that it stopped traffic cold. The cops couldn't get us, and when it was over, we had a straight shot out of town. It was after that fight, and the bad mouthing we got in the press, that we folded the Unforgiven Ones. Black Bill went on to become a Daly City Hells Angel; in fact, he was one of the six members who came to San Jose to start the charter.

The girl I was seeing around this time rode her own Harley, a K model. She came to see me one day and she was really upset. Her bike had been stolen. I put out some feelers to see if I could find out what asshole did it. It turned out that the asshole was my good friend Dirty Doug.

Snoopy Doug riding his bike in the campground parking lot.

When I asked Doug if he had heard anything about it, he said, "Yeah, I know about that bike." Then he told me that he'd seen the bike on the street and grabbed it so that he could have a little fun. He took it up into the hills to ride the hell out of it in the dirt. He had someone follow him up in a car because he didn't plan on bringing it back. Not only didn't he bring it back, he ran it off a cliff. That bike ended up about 150 feet down the cliff and it looked like it wasn't coming back up.

I told a friend who worked for a tow company about it and he said that we could bring it up. We went up there and he lowered me down the cliff on the hook of the towline. I tied the bike to the hook and used the towline to climb back up. After I was up top, he brought the bike up.

The front end was torn up and the tank had a bunch of dents, but overall it was in better shape than I thought it would be. I had to pay to get the bike fixed. Thanks, buddy!

At this time, Jim Blackmore's uncle was chief of the San Jose Police. Jim took me to meet his uncle, and his uncle arranged for us to have a liaison for the club on the force. His name was Stuefloten. Any time we were going to have a party, run, or something that was going to impact traffic or the community in some way, I would meet with Stuefloten and iron out the details. It was actually a pretty good working relationship.

There was a period of time when our charter had a lot of bad luck with fire. It seemed like everywhere we went we left a trail of flames behind us.

LEFT: Dirty Doug getting a rare bath. He took off his boots once, and the bottom of his sock stayed in it.

I've always been good at catching a few Zs wherever I can.

There was one time we stopped at this bar on our way to Eureka. It was really rural. I don't even know how we found it in the first place. It had a real steep curving driveway leading down to it. The bar had a big fireplace and a long bar. We stayed there, drinking and throwing wood on the fire for about three hours. Our fire was really impressive with roaring flames. Unfortunately, I guess we threw too much wood on that fire because those impressive flames crawled right up the wall of the bar. It was time to go.

My bike had a suicide clutch with an open primary. When I got to the top of the drive, I stopped and looked back at the scene below. The bar was fully ablaze by then, and the owner was in a rage. I wanted to make sure my guys got out and that the bar owner wasn't shooting at them or something. I was still looking down below when I reached back to shift and accidently stuck my fingers in the spinning clutches. I lost my fingertips that night. Damn that hurt. I guess it was a fitting end to that escapade.

Our next fire was while we were in Soquel partying with another club, the Monterey Losers. This place we were at was pretty much a rundown chicken ranch located on the corner of 41st Avenue and Soquel Drive. Eventually, things went south. I don't remember what happened, but the partying stopped and the fighting started. By the time we left, the place was on fire.

As we were pulling out, we could hear all kinds of sirens, so everyone scattered. Most guys headed for the highway, but I knew the road through the hills and took off that way. I was really drunk on tequila and didn't want to risk taking Highway 17 back to San Jose. Dave Lanham and Dietz were right behind me because they knew the road too. Dave and Dietz had both dropped acid that night, and Dave told me later that the whole ride home he never could

Me and Apache talking politics.

see the road. He said, "I was just riding through a sea of paisley and following Drunk Phil, and all I could see was the Joker patch in front of me. If you had gone off a cliff, I would have followed you right over, and Dietz would have followed right after me. We would have been stacked three high at the bottom." I thought the ride was fine.

Just before we left that night, Dirty Doug ran up to a wall that had a zebra skin on it and pulled it down to save it. He had that thing for years. The thought crossed my mind that maybe he created a diversion by setting fire to the place just so that he could grab it. It turned out, though, that another Joker, Walt "the Whale," was a suspected firebug. It did explain all that trouble we had been having.

I doubt that any of us will forget the night we went to Santa Clara to see Jim Blackmore. He invited our charter over to show us the new clubhouse of the Santa Clara Gypsy Jokers. It was just our two charters hanging out that night; no one else was there. We never really knew how it happened, but a fire broke out, and the cops showed up before the fire department.

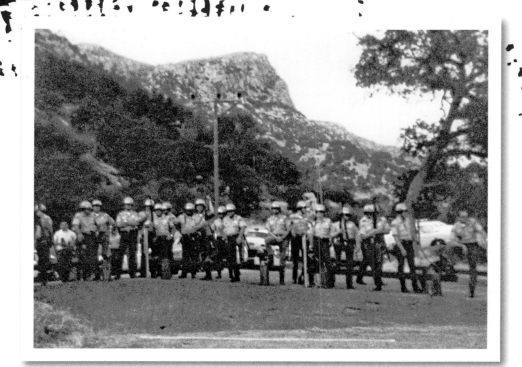

This is about half of the cops they sent to deal with us.

Well, nobody wants to stick around when they hear sirens, and we all headed for our bikes to split. When I got outside, Dago's dog, this nasty ass German shepherd, was tied to my bike. This asshole dog had already bit me once, just above the groin, so I was pissed that someone thought it was funny to do that. I tried to buy the dog from Dago once, just so I could have the pleasure of shooting the son of a bitch, but Dago wouldn't go for it. Anyway, it took both Buzz and I to get the dog loose (Buzz almost got bit that time), and it cost us precious time. By the time I got on my bike, the street was crawling with cops, so I decided to try to get away through a big field next door to the clubhouse. A cop saw me and drove in after me, but got stuck. Two other cars came in with him and spread out. The cop who got his car stuck got pissed off. He got out and leaned on the hood of his car to steady his gun and drew down on me. He kept tracking me with the gun, and I kept riding in circles (and going really fast) and moving between the other two cop cars to avoid getting shot. Eventually, I shot straight across the road, parked my bike with the other bikes, and went to mingle with the other guys. It didn't work. The cops picked me out of the group anyway.

That was the night that Big John was shot and killed by a cop named Hogate. I saw it all because I was handcuffed in a cop car across the street. The cops had the whole thing pretty well in control, but there were a few guys left who hadn't been wrapped up yet. Hogate was arresting someone and John came up behind him. It looked like he planned to throw his jacket over Hogate's head so that the guy could get away. Hogate had a dog with him and I guess John could see that his plan wasn't going to work, so he turned and took off. But the dog got him and he went down. Hogate ran over to Big John and stretched out over the dog and shot John in the side just above his belt. The coroner's report said the bullet hit his pelvic bone and ricocheted up, killing

him. Hogate got away with it. John was down, with his hands up protecting his head from a dog that was attacking him; there was no need for Hogate to use his gun at all. You would think that this story would end here, but it didn't—at least not for me.

I had a very interesting ride to the police station that night. I was in a car with only one cop, and on the way to the station he radioed in. Dispatch asked him if he knew whether or not Phil Cross had been picked up. He said that he didn't know. After about a minute, he looked in the rearview mirror and said, "Say, what's your name?" I told him the truth: "Phil Cross." He didn't say another word; he just radioed back in and told dispatch that he had me. They said some other stuff to him, but I had stopped listening at that point. We drove for about ten minutes, and then he pulled over, parked, and got out

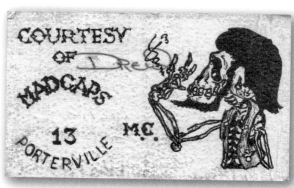

I'm contemplating something, either my next move or my next beer.

of the car, leaving his door open. When I looked out my window, all I could see were cop cars and cops. There must have been ten cars and at least fifteen cops. One of them walked over to my window and said, "Well lookie who we have here." It was starting to look pretty mean out there. Just as it dawned on me that at the very least I was going to be a punching bag for those bozos, a full sergeant walked up and said two words that put an end to the whole situation: "So what?" I have no idea who he was, but I have never forgotten him. Every couple of years, I think about that day and I mentally thank him. He may even have saved my life.

On our last annual rain run in 1969, we went to the Pittsburg Caves. A valve spring broke on Greasy George's bike while we were there. Going to a bike shop for repairs was out of the question. We were all too broke in those days, but what we lacked in money, we made up for in ingenuity. Greasy went to a wrecking yard and found the closest match (off of an old Ford motor) and adapted it to fit. It worked like a charm; in fact, I don't think he ever took that valve spring out of his bike. I had a little bike trouble on that trip too. There was a little restaurant up there with a concrete sidewalk out front and two big plate glass windows. The windows had a four-by-four post between them. I was riding up to the restaurant in the pouring rain, and the hat I had on slipped over my eyes and then my foot slipped off the brake. When I got my hat pulled back, what I saw was a terrified waitress holding a

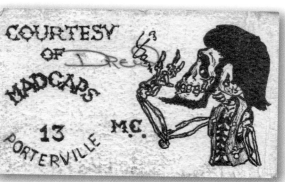

Madcaps, Porterville courtesy card.

big tray way up high in one hand. Her eyes got real big, and she screamed, dropped the tray, and ran. I hit that center post so hard that it bowed both of the windows back about four inches. It bent my forks backwards too, but I rode that bike home. The ride home sucked, but it wasn't just the bent forks: it was the rain!

4 Hurt In Gang Clash

Big Downtown San Jose Fight

Several youths were hurt as a brief but wild clash broke out when a group of motorcyclists were attacked by members of a motorcycle club late last night.

One motorcycle reportedly took a pair of bullets in the gas tank and exploded in a ball of flame at Second and San Antonio streets, where the violence occurred.

One youth, his hair matted with blood, said he was sitting on his "bike" when he was jumped by members of the Gypsy Jokers, a local motorcycle club.

"They used their feet, iron bars and I don't know what all," said the youth.

"They really worked me over with their feet too, then I heard some guy shout, 'let's go!' If they hadn't let up I'd be all washed up."

The fight took place in front of the YWCA, and a woman inside told of hearing wild screams and shouts punctuated by a series of gunshots.

Four youths were taken to San Jose hospital, where a nurse said the condition of the victims "does not appear to be too serious."

No one could immediately explain why the fight suddenly flared.

One boy shook his head and looked bewildered. "We were driving around on our bikes looking for a place to park. We stopped at the red light and two carloads of Gypsy Jokers roared up and stopped in the middle of the street.

"Then they came pouring out at us."

In the confusion, just after the battle, no one could give an estimate of how many persons were involved.

When a dozen police arrived moments later, most of the action was over. One victim was reportedly smashed over the head repeatedly with a heavy

(Concluded on Page 2, Col. 1)

The article says that the "victims" weren't members of a club, but it was the Unforgiven Ones.

Gang Fight; 4 Injured

(Continued from Page 1)

club by his assailant.

"I guess they must have been wired up on something," said one dazed youth. "I never saw them before but they were Gypsy Jokers — they were wearing their colors."

The motorcycle club wears distinctive jackets with "Gypsy Jokers" emblazoned on the back.

Witnesses said the attackers swung tire irons and chains and worked over the youths on the motorcycles and then smashed their cycles.

Identities of the injured were not immediately available.

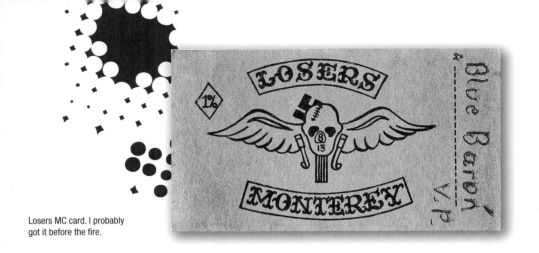

Losers MC card. I probably got it before the fire.

Now I know this was the rain run, but on the way home we hit the most severe rainstorm I have ever seen. There were about twenty of us in the pack, and you could barely see the bike right in front of you. Deluge isn't a strong enough word for this storm. We were on the other side of the bay, but we didn't pull over, we didn't stop, we just kept going. When we exited the highway, the water in the street was so deep that it went halfway up my front tire. I don't know whose idea those fucking rain runs were, but I'm glad I don't have to do them anymore.

La Grange, April 1969, was a run that ended up being just plain bad luck for us. It started off the first night with Mark hitting a barbed-wire fence around a cow pasture. When I pulled up, he and his bike were all wrapped up in the wire. We cut him loose, and both he and the bike were OK. Gypsy Jack and Dirty Doug both got into accidents on the way home. Doug's bike hadn't been running, and even though he didn't have much money, he'd been working on it himself to get it ready for the run. He was going to be suspended if he didn't get it going for that one. He did, but his brakes were practically nonexistent. Well, he hit this old couple on a one-lane road headfirst. He went up over the handlebars, and his head hit their windshield. Doug went to the hospital with serious facial injuries, but after he was all put back together, he looked exactly the same. We went to a bar to wait on word about Doug, and after making sure he was going to be OK, a couple guys stayed behind and the rest of us headed home.

We had just hit Manteca when Gypsy Jack had his accident. We were on the highway just outside of town and going sixty-five or seventy miles per hour when Jack decided to drop back. We had this rule that if a guy really wanted to get it on, he had to drop back about a half-mile and then hit it. He had to be well away from the pack. Gypsy Jack was doing just that as we hit the edge of town. Everybody in the pack braked because of traffic, and Jack didn't realize where we were and just tore right on through. A car pulled out in front of him, and Jack went over the handlebars and hit his face hard. The accident really messed his face up, and even though the surgeons did a great job putting him back together, Jack never felt that he looked right again. Anyway, after the ambulance took Jack to the hospital, all hell broke loose.

A few of the Jokers had grabbed the guy driving the car, so the cops came out. There were about ten of them and forty of us. The cops decided to arrest Wino Joe (I can't remember what for). The cops had him handcuffed, and

OPPOSITE: Big John. The nickname says it all.

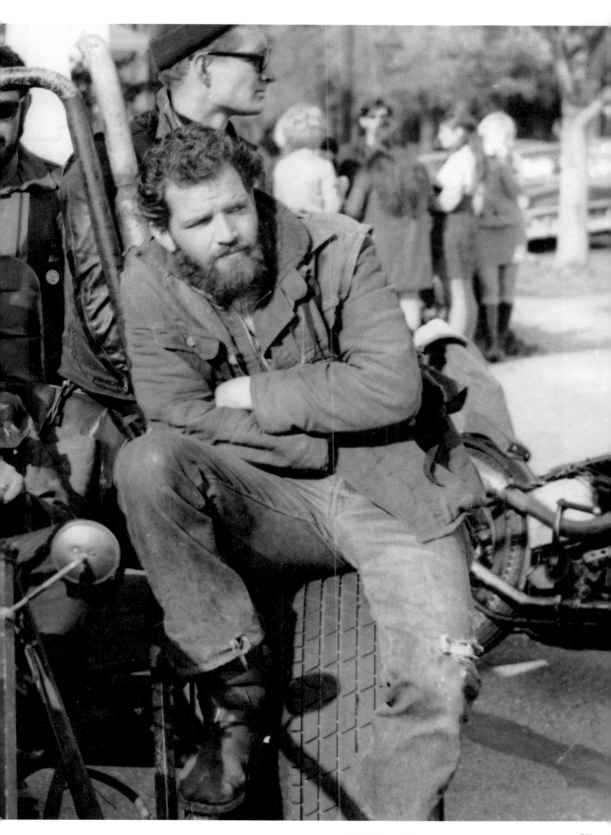

Joker Shot By Police After Fire

A member of the Gypsy Jokers motorcycle club was shot and killed by a San Jose police officer when the man allegedly attempted to attack the policeman from behind after an arson fire in a club hangout early Sunday.

John William Van Huyster, 30, a San Rafael truck driver, was dead on arrival at Valley Medical Center. The revolver slug entered his body on the left side a b o v e the belt, veered upward and lodged in the left shoulder, severing the aorta.

Officer Charles Hogate said he was holding two other motorcyclists at bay with his drawn revolver, his police dog beside him, when Van Huyster sneaked up from the rear.

Hogate said he did not fire intentionally, but believed he triggered the gun in reflex action when he felt someone lunge at him.

He had just stepped aside to look behind him when he noticed the victim rush by, inches away. The dog, "Double," attacked the fallen Van Huyster but was immediately called off.

The patrolman and his dog were keeping two other suspects, Michael Chalres Kielman and his unidentified companion, at bay when Huyster came upon them. Hogate had stopped the pair on Highway 85 near the burning house.

Two of the club members had been evicted by owner George Caffini for failure to pay the rent on the 1107 S. Highway 85 structure. It was gutted in the blaze.

Mike Devitt, fire prevention bureau inspector, said mattresses had been thrown on a fireplace and what appeared to

(Back Page of Section, Col. 8)

page 20

they were knocking him around. When we saw that, we all jumped in and started beating up the cops. We beat the shit out of them. I swear to God, I even heard one of them calling for his mother! During the fight I took enough time out to put Wino Joe, who was cuffed; his bike; and all the women into a van to get them all out of there. The fight was finally broken up when the highway patrol showed up in force to help the cops. Now our numbers were even. Incredibly, no one was arrested, other than the attempted arrest of Wino Joe. Maybe it was just that there were so many of us that they didn't want to deal with the paperwork, or maybe they just wanted us gone. The cops were really upset about those missing handcuffs, and Joe had to wear them all the way home.

There was an eerie thing about that accident of Jack's. The one that killed him a few years later was almost identical, kind of like fate was mad at being cheated, so it arranged for a repeat performance.

The rain run may have been our wettest, but a run to Eureka was by far our dirtiest. We were traveling on Highway 101, and at about nine o'clock at night we hit the town of Garberville. The city fathers evidently decided that the road needed drastic repair, but they neglected to post any signs to let motorists know that they had completely ripped the road out. There was nothing but dirt; technically, since it had rained, it was nothing but mud. There were about forty of us in the pack, and we were going about sixty miles per hour.

I was leading the pack and I had a lot of experience in dirt riding, so I knew not to break. I geared down and rode right on through that sloppy mess of a street. A few others made it through as well. Many of the others weren't so lucky. When I stopped the bike and looked behind me, it was total chaos; the scene looked like motorcycle mud wrestling. Although there were a lot of bikes that needed repair, no one was hurt. Every single one of us was filthy; even the riders who didn't go down got hit from mud slinging off the rear tires.

We used the down time for repairs to visit the local bar. I suppose the girls tried to clean up; we just drank.

I got in three fights on that run. The first one was right there in that bar in Garberville. A local guy started mouthing off and I wasn't in the mood, so I told him to shut the fuck up. He just wouldn't listen. What we had there was a failure to communicate, so I hit him. This good old boy was more than happy to fight, but nothing much happened because just as it was getting good, a cop came in, broke it up, and told us it was time to leave.

A *San Jose Mercury News* article about Big John's death.

The Gypsy Jokers say farewell to a brother

Cyclists ride in a strange funeral procession to Oak Hill Cemetery.

Big John's funeral procession.

My second fight on that trip was in a bar in Eureka. We were standing at the bar having a drink when a couple of guys showed up. They looked like lumberjacks, big lumberjacks. One guy in particular was about six-foot, four inches tall and stocky. He came up next to me and asked if I had a quarter for the jukebox. I thought it was odd but said sure and slid a quarter down to him. When it got to him, he took his finger and flicked it off the bar. I knew what this guy was looking for, so I hit him first. The fight went on for a little while with nobody gaining the upper hand, so it just sort of ended. After we were done, he said to me, "I just wanted to see if you'd fight," and he left.

Later on that night at the campsite, someone came up to me and said that there were a couple of guys in a pickup wanting to talk to me. I thought this might mean trouble, maybe somebody coming to complain about noise or some shit like that. But when I walked over to the truck, sitting in the driver's seat was the guy I fought at the bar. My first thought was, "Here we go again." I really didn't want to fight this dude again. I have always disagreed with the premise of the bigger they are, the harder they fall. I have found it to be more true that the bigger they are, the harder they hit. Well, he got out of the truck, reached into the bed, pulled out a case of beer, and said, "Let's party." He and his buddy hung out with us drinking beer most of the night.

My third fight was the one that landed me—and everyone else—in jail, but not for very long. We had pulled off for gas in Ukiah, and one of the guys needed some repairs on his bike. Guess where we waited? The bar had a couple of pool tables. One was empty, so we started playing. The next table had a couple of locals playing on it. One of the guys was a pretty good-sized dude, about

Getting ready to head out to La Grange.

Away from the shop, you have to be creative when working on a transmission.

six-foot-one, 220 pounds, and he looked like trouble. I told one of our members, "You watch. Billy Bob over there is going to come over and give me shit." Sure enough, he did. I don't remember if I accommodated Billy Bob by hitting him first or if he got the first shot in. Either way, a pretty good fight broke out, with ten or twelve people fighting, pool cues breaking over heads, and shit flying everywhere. The first cop through the door tried to break Billy Bob and me apart and got a broken arm for his effort. I want to make it perfectly clear here that this was one time I did not assault the officer; he was just in the wrong place at the wrong time.

When more cops came in, the fight ended and we all went to jail, including a guy named Little Mike, who was a guest of the club. Mike wasn't even in the fight; he only weighed in at about 140 pounds. Billy Bob, who was not at all happy, was in the cell across from me. His cellmate was a very cautions, very nervous Little Mike. What the hell were those cops thinking? It was like putting the rabbit in with the pit bull. Luckily, the rabbit got sprung before the pit bull got to him.

The cops cut us loose with no court and no charges (although they weren't happy about the cop's broken arm). We made it the rest of the way home with no incidents. It was just an average run for those days.

The Daly City Hells Angels had decided they wanted to open a chapter in San Jose. They started coming down to San Jose a lot. We bounced back and forth for about five months, not getting along, and then things

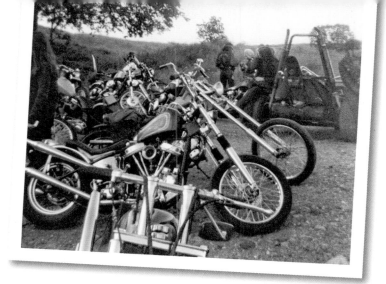

At the run site in La Grange, California.

would be OK, and then not getting along again. On one of the not-OK times, the Jokers planned to make a united front against the Hells Angels. We were having a big meeting with two other charters to set it up. When we got to the site of the meeting, the only Jokers there were Theo, Mark, and me, and not another soul. Well, so much for unity. Andy Holley's words hit home.

At this point, the three of us started talking and came to the agreement that there had to be something better. The San Jose cops were against us, the press was against us, the Hells Angels were against us, and we knew that the Hells Angels were taking over that town.

La Grange at night. A classic shot of the bikes and the crew.

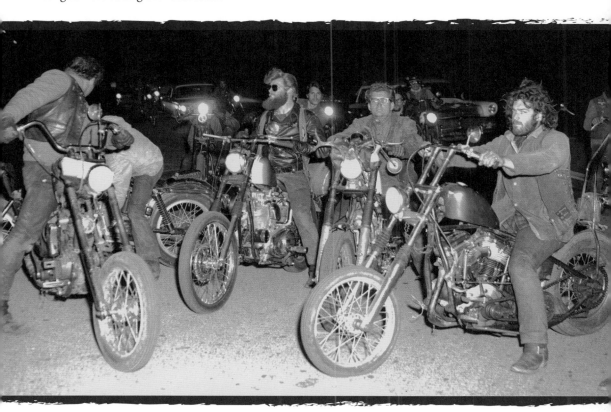

Mark (sitting against the old drum) doesn't look too happy. He was probably thinking about detuning his bike.

The Soul Brothers came on the La Grange run too.

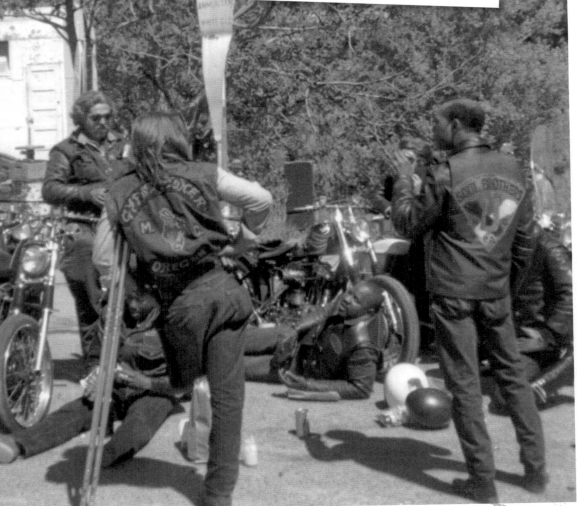

Mark and I met at Theo's house to talk about changing over to the Hells Angels. We knew the Gypsy Jokers weren't going to win a war with them. We knew a lot of people were going to get hurt or killed and most of them would be Gypsy Jokers, and we knew that we were going to be the main targets.

We didn't start the ball rolling until we talked to Nelson Ramos, president of Frisco. Frisco was the founding charter—or, as they liked to call it the mother charter of the Gypsy Jokers—and it was only right to discuss something that important with their president before acting. After we met and talked to Nelson, he reluctantly agreed that we should do it, so we went back to San Jose to tell everyone what was going on.

Hippie Tom (in the scarf) wasn't a member, but he rode with us a lot in those days. Check out that old gas pump.

Mark's bike after his rough
run in La Grange.

Stockton Record
DAILY EVENING

Stockton—California's Deepwater
Inland Seaport Since 1933

Central California's Outstanding
Newspaper Since 1895

Vol. 75, No. 6 KO STOCKTON, CALIFORNA — MONDAY, APRIL 14, 1969 36 Pages

Gypsy Joker, 2 Others Hurt in Manteca Collision, Fracas

MANTECA—A motorcycle-car smashup in downtown Manteca yesterday involving a member of the Gypsy Jokers motorcycle gang had these immediate results:

—The cyclist went to the hospital with critical injuries.

—His friends jumped the driver of the car.

An off-duty policeman suffered a broken nose when he tried to rescue the motorist.

—A total of 35 officers converged on the scene, some with

(See pictures on pages 8 and 9.)

shotguns. Manteca police were assisted by Escalon officers, sheriff's deputies and California highway patrolmen.

—A bystander who refused to obey a police order to move back was clubbed, subdued, arrested and hospitalized.

—The only Gypsy Joker arrested escaped, still in handcuffs.

Chain reaction of events began, officers said, when the motorcycle of Gypsy Joker Jack

Nyle swerved into the car of Robert Foulds, 116625 Highway 99, on Yosemite Avenue near Jessie Street.

Officers said Foulds turned the corner, stopped and was walking back to check on the 'cyclist when other Gypsy Jokers jumped him.

Foulds was not injured, but Police Sgt. Weston Robinson, who was off duty and not in uniform, suffered a broken nose, facial cuts and bruises when he attempted to help Foulds.

As the call for police, and

(Continued on Page 2, Col. 5)

The *Stockton Record* newspaper article about Gypsy Jack's accident (note that the article has Jack's last name wrong).

Gypsy Joker, 2 Others Hurt After Crash

(Continued From Page 1)

more police, was relayed, the crowd grew. One of the Jokers, who was arrested on a charge of disturbing the peace and handcuffed, escaped from a police car in the melee.

Lester Troy, 25, of 1207 E. Louise, one of the some 200 bystanders who materialized during the episode, refused to obey an officer who ordered him to

against a building and searched them before letting them leave town.

Ramos objected to the search:

"We didn't break the law. The cops had a job to do, though. But they didn't treat us like regular citizens. It's not legal to search someone unless he is arrested. A few sergeants cooperated, but the others . . ."

After the search the club went to San Joaquin General Hospital to await news of Nyle's condition.

Members received these orders from Ramos:

"We've got to do this sensible, man. No trouble. Get lined up and let's go like they (the officers) said. Let's do it right."

A near-incident at the hospital, stemming from one Joker's objection to a photographer taking pictures, was quickly stopped by Ramos.

Later, the Joker apologized and shook hands with the photographer.

Nyles has a broken jaw, broken bones inside his mouth, and "his face is pretty well beat up," a doctor said.

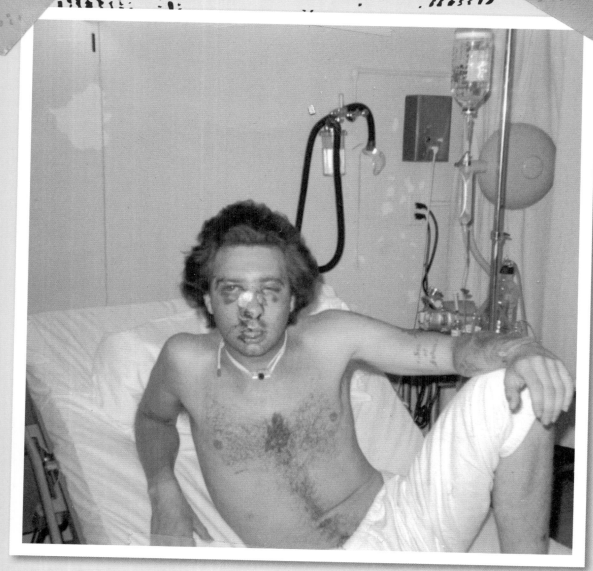

Jack sitting in his hospital
bed after his accident in
Manteca.

We held a meeting in a cellar to vote on the issue. Walt had warned Theo
that Three-Fingered Bob from San Francisco was pissed and that he was bring-
ing a gun to the meeting. Well, Bob brought out a knife, not a gun, and started
messing with it, twirling it around and shit. Theo saw the knife and recognized
the challenge, so he went and sat next to Bob and pulled out his own, bigger
knife. Theo started casually cleaning his nails, and after a while, Bob put his
knife away. Theo never said a word to him. We voted to fold the charter, and
the San Jose Gypsy Jokers decided to try to become the San Jose prospective
charter of the Hells Angels on June 11, 1969.

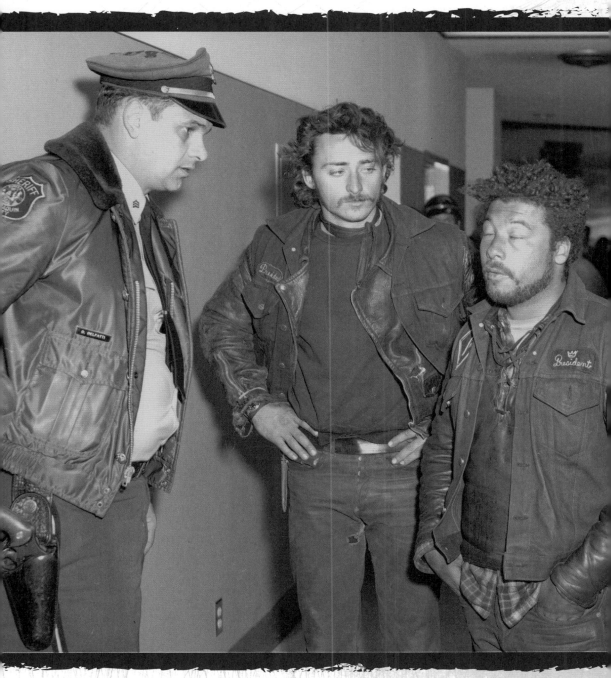

Nelson Ramos, president of the Frisco charter, and me at San Joaquin Hospital, talking to a San Joaquin County sheriff about Jack's accident.

CHAPTER 7

HELLS ANGELS

e transition from Gypsy Joker to Hells Angel was
sk. After all, we were at war.

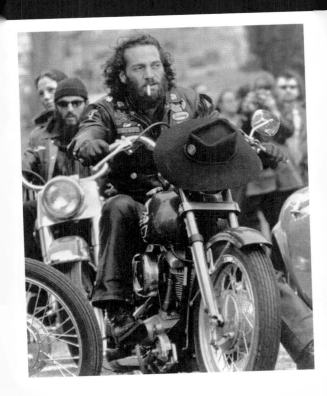

Dick Smith, San Jose charter member, at Bass Lake.

O ur first step in achieving this goal was to figure out who we should talk to about it. It was suggested to us by someone (I can't remember who) that if we tried to approach Sonny Barger, he would just kill us. So Theo said he thought Bob Roberts would be the best guy. Then just like the three wise men, we set off on our quest. But instead of gold, frankincense, and myrrh, we carried .45s. When we got to Bob's house, we decided to leave the guns in the car. We figured we'd be way out numbered and end up dead anyway if we were found with them, so why bother. It turned out to be a good decision because as soon as we got through the door, armed men started arriving to sit in on the discussion. I'm sure if we'd had those guns there would have been very little talking, just a whole lot of bleeding. The talk actually went pretty well, and a couple of weeks later we had another meeting with Sonny, to set up the details for starting the prospective charter. At that meeting I met some notorious characters. Sonny Barger, Big Al, Terry the Tramp, Johnny Angel, Cisco, Skip Workman, and Charlie McGoo were there. It was really amazing.

Sonny set it up so that half of our members would prospect for Frisco, the other half would prospect in San Jose under six members who would come down from Daly City. Those six members were Dick Smith, Black Bill, Nigger Rick, Dirty Ernie, Freddy Flores, and Leo Aragon.

You know, I have often wondered what the officers meeting that the club had after we approached them about patching over was like. I'll just bet it was a hot one.

I was only a prospect for a month, but it sure was action packed. I'll give you two quick stories from that time.

Black Bill, Nick Debbas
(who prospected with me),
and Freddie Flores helped
start the San Jose charter.

Freddie Flores at the old
San Jose clubhouse.

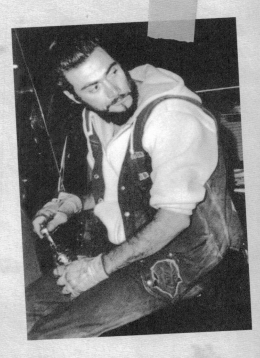

The old San Jose
clubhouse was the same
one used by the Gypsy
Jokers.

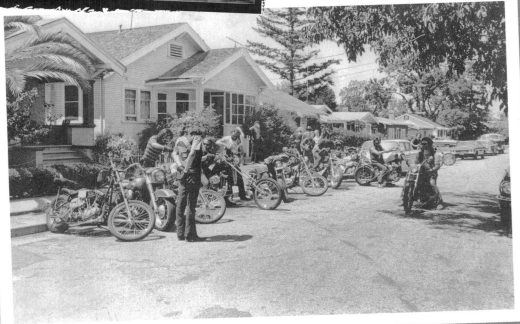

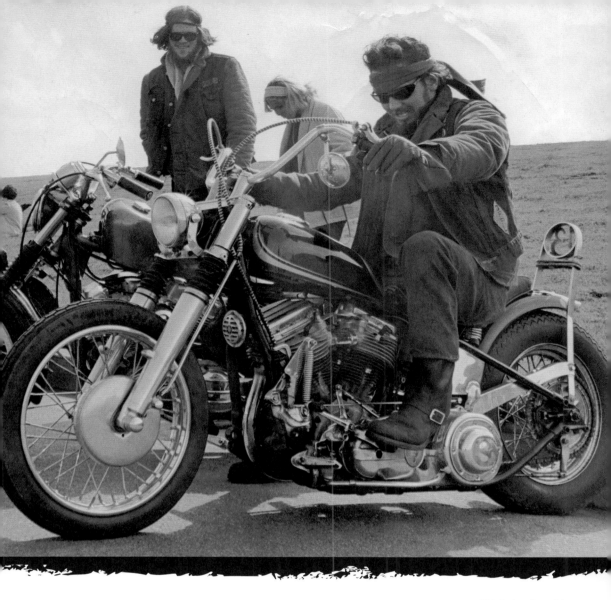

Dirty Ernie, a Gypsy Joker who became a Hells Angel and helped start the San Jose charter.

Once, a member told me to go and collect a debt owed to him from a guy named Skeet (the same Skeet who everybody knew was real fond of shooting people). Well, I had to go to Skeet's place unarmed because I didn't have a gun on me at the time (I really would have liked one). So I get to Skeet's and start talking to him about the money, and as we're talking, he sits down on the couch. Right away, I know this is wrong so I told him to get up. He did. I went to the couch and looked behind the pillow, and sure enough tucked in nice and cozy is a .38. I took the gun, and Skeet went and got the money. When he came back into the room, we made a switch—his gun for money—and I left. I took the money to our clubhouse (such as it was, an abandoned building by Camden Avenue). When Dirty Ernie heard that I just made this collection from Skeet, he jumped up and yelled, "That dirty son of a bitch owes me three hundred dollars. Go and get it." Now the last thing I wanted to do was go back

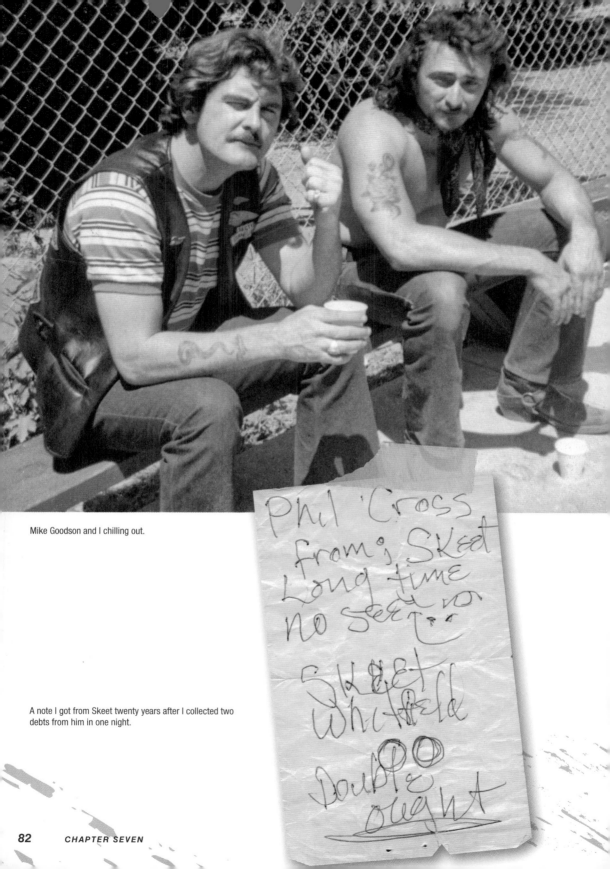

Mike Goodson and I chilling out.

A note I got from Skeet twenty years after I collected two debts from him in one night.

into Skeet's house. Having just been there, I knew he had that loaded .38 and I also knew that he liked using it, but back I went. I knocked on the door, and I guess surprise was on my side (I mean, he really didn't expect to see me again so soon) because he just opened the door with no fuss. I told him to hand me that gun one more time. I said I was there collecting for Ernie and to give me the three hundred dollars he owed. He said he didn't have it, he'd have to go and get it, and he would need his gun. I took the bullets out of the gun, handed it to him, and told him to bring me the cash. He came back in about forty-five minutes with the money. My guess was that there was a liquor store in the vicinity that had a three hundred–dollar shortage in the till. I took the money to Ernie and left Skeet with his gun again, but this time it was empty. I wanted him to have the night to cool off before he had a loaded gun again.

My Hells Angel patch.

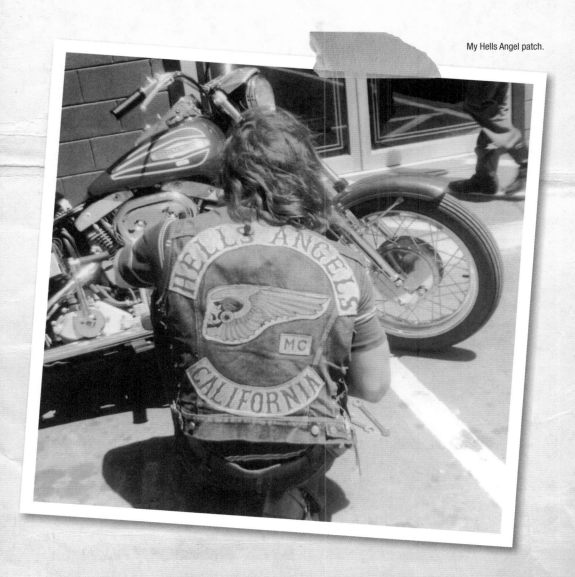

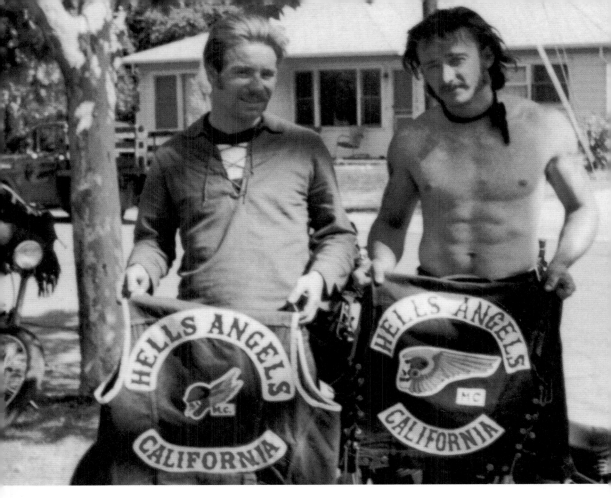

Theo and me holding our
new patches.

One night while various H.A. charters were partying at a bar in East Palo
Alto, Mike Goodson and I decided to walk up the street to check out a street
fair. We had an altercation with a tall black kid. This kid had the longest arms I
had ever seen, or maybe it was just the extension of the knife he had pulled on
us. Neither Mike nor I had a knife (lesson learned—I was never again without
one). When this kid couldn't get to us, he spun around and disappeared into
the crowd, the all-black crowd. So much for two white boys chasing him down.

Later that night, two cars loaded up with him and his friends came right up
to the bar we were at and started shooting. I was leaning against a brick wall,
and I could feel the chunks from it flying and hitting me. The Hells Angels
who had guns returned fire, and the ones who didn't were throwing anything
they could lay their hands on. I loaned Dick Smith (our charter president) my
.32 automatic, and he ran right out into the middle of the street and started
shooting . . . and the gun fell apart in his hands. I guess you could say I had put
it together poorly (I know Dick sure thought so). Amazingly, out of that hail of
gunfire, the only injury was Little Mike's oil bag. Later that night, after Sonny
heard the story about the gun coming apart, he told Dick, "You've either got to
kill him or make him a member." Lucky for me, Dick chose the latter.

I became a member of the San Jose Hells Angels on my twenty-seventh birthday. It's the best birthday gift I have ever received.

A few months after I made member, I was dating a little hippie gal. She was dingy, but cute. One night she and a friend were smoking weed and partying at a house with a group of people she didn't know real well, and she ended up getting raped by a guy we all knew as a passing acquaintance. After she told me about it, I went to the house to see if the guy was still there. I was really pissed and intended to make that guy pay, so I brought my .45 with me.

When I got to the house, he was gone, but there were still other people there. I interrogated them pretty hard, and they told me where he was going. I guess they were more afraid of me than they were of him. I went to the next house and it was pretty much the same story: he wasn't there. I went door to door like that for three or four houses. The guy was definitely on the run. At each house I would go through the same interrogation routine: question the person least likely to know anything first, and not be soft. That way, the next one up would know what was coming and the fear had time to build. I finally got a lead that he was at a hamburger stand, and just as I got there, the San Jose PD pulled in. This was not a coincidence. One of the cops came up to my window and said, "Mr. Cross, I want you to stay here for a little while." I had to sit there for at least forty-five minutes. I no choice; they had me hemmed in. I could only guess that the guy was so scared that he called the cops himself, and they were giving him a head start out of town. Things were different in those days. I think the cops just figured it was better and a lot less messy to make sure he was gone.

It was the summer of 1970, and my good friend Bill was in a bit of trouble. There was a guy named Lenny who hated him something fierce and threatened to shoot him on sight. Bill called me up and asked me to have a talk with the guy. I got in contact, and the dude set up a meet in San Juan Bautista, which was OK with me; I liked it there. I got there early to scope it out, and the spot turned out to be in a field, by a dry creek and some eucalyptus trees (it's probably a housing development now).

Anyway . . . I got out of the car and put my .38 in my belt, right by my buckle (damn straight, I came prepared for the worst), and then I waited.

About half an hour later (and he was early too), a car drove up, parked about twenty feet away, the door opened, and a western boot came out and hit the ground. The guy who stepped out of that car was a lot like me, six foot tall, muscular build but lean, dark hair, and wearing a western hat.

We both had on an unusual belt buckle, ring, and necklace. Mine were all club; his were all Navajo. Both of us had our .38s in our belts.

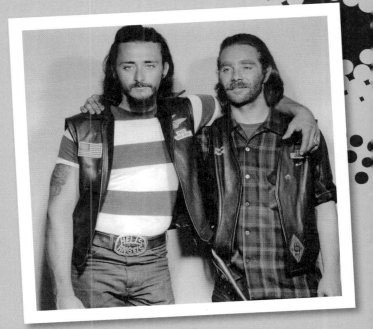

Theo and me as new members of the Hells Angels.

Except for the fact that we showed up in cars, it might have been the old west. You could almost hear the theme from *The Good, the Bad and the Ugly* playing in the background.

Seriously, though, this guy wanted Bill dead, and I wanted to make sure it didn't happen. I knew that we were going to have to work things out . . . one way or another.

We kept our distance. I told him, "Bill is a friend of mine and I don't want you to kill him. And you won't kill him." After that we talked for about twenty more minutes. Basically, we were ironing out the details of the deal, which I won't go into; then we each got into our cars and drove off.

On August 7, 1970, Bill Thompson and I were in court in Marin County Civic Center. We'd been in a meeting with the district attorney because we'd heard a rumor that there was yet another bogus case being built against me. We pushed the button for the elevator, and when it opened, there was a young black kid in there with a sawed-off shotgun and a bunch of hostages. This was some serious shit; I mean the kid had the shotgun taped to one of the guys. We decided to take the stairs down. That was the famous Soledad Brothers escape attempt, the one that ended up being a bloody mess, with four people dead: the judge, the gunman, and two of the escaping prisoners. Two people were wounded, a deputy district attorney and the third prisoner. Angela Davis had bought the guns used in the escape and was tried on conspiracy charges, but she was acquitted. I'm surprised they didn't try to blame the whole damn thing on me.

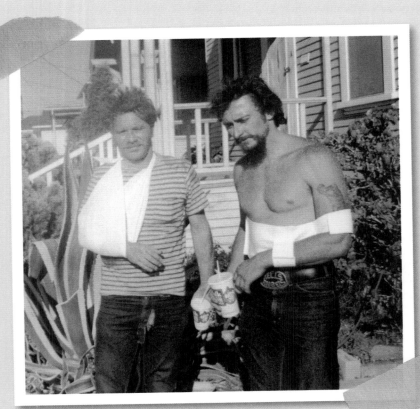

Theo and me after a wreck on Summit Road.

I've been in a whole lot of bike wrecks in my life. None of them are fun, but some are definitely memorable. The afternoon that I was rushing back from Oakland so I could work out at Babe Griffin's gym was one of them. I was going eighty miles per hour on Highway 17 (it wasn't called 880 yet). I was about halfway to San Jose when I had a front tire flat. I eased the bike over to the center median, and slowed down to about seventy miles per hour. Although I was in pretty good control, the front tire was wobbling from left to right . . . and then I hit gravel. So much for control; the front end of the bike jerked violently to the left, the bike flipped over, and suddenly I was airborne and landed in front of the bike, on my chest. I didn't have a leather jacket, just a T-shirt and my vest, but I crossed my forearms in front of me to protect my face. As I was sliding down that gravel-covered median, I wondered where my bike was. When I looked back over my shoulder, I saw it, cartwheeling, end over end behind me. I was afraid it would catch up and hit me before it landed permanently.

Armond with Gandalf, a dog who was his equivalent in the canine world.

A California Highway Patrol cop had been following me and was just getting ready to give me a ticket for speeding when I had the wreck. He stopped to check on me. In a gruff voice, he asked if I was OK. I said I thought I was, and without further ado, he pealed out scattering gravel all over me. Did I just hear maniacal laughter? Oh well, so much for the work out.

Armond was a classic example of "the bigger they are, the harder they hit," and he was quick too.

Around this same time I had another memorable wreck while I was on my way to see Johnny Angel in Oakland one hot summer afternoon. I was almost at his place, traveling on a side road with pavement that was sweating due to the heat and humidity. The bike slid out from under me in a turn. When I went down I was sliding on my back, with the bike on top of my bent legs. The fuel line broke, the spark plug was arcing, and the bike caught fire. There I was sliding down the road underneath a burning bike, an interesting sight for an onlooker. When the bike came to a stop, I pulled my legs out, jumped up, pulled the bike up, straddled it, and the flames went out immediately. I stood in the intersection for a bit, trying to figure out what happened. Then I thought, fuck it, and pulled the bike to the curb, reconnected the fuel line and spark plug. The bike started right up and I rode to Johnny A's and had a very large glass of red wine.

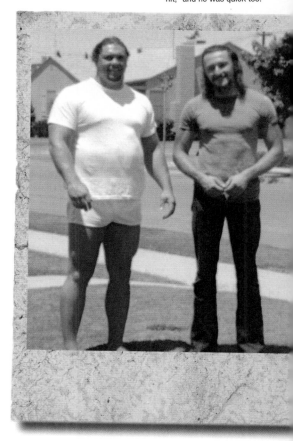

Not long after that wreck I had another one. Theo and I had been at the Chateau and decided to go to the Summit Restaurant to get something to eat. I was packing Theo, traveling down Summit Road behind a Volkswagen. The dude in

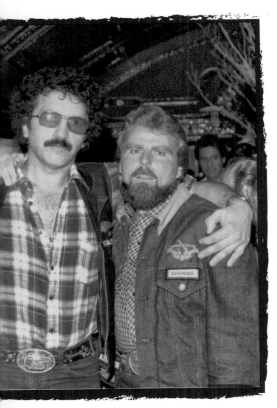
Ted DeMello with another
member, Rooster.

the V.W. pulled far to the right, onto the dirt shoulder.
I thought he was pulling over to let me pass when
suddenly he made a hard left and crossed the road into
a driveway. I hit that V.W. so hard that it bent my frame
and ruined my front end. Theo went over the trunk
and I hit the car with my shoulder. That wasted my
shoulder and it had to be pinned back together. It was
the only wreck that I had where I had to be hospitalized
and that injury has plagued me in one way or another
ever since.

I've had my homes raided so many times that
honestly I've lost count, but one particular time really
stands out. It happened at my house on Comstock
Mill Road, up in the Los Gatos hills, five days after my
thirtieth birthday, August 16, 1972.

I was in bed when they hit the house, but I heard
them coming. They made such a racket, and they were
yelling: "Police! Police!" It's not like they were going
to sneak up on me with all that going on. I guess they
were looking for drugs. The cops never could seem to
understand that I wasn't a druggie and I wasn't stupid
enough to keep shit in my house if I was going to deal.

In those days, I wasn't a felon so I could have guns,
and I did. I kept a .30-30 Western-style rifle next to
my bed. I thought that it might not be the best idea
for them to come in and see that sitting right next to me, so I grabbed it and
stashed it out of sight, under my bed. No point in making anybody with a gun
twitchy.

A Santa Cruz sheriff kicked in my unlocked bedroom door. Something
told me this wasn't going to be smooth. I stayed where I was, lying on the bed,
hands on top of the cover, not exactly what you could call resisting (at that
point jumping up would have looked way to aggressive). The sheriff who came
in was wide-eyed, sweaty, and breathing hard, and he jammed a shotgun into
my sternum. He hit me with it so hard that the barrel drew blood. To this day,
forty years later, I still have a faint crescent-shaped scar from it. That wasn't the
bad part, though; that crazy motherfucker actually pulled the trigger. Luckily,
it misfired. He ejected the dud shell, and literally just in the nick of time, the
San Jose PD came through the door before Psycho Sheriff could pull the trig-
ger again. I never thought I would be happy to see the San Jose PD

I was arrested for possession of a billy club. The thing was actually a balsa
wood replica of a medieval mace. The charges were dismissed, but still, I was
almost murdered over a toy!

A short time after that raid, it was time for me to start collecting some
debts. My friend Ted was one of the people who owed me, and he was past due
paying me back. Ted may have been a friend, but I needed my money. Ted's
phone was disconnected, and I had no other way to get hold of him other than
driving to his house, which was in Fresno. I didn't want to drive to Fresno, so
I called Armond and asked him to get Ted to a phone booth. Armond went to
Ted's house, and when he opened his front door, Armond reached through the

screen door and dragged Ted right through it, put him in the car, and drove him to a phone booth. Ted was more than happy to pay me off. Armond's errand for me didn't hurt his friendship with Ted, even though Ted had to get new roommates because Armond scared the old ones off. That was the kind of guy Ted was. It's odd that both Armond and Ted were murdered. Armond's murderers got away with it. Ted's didn't; they were charged with first-degree murder, found guilty, and I think they are still doing time.

Another guy who owed me was a pretty well-known lawyer in San Jose who had a little side business dealing drugs. This dude kept claiming that he couldn't pay, but seeing as he was an attorney and had his side business, I didn't believe him. I decided that a good place to confront him would be right in front of the courthouse. It was the one place where I knew I could find him. I waited quite a while for him to come out of the building. His Cadillac was sitting right out front, and to keep myself amused and to keep him from running, I pulled a couple of his plug wires. Eventually, he did stroll out and headed for his car. I walked up to him and told him I wanted my money. He started with the same "I don't have it" bullshit, so I smacked him a couple of times. Well, he got scared and ran to his car. I didn't worry because it wasn't going to start. Right? Guess what? It started. When he pulled away, that old Cadillac was coughing and popping and chugging forward. It was comical, almost worth never getting my money since he pulled up stakes and left town poste haste. Lesson learned: no point in pulling any plug wires if you don't pull them all.

My good friend Gypsy Jack died on February 21, 1971. He was killed in a bike wreck almost identical to the one he'd had a few years earlier as a Gypsy Joker. This is the eulogy that I wrote for him.

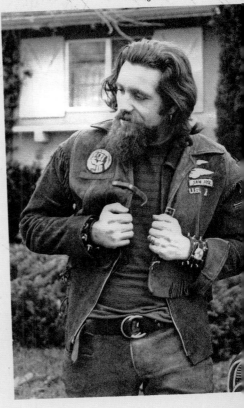

Gypsy Jack as a Hells Angel.

Between the security of the citizens and the insecurity of the hippies is a fascinating group of humans called Hells Angels.

One was Gypsy Jack. He came in many states of sobriety, and he could be found anywhere, on a motorcycle, in bars, on court calendars, in Cadillacs, and always in trouble.

Girls loved him, towns tolerated him, and the heat hassled him.

Jack was brave. He stood as protector of the club.

He had the energy of a mustang, the slyness of a fox, the sincerity of a liar, the aspirations of a Casanova, and when he wanted something, it was usually connected with money or power.

Some of his likes were women, money, motorcycles, and anything that turned him on.

He disliked being badmouthed, jail, snivelers, and small talk.

No one else could cram into one vest pocket a little black book, a pack of cigarettes, a comb, a knife, and a snorting spoon.

He liked spending his money: a little on girls, some on alcohol, and some foolishly.

You could lock him out of your home, but not your mind and your heart.

He is our long away from home brother, and our one and only Gypsy Jack, bleary eyed on route 580.

Nazi Dave (on right) and
my good friend Cisco.

Just because I had now turned thirty didn't mean that I rode any less reck-
lessly. The cops always seemed to be after me, and I would have to find creative
ways to evade them.

One such time, I had just left Buzz's house in San Jose, just off of Blossom
Hill Road and Camden Avenue. I was cruising along, and a cop passed me
going the opposite direction. I had a feeling that he was just going to have to
mess with me. Sure enough, when I looked in my mirror, I could see his brake
lights and his car starting to turn around. No freaking way. I had been really
enjoying myself, and this guy was not going to ruin my day. I hit it, made a few
turns, and came up on a pretty good rise in the road. When I hit the rise, I was
doing one hundred; I flew over it, and when I hit the bottom of the rise, right
there in front of me was a good-sized property with an enormous willow tree.
I scooted right into the covering branches of that tree (they grew all the way
to the ground), bike and all. I parked the bike, and I was peeking through the
branches as the cop drove slowly by looking really perplexed.

Another evasion happened right on the same street a few months later.
I don't know if it was the same cop or not, but it would be funny if it was.
I was heading to visit Buzz when I noticed a cop on my tail. I sped up a bit
and put some distance between us. I made a hard left onto Buzz's street. He
and his wife, Jerri, were standing in their kitchen looking out the window at
me when I pulled into their driveway. I waved toward their garage and Buzz
politely waved back. Jerri got a questioning look on her face as she watched
me frantically wave my arms. We made eye contact and I pointed to the garage
again. She disappeared, and no more than a few seconds later the garage
door opened. I rode in and Jerri slammed it shut. Even before the door was
fully closed, we could hear the siren. That cop didn't give up easy, though. We

watched from the kitchen window as he cruised the neighborhood for quite a while. I was invited to stay for dinner, pot roast I think.

The last one I'll share here took place on my way to visit a girl I was dating, and I'm really quite proud of it. Once again, a cop decided that I needed to be pulled over for no reason. It turned out that I had a warrant at the time, but he didn't know who I was, so that didn't count. Anyway, he ended up chasing me through the neighborhood streets while I was busy formulating a plan. I knew of this pedestrian overpass that crossed over the freeway and it had a sloped ramp that led up to it, rather than steps. The ramp and walkway were wide enough for a Harley, but not wide enough for a police cruiser. All I had to do was get to it. There is one other little detail about the entrance ramp; it was a spiral. I made the ride up going as fast as I could, which was about fifteen miles per hour. The speed didn't matter, though, because once I got onto that ramp, I was home free. I shot across the walkway, down the other side, and I was gone.

In those days, the cops hassled us just for riding; you didn't have break any traffic laws to get pulled over, and I was always on a bike. I didn't even own a car for about ten years, just my bike. Well, technically I did own a car, an old piece of shit Buick. It was really old, like fifteen years old, and about the crappiest car on the road. About a month after I got it, I pulled into Sam Arena's Harley-Davidson, and right when I stopped, directly in front of the shop, both tires folded in and the car collapsed. Man was Sam pissed. He did not want my piece-of-shit broken-down car sitting right smack in front of his shop. Sam and I never did get along anyway; he really would have preferred if I never went into the place. I bought my first bike from him, and he repossessed it because I couldn't make the payments. But old Sam didn't lose any money. The bike was in good shape, and he turned around and sold it all over again. Sam really didn't like the outlaw biker type; he didn't even like selling us parts. Maybe it had something to do with a member going into his shop loaded on Seconal, picking up a display motor, losing his balance, falling over backward into a row of brand-new bikes, and knocking them down like dominoes. The member dropped the motor and left the shop laughing. Sam didn't think it was funny at all. Some people have no sense of humor.

I loved riding, and I loved doing crazy-ass stunts on my bike, just to see what I was capable of. Once, on the way to meeting, I decided to see how far I could ride down Highway 17 . . . on my handlebars. When I got onto the highway, I stood up on the seat, and then I put one leg at a time over the handlebars. Getting into position wasn't easy because the road was twisting and turning,

Fuzzy Neal, H.A.M.C. Oakland.

but I did it. I sat on the handlebars with my hands behind me on the throttle and grip, and my feet dangling on either side of the front wheel. If you don't know Highway 17, it can be dangerous under the best of circumstances. It's a

downhill, curving road through the mountains. I rode like that all the way to where it straightened out at Lexington Reservoir, a good place to get off the bars and back into the seat. I rode those handlebars for a total of about nine miles. I thought it seemed like a good idea at the time.

The other thing I liked to do in those days was fight. Some fights are pretty routine, almost mundane, not that memorable. But others really stick with you. Like the time I was in a hole-in-the-wall bar off of Almaden Expressway. The bartender was a big guy, over six feet and tough, more of a bouncer than a bartender, but I guess he could pour a beer. He was also rude and disrespectful, not a good trait in a bartender; he really shouldn't have been behind the bar. So not knowing all of this (and not caring if I had), I went in and sat down at the bar. I ordered my drink and tried to strike up a conversation with the guy. I don't know if it was because I was a biker, or a Hells Angel, but he started talking tough. I didn't even get to finish my first drink before we got into it. I got so pissed that I jumped over the bar, and we fought right there. I knocked him out cold, but not for long. I went out to my bike, which by the way had a magneto on it. I would never recommend having a magneto—they make bikes hard to start, and that day was no exception. I kept kicking and kicking, and it seemed like it took forever for that bike to start. I finally peeled out of there, and as I looked back, the dude was at the door with what looked like a long-barreled .375 magnum. I sped out of there under a hail of gunfire.

Another good fight was at the Loser's North Bar. This time I wasn't alone, though. I was with Armond, a good guy to have fighting alongside you. Two tough-talking, heavyset Mexican guys started mouthing off to us about how tough they were. Even though they were a good 220 pounds each, I don't know why they wanted to mess with us. I mean, I was in really great shape back then, and Armond was . . . well, Armond. So we started fighting these guys, and I had one of them bent backward over a picket fence that was inside the bar and I was pounding on him. That had to hurt, not just the beating that he was getting from me, but the picket fence jammed his back. I was hitting this guy, and suddenly his eyes got huge and he became oblivious to the whooping he was getting. Naturally, I was curious, so I pinned him and turned to see what he was looking at. There stood Armond Bletcher holding the other guy, all 220 pounds of him, lengthwise across his chest, like he was doing a human bench press. Then he just threw that guy across the bar. I looked back at the guy I was fighting and said, "You know where you're going, motherfucker." Then I yelled, "Hey Armond, I got another one for you," and pushed him toward Armond, who immediately and enthusiastically finished him off. Ah, good times!

I got a pretty frantic call one evening from Dave Lanham that resulted in making those fights seem safe and tame. He discovered that some dynamite that he had been storing for me had crystalized. That happens when dynamite gets old—the nitro leaks out and then it crystalizes. This is very bad, and very dangerous. When it gets in this kind of condition, it is unstable. If it rubs together, it can explode, and Dave was sitting on a case full of it.

Jud and I went and got the dynamite. We soaked it down before we left Dave's place and then put wet newspaper on it. This was all done at 2 a.m., and even then it was as hot as hell. The dynamite was in a little town named Corralitos. We drove it the back through Corralitos to Summit Road, over I don't know how many damn potholes. Every time we hit one, we had to

wonder . . . BOOM? Next we headed down the highway to find some water that wasn't used for human consumption to drown it in. Not as bumpy, but we were still spending more time in its company than we liked. After what seemed like forever, we finally found the right place and gingerly unloaded and drowned the sticks.

I really wanted to take it and put it against a remote hillside somewhere, shoot it, and blow it up. Jud was not at all in favor of that idea. It wasn't the blowing it up part that bothered him, but rather the risk of getting blown up while driving looking for a place to do it.

We were joking and laughing on that drive, but we were scared shitless the whole time. After we dumped the dynamite, we went up to the Chateau Liberté and put the empty case in a dumpster. Then we had a few well-deserved drinks.

One of the many Altamont photos in the news.

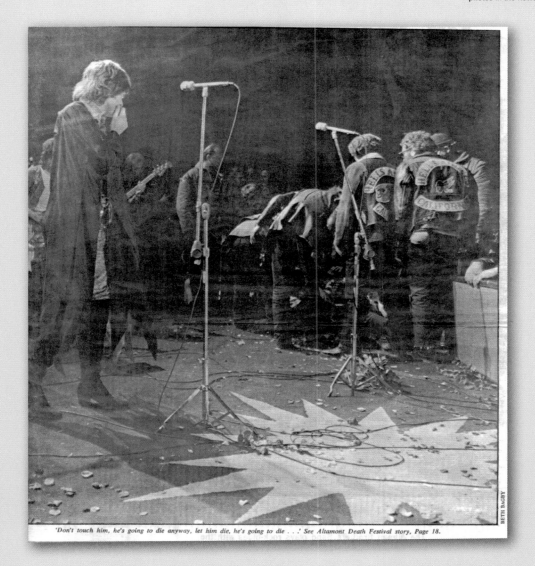

'Don't touch him, he's going to die anyway, let him die, he's going to die . . .' See Altamont Death Festival story, Page 18.

Brendan, H.A.M.C. New York, and me thirty years after a fight at a Willie Nelson concert. He doesn't look any different here than he did then (except his hair was brown then).

In November 1970, there was a Willie Nelson concert at the Ashton Theater in New York City. Ted DeMello was guarding the door, and I and eight or ten other members were hanging out in the lobby shooting the breeze. The rest of the Hells Angels, members from all over the East Coast, were inside the concert hall.

After the concert had started, The Breed, another club that we did not get along with, showed up. There were about seventy of them and maybe ten of us out front. The president of their club walked right up to Ted. Ted thought he was being too chesty and proceeded to beat the crap out of him. With that, all hell broke loose, seventy of them against ten of us. The entrance was only about ten feet wide, so they couldn't get past us. I saw a guy who wasn't a member standing there and told him to go inside and tell the other Hells Angels what was going on. No one ever came, though, so I think the little asshole just took off.

As usual, there was a police presence at the concert, but they never intervened—not when Ted beat up The Breed's president and not during the fight. I didn't blame them, though; seeing those seventy Breed was pretty intimidating, or maybe they just enjoyed the show.

During the fight, I didn't see any guns, but there were lots of clubs, pipes, knives, and, of course, fists and boots. But no guns. One of our members went down, and I saw him being dragged off. I ran over to him, stabbed a couple of guys who were stabbing and beating him, and stood over him. That's where I

OPPOSITE: My good friend Larry Gorham, sitting on my bike.

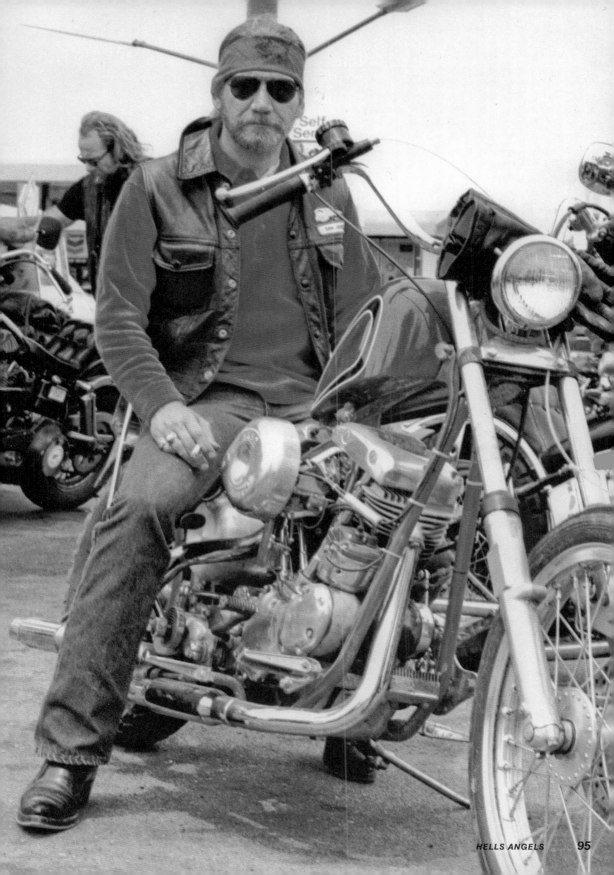

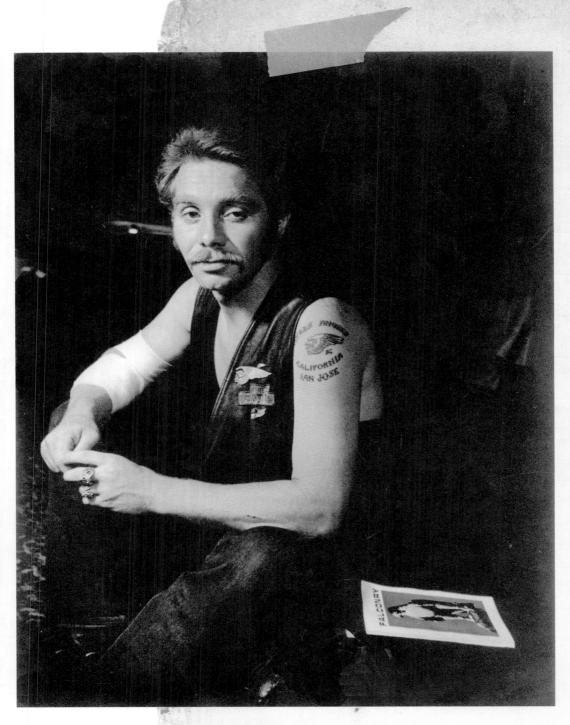

Theo was always
interested in learning
something new,
like falconry.

made my stand and did my fighting, with him on the ground right between my feet. The fight was vicious, but it didn't last too long. Ted, Fuzzy, Nazi Dave, Sandy (New York City's president), and I were the only members left standing when the fight ended. I got hit in the head with a two-by-four during the fight, and the wound got so infected that I ended up in intensive care for two weeks when I got back to California. Even more memorable than the fight was seeing Armond Bletcher in the hospital mask and gown my visitors were required to wear. It looked like he got the miniature versions.

New York City concerts were a good place to get into fights in those days. We got into another one with The Breed on Staten Island, and it was a Willie Nelson concert too. Some members from the New York charter were there as well as Larry Gorham and myself. Larry is a San Jose member who works for Willie as security.

Near the end of the concert, one of the roadies came and told us that some of The Breed were coming up one of the hallways. They hadn't bought tickets; they came in through a rear door behind the stage. We went to intercept them. This time the numbers were about even up. They had a few more guys than us, so pretty much even up. Sandy started talking to one of The Breed, who, it seemed, had a grudge against him. Sandy told him that they should keep the fight just between the two of them. The Breed agreed. The fight started, and the tension between those of us who were watching was tremendous. Eventually, one of our guys thought one of The Breed was getting ready to make a move and threw the first punch. Once again, all hell broke loose, but the audience had no clue that seventeen guys were fighting in the hallway that was just out of sight. I saw Brendan hit one of The Breed so hard that he hit a wall, slid down it, and was out cold. I felt that the odds were more than evened up after that.

Theo sleeping.

One of the guys I fought was a stocky red head with frantic, wide eyes. On both arms, he wore leather bands that went from wrist to just below the elbow, and they were covered with sharp dog collar spikes. This made it hard to fight him. I had punctures and scrape marks all up and down my arms and hands before I finally got him beat. It looked like I'd been in a fight with a wild cat. We beat them to a standstill and ran them back out the door that they came through. Afterward, we made sure to lock it.

Of course, the most famous concert incident involving the Hells Angels was at Altamont, December 6, 1969. The story goes that the club was hired as security. Well, that's a crock of shit. We agreed to keep people off the stage, away from the performers, if they didn't have the proper pass. We didn't get paid; we got to see the concert and we got some beer. I know what I'm talking about here because I was one of the guys on the stage while the Rolling Stones were performing. I never got in a fight with anybody while I was on the stage; I never once threw a punch. I did have to get people off stage, though. The stage was only four feet off the ground, and all three hundred thousand fans had direct access to it. I often wondered why

anyone would have such a low stage with no barrier if they wanted to keep fans off. There was this one crazy ass chick who jumped on stage, and when I tried to get her off, she attacked me. I mean this crazy girl wanted at Mick Jagger in the worst way. I thought I was going to have to knock her out. When I finally got her off the stage and planted her back with her friends, she tried to climb right back up. I told them they'd better get control of her because if she came back up I would definitely knock her out. They listened, but they had to drag her off kicking and screaming. Next I met Owsley (not that we were formally introduced). He came strolling on to the stage like he owned it. I said he had to leave. We were told not to let anyone on stage without a pass, and he didn't have one. He couldn't believe it. He actually said to me: "Do you know who I am?" I told him I didn't care, and away he went. As I said, during the whole concert, I never threw a punch. When I was done, it was about two or three in the morning and really cold. I was walking toward my motorcycle, and I couldn't believe my eyes. There was a guy on it trying to start it. Thank God for that stupid magneto, or he probably would have gotten away with it. At that point, I finally got to throw a punch. I hit him pretty hard and knocked him off the bike. I gave him a couple of kicks for good measure, got on my bike, and left. It had been a long day.

I was living on the east side of San Jose, and I didn't like it at all. In the summer of 1970, I decided to move to the Santa Cruz Mountains. I was finishing the last of the packing at my old place and had my truck loaded and ready to go. I was just about to head out the door when I heard a whole bunch of sirens. I was sure I was about to get raided. I went to the front door to see what was going on, and there were three squad cars and two motorcycles parked across the street. The sirens were dying down, and all of those cops were waving at me. I got the feeling they were glad to see me go.

Larry Gorham and I got a house to share in Redwood Estates. House is a generous term for it; it was nothing more than a shack. There were so many holes in that place that a strong wind blowing outside the house would have put out a candle burning on the inside.

Larry and I both had German shepherds. We were outside one afternoon working on our dog training when I called my dog Tramp. He jumped over a three-foot picket fence to get to me. Larry called his dog, but he didn't want to make the jump. Larry called him again and again, and the dog finally made the jump. Well, he couldn't quite clear the fence and got hung up. A photo of that poor bastard would have been a good advertisement for neutering your dog; he was hanging there by his nuts. When we finally got him loose, he was so pissed he bit Larry.

Theo had a dog around that time too. Her name was Sheena. Her mother was a timber wolf and her father was a Siberian husky. Theo was trying to train her to be a guard dog. He particularly wanted her to watch over him when he

Sheena was a great-looking dog, but she was more sweetheart than protector.

was sleeping. He decided to test her one night and asked me to help. We were on a run, camping out, and he asked me to sneak up on him like an attacker during the night. He had Sheena chained to a tree, so that she couldn't get to me. He didn't want me to get hurt. So at around three in the morning, I went sneaking over to Theo. I got a little closer to Sheena than I was supposed to and she jumped up and ran toward me. Theo was watching from his sleeping bag as his guard dog proceeded to wag her tail and lick me. Man was he pissed. Theo stopped training dogs after that.

After I moved from Redwood Estates, I shared a house in Aldercroft Heights with Dave Agee. When I was living in that house, there was a pack of dogs that would attack me when I came in at night on my bike. I had to slow down for a steep hill with a tight turn over a bridge at the bottom, and I was constantly having my lower legs bitten by these little assholes. I figured it was only a matter of time before I got in a wreck because of them. I had a plan. I came in one night with my .38 in my left hand, and when they came at me, I started firing randomly into the pack. I don't know if I actually killed any of them, but I heard a yelp or two and they scattered quick. Those dogs never bothered me again.

Another animal that bothered me while living at that house was a wood-pecker. He did his pecking on the house, right around the corner from my bedroom window. That was bad enough, but he started at about six o'clock in the morning. Not good for a guy who generally closed the bar and had an hour-long ride home. After a particularly booze-soaked night, I decided I'd finally had enough. I got my shotgun and leaned out my window. I waited for him to tap-tap-tap. Then I used the barrel of the shotgun, and at the corner of the building I did my own little tap-tap-tap. We went back and forth like this for a few minutes until Woody got curious. He leaned around the building to take a look-see and . . . BOOM! No pecking, no more.

In November 1971 my friend Lloyd Schallich and I had this great idea to learn to skydive. On November 6th we went to this place that gave us two hours of instruction, packed the chutes for us, and put us in a plane. We were jumping from twenty five hundred feet and neither of us was afraid. We were stoked; we couldn't wait to experience it. Lloyd was scheduled to jump first and just before he leapt out of the plane he turned back to me and said, "This is going to be the ultimate high." Those were Lloyd's last words. Lloyd's first shoot didn't open all the way and was spinning around (they called it a streamer). When he pulled the reserve shoot it got tangled in the main shoot. I watched my friend plummet to his death. Lloyd landed in a wheat field and when he hit the wheat rippled, just like when you throw a rock in a lake.

Lloyd and I were at a party the night before he died and he passed out on this makeshift couch. We took a photo of him and looking at it now is eerie. He looks like he is dead and in a casket.

After Meg and I had been married for about a year, I said that I thought I should try skydiving again. I felt like I needed to complete something that was unfinished. She was adamantly against it and said that I should accept what happened as a sign that I should not jump out of perfectly good airplanes. I didn't.

I got a call from a charter up north that some people in the Santa Cruz Mountains owed them money for product. I told them I would check it out.

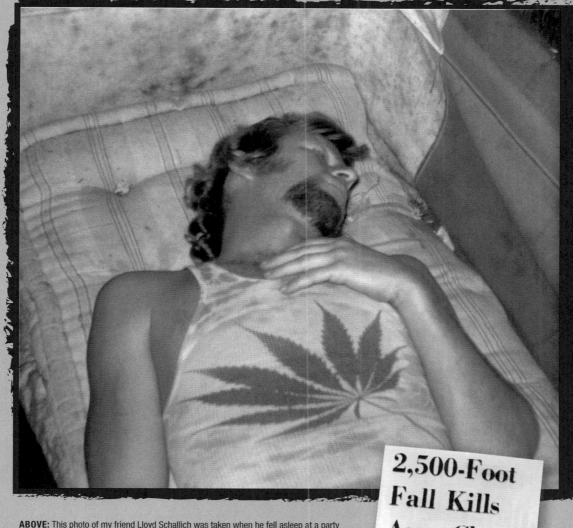

ABOVE: This photo of my friend Lloyd Schallich was taken when he fell asleep at a party the night before we went skydiving.

RIGHT: The newspaper article about Lloyd's death. It was short, but at least they spelled his name right.

2,500-Foot Fall Kills Area Chutist

ANTIOCH (UPI) — Lloyd Schallich, 32, Campbell, plunged 2,500 feet to his death Saturday when his parachute failed to open properly on his first jump.

Contra Costa county coroner's deputies said Schallick, a cement mason, apparently got tangled in his chute lines after jumping from a light plane.

He opened his reserve parachute but it tangled with the main one, they said.

I'm undoing the tie-down on the plane in preparation for a lesson.

They gave me the name of an informant who knew about it, but the guy wasn't involved. I asked my friend Vito to come along as backup, and he and I met with the informant, Reggie. Reggie took us to the house, I told him to knock on the door, and when they asked who it was, to just say his name and nothing else. He knocked, they asked, and that little asshole said, "It's Reggie. I have some people here who want to talk to you." I didn't want anybody inside to have time to get their hands on a gun, so I immediately kicked in the door, pulled that little weasel Reggie in front of me, and went in. I figured if they had a gun and someone was going to get shot, he could take the bullet for his stupidity. Plus, it would give us time to get to the shooter. There was no shooting, just two guys sitting there dazed and confused. I explained why I was there, and I told them to give up either the money or the drugs—I didn't care which. While I was talking to those two dudes (I'll call them Bill and Ted), Reggie was talking too. He didn't like Bill and Ted and was tough talking them. I kept telling Reggie to shut up, but he wouldn't listen and that really pissed me off. Finally, I grabbed Reggie, shoved my .38 in his mouth, and said, "If you say one more word, I will blow your brains out." Vito never said a word the whole time; he just stood there looking intimidating. It was one of the things he did best. My threat to Reggie was very effective. He finally shut the fuck up, and Bill and Ted found all the drugs in a matter of minutes. I took the drugs and the northerners came and picked them up. The funny thing is that my former housemate, Larry Gorham, ended up renting that house after Bill and Ted moved on.

I took up flying after I met Bill Thompson. He had a bail bond business and used his plane to track down bail jumpers. I went with him a number of times on those flights. It was during those flights that Bill taught me to fly. One night we were coming back from Southern California, and Bill was in the back sleeping when the stall warning went off. I brought the nose up, we were too high, which means that the plane will basically just fall to the ground if you don't correct. Bill woke up, grabbed the stick from behind, and pushed it forward, but I landed the plane. It was time for some professional lessons.

I took those lessons, and it became known among law enforcement that I was. I had a few cops ask me where my secret airfields were. Like I'd tell if I had them.

It was a good thing I took those lessons too because I had a forced landing with my instructor (again with Bill in the plane), and if I hadn't been more confident in my ability, our landing might not have been as smooth.

We were headed to Arizona, and when we took off, the motor smoked. When we were at about 750 feet, the engine died. After the engine died, my instructor took the controls. We only had one crack at this; there was no second chance. We circled around, and my instructor wanted to land in the fields below. I told him no; we needed to go back to the airfield. He kept looking down at those fields. Bill told him that we needed to go to the airfield too. I told him that we had enough altitude to make it back; there was no need to land anywhere else. He insisted that we land in the fields, but I was more worried about that than not making the airfield. Again, Bill and I both said that we could make it back.

I realized he wasn't listening to us, so I grabbed him and told him, "I'm flying this plane back to the airfield and landing it there; if you try to stop me, I will knock you out. Do you understand?" He did. I took the controls, and we made it safely back to the airfield. I didn't want to take lessons from him after that, and I kind of doubt that I was going to be his favorite student. I never did get my license. Not too long after that, some warrants came out and I go had to go on the run.

It's never a good thing when it snows in the Santa Cruz Mountains, and as strange as it sounds, that's exactly why I got into trouble and had to become a fugitive . . . for the first time.

Exiting the plane after a lesson.

ON THE RUN

THE WINTER OF 1973 was a bad one, in more ways than one. At one point, we had a big snowfall in the Santa Cruz Mountains, and the road to my house was closed. I really do not like snow; I never have, so needless to say I was less than thrilled when I couldn't get to my own home because of it. I called my friend Buzz and asked if I could crash at his place for a couple of days. That turned out to be a really bad idea.

My piranhas froze in their tank. When I thawed them out
(using my hands), they were still alive.

Buzz had about a pound of Benzedrine that he was trying to sell, and his phone was tapped. The name Phil was on a list from one of the sellers, but just Phil, not Phil Cross. I was also mentioned in the transcript of one of Buzz's phone conversations, but not in any sort of a business context. The transcript just showed that I knew him and that I was staying there. Big fucking deal.

Most of the people involved in the case (except for one guy) got six months. One chick didn't do any time, and they each sold thousands and thousands of those things. Things didn't work out so well for me. I was railroaded on that one. I got four years in prison for that, plus a three-year special parole. It seemed like a bit of overkill for a lousy bag of Benzedrine. Judge Peckham was a railroading motherfucker; I'm sure he would have given me life if he could have. It also turned out that my attorney didn't help matters much either, but I didn't find that out until after I got out of prison.

I need to back up a bit, though, because before Peckham railroaded me, and before the cops could arrest me, I skipped town. This was my first time going on the run, but I was more than willing to risk being a fugitive. I wanted time to find out all the components of the case they had against me and what the hard evidence was.

It was June of 1974 when the warrant for my arrest was issued. I was driving home from a trip to visit friends in Washington, and I made a last-minute decision to stop for a drink at The Cats Restaurant in Los Gatos. I knew the bartender there really well, and when I sat down at the bar, the first thing he said to me was, "Have you seen any news lately?" I told him that I hadn't because I'd been on the road for hours. He turned on the television and said, "Well, you better. You're all over it."

Craig let me stay at his place for a while before I headed back east.

I was damn lucky that I wasn't arrested on Highway 5, just outside Redding. I saw a cop as a tiny dot in my rearview mirror and dropped down to the speed limit and waited. I got pulled over for speeding. I had a Firebird with a 454 in it, and it was always begging to go flat out. I was going over one hundred miles per hour, but the cop gave me a ticket for eighty. He said that if he wrote my real speed down he would have had to arrest me and he didn't want to take me in. He must not have run me for warrants, though, because if he had, he would have felt differently.

I drove to Santa Cruz and stayed with an old high school friend for a few days while I figured out what my next move was going to be. I needed to find out what was really going on, not just what the media was saying, so I got in touch with Bill Thompson and he started on investigating things for me.

I knew I couldn't stay in Santa Cruz any longer, so I called my old friend Craig who lived in Sonoma. He told me to come on up, that I could stay at his place for as long as I needed. He and his wife were good people, and I stayed with them for about a month.

The time had come for me to get out of California. I made two airline reservations under two different assumed names, changed up my look with a wig and glasses, and flew from San Francisco to Chicago. In Chicago, I changed my appearance again (I replaced the wig with a hat) and grabbed my flight to New York.

The president of the New York charter at the time was Sandy Alexander, and he and his wife helped me find an apartment in Greenwich Village. It took a little while to find a place, but Sandy's mistress was nice enough to let me stay in her guest room until I did. That's how I met Willem de Kooning's daughter Lisa, and eventually Bill himself.

As a fugitive, I couldn't hang out with Hells Angels on a regular basis, but I did manage to attend meetings once in a while. For security reasons, I'd just have to show up unannounced, but it was never a problem. I even wore a New York patch on a few occasions. The charter gave me a one-year plaque with the name Hundred Dollar Bill on it. They used that name because when I got to the city I had a wad of cash on me, and it was all one hundred dollar bills.

Sandy and I went to dinner one night, and he introduced me to his friend Angelo. Angelo owned a restaurant, an upscale place in Manhattan. He was connected to one of the New York families. I liked Angelo, and I liked the restaurant. Since I couldn't hang with the club, I hung out at the restaurant pretty often. Angelo and I got to be good friends, and since he knew my story, he offered me some work. What I did was go around with some of his guys and check on different people to make sure they were on the up and up, doing what they were supposed to be doing. I made one hundred dollars a night, which helped me out a lot. Angelo was good guy.

Being a fugitive can be boring, even in New York, but it does give you time to learn new things. I decided to learn about art, so I started doing a lot of reading and I went to museums. The Met, the Guggenheim, and the Frick are my three favorites. The great thing about museums is that exhibits change fairly regularly in them, so you can go on a pretty regular basis and still see something new. If you go too often, someone might think you're casing the joint, though.

After I had been in New York for about six months, my old friend Whitey showed up and, wouldn't you know it, he was a fugitive too. Whitey's

philosophy for being on the run was to not stay in any one place for too long, so he just drove his van all over the country, visiting people. Our mutual friend Dave once told me that when Whitey came to visit him, he was driving a big Cadillac and pulling a trailer with a red motorcycle that had a wild paint job. Nothing subtle about Whitey; he definitely hid in plain sight.

Looking the other direction.

The view from the roof of my apartment building.

With Sandy and his son in New York.

Sam Cutler

One benefit of being on the run is that you are free to take off whenever you want. You don't have to get time off from work or explain to anyone where you're going or how long you'll be gone. You can just up and go. Whitey was heading to Texas to visit his friend Sam Cutler. Sam was the former manager of the Rolling Stones, and he had a big ranch in Austin. I went along for just for the hell of it. After all, I had nothing better to do, and I needed a break from the monotony.

First we headed to Durham, North Carolina, to visit the charter there. We stayed for about a week and then decided that Baton Rouge was next up. We pulled into town at night and, of course, hit a bar. After a few drinks, old Whitey wanted to go to a whorehouse that he'd heard about. We couldn't find that place, but he saw another one and headed into it. I hit the bar for a drink and Whitey came tearing over to me before I could even get it to my lips, grabbed my arm, and said, "We gotta go . . . *now!*" and he pulled me to the door. I thought we had been made, but that wasn't it at all. Whitey had discovered that all the "ladies" were actually dudes. I never asked him how.

We decided that Baton Rouge wasn't for us, so we went to Austin the next day. We stayed at Sam's ranch for about a month. His house was big, so Whitey and I each had our own room. The thing I remember best about the house was that it had a huge porch and we would sit outside at night and watch the thunderstorms. Sam also had a shooting range on the property, and Whitey and I put it to great use.

On the drive back to New York, we hit a mother of a blizzard in Pennsylvania. Crap, snow. With the wind chill factor, the temperature got to forty degrees below zero, and Whitey's van had no insulation. Whitey loved to drive, and he could drive for hours and hours before he got tired. He finally did get tired, so he climbed in the back to get some sleep after getting my assurance that I was OK to drive. I am the opposite of Whitey; long drives make me tired. I can go forever on the bike, but driving just makes me sleepy. After I had been driving for about an hour and a half, I started to get sleepy, so I pulled over to take a nap. I slept for about an hour and headed into the blizzard again. When Whitey woke up, he asked me where we were. I said, "No idea. I can't see a damn thing out there." He never knew that he drove for something like fourteen hours before sleeping and I made it for less than two.

After we got back to New York, Whitey stayed on for a week or so, and then

TOP: Part of Sam's ranch, including the gazebo.

BELOW LEFT: The stables at Sam's ranch. I don't ride horses now, and I didn't ride them back then.

BELOW RIGHT: Whitey's van that had no insulation.

he hit the road again. We didn't see each other again until many years later, after we both got out of prison.

After fourteen months on the run, it seemed that everything that could be done to improve my odds in the case had been done. It was time to turn myself in. I didn't want to risk having some trigger-happy cop being the one I dealt with, so I had Bill Thompson get in touch with my old Gypsy Joker liaison, Larry Stuefloten. I met him at a bar in San Jose, we had a drink, and then he took me to San Francisco. I already had my bail arranged, so I didn't spend any time in jail. I just went through the booking process and on to home.

I had three months before my trial was supposed to start, although I never did go to trial. My attorney arranged a plea bargain in November 1975, the same month Armond Blecher was killed in Fresno.

Armond was shot in the back three times and the shooter claimed that he was protecting his brother. The cops were satisfied with that story and the case was closed. I never thought that the cops did right in that investigation.

Aside from getting stuck with a hanging judge, I also had Michael Sterrett, a bulldog of an assistant U.S. attorney after me. In comparison to Sterrett, my attorney, Gilbert Eisenberg, was a toy poodle.

I heard that Sterrett was in on all facets of the investigation, including the raid at Buzz's house. I don't know if he was present at the raid on my house because I wasn't there. He once told me that I almost ran him off the road as I was leaving Buzz's house. Evidently, he liked doing his own surveillance too.

2 Freed In Bletcher Slaying

By LARRY CARROLL

Fresno police have questioned and released John Timothy Pashayan, 27, of Miramonte, in the fatal shooting Tuesday of Armond Edward Bletcher, 33, of 2895 Winery Ave., Clovis.

Police indicated they are satisfied Pashayan acted in self-defense when Bletcher entered Pashayan's business, Pro Custom Wheels, 650 Fulton St., and allegedly threatened Pashayan's brother with bodily harm.

A preliminary autopsy revealed that Bletcher was struck in the back by three bullets from a 9 mm automatic pistol fired by Pashayan.

Police also questioned and released David Pashayan, 2 26, of Sanger, who Bletcher allegedly had originally threatened.

Investigators believe an argument ensued over a debt Bletcher owed the younger Pashayan, but sources indicate the quarrel had deeper roots.

One unidentified police official said the Pashayans allegedly had been using Bletcher's name as leverage to collect debts owed them by customers.

Bletcher's physical prowess — he stood 6-foot-2 and weighed 325 pounds — was well known in the community, police said. He was an avid weightlifter and physical fitness advocate.

Still other sources said Bletcher allegedly had been a "silent partner" in the Pashayans' business, specializing in tires and custom wheels.

The most plausible motive, according to police, was the the one related to them by David Pashayan.

He told police that Bletcher telephoned the wheel shop several times Tuesday morning, asking the brothers if they had been in contact with the FBI.

The brothers told police they did not know what Bletcher was talking about and subsequently hung up on him when he and his wife called back later.

It was about 20 minutes after the last call, police said, that Bletcher showed up at the shop.

David Pashayan, police said, yelled to Bletcher as he entered the garage area and told him not to come any further.

Bletcher allegedly ignored the warning and advanced toward Pashayan in a menacing manner, police said. David told police he took a swing at Bletcher but missed when the man was at arm's length.

It was at this point, the elder Pashayan said, that David picked up an ax handle and struck Bletcher twice in the shoulder area.

These blows, according to reports, did not faze Bletcher, but he slipped on the pavement and fell to the garage floor.

He got up, police said, reportedly growled, "I'll stick it (the ax handle) down your throat," and again advanced toward David Pashayan.

It was at this point, police said, that John Pashayan reportedly fired two warning shots into the concrete at Bletcher's feet.

The brothers both told police that Bletcher muttered something about killing David and advanced on him again.

John Pashayan then fired the weapon into Bletcher and he staggered and fell to the floor, police said.

The debt motive, as explained by David Pashayan, concerned money Bletcher allegedly owed him from last year. Pashayan told police he posted $500 bail when Bletcher was arrested and said the victim also owed him about $400 for tires and wheels.

Pashayan said Bletcher never paid either debt.

Another witness to the slaying told police the same version as related by the brothers.

The body was taken to Stephens & Bean Chapel where services are pending.

Armond E. Bletcher

The newspaper article about Armond's murder.

I thought it was odd that Eisenberg felt my case was so indefensible, but he had come highly recommended by a friend. I felt I needed to trust his judgment. I also didn't have a lot of money to put into a defense that wasn't going to work, so I took the deal he arranged for me. After I got out of prison, I was told that Eisenberg had brokered a deal in which he offered me up in exchange for a good deal for a high-paying client. I don't know if it's true or not. What I do know is that he never wanted to talk to the informant who was supposed to testify against me, even though I had gotten a phone call from him and he told me that he was refusing to testify in court.

Eisenberg's deal was arranged in November 1975. I managed to talk the judge into letting me spend Christmas with my family. I had to surrender myself at the Federal Correctional Institution, Terminal Island, on January 2, 1976. *Happy New Year*!

Armond's funeral.

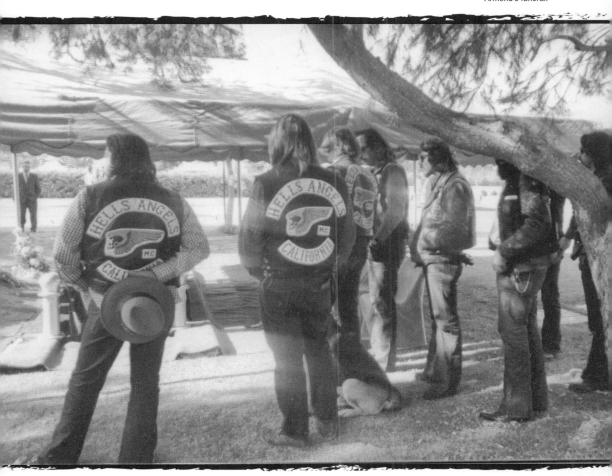

TERMINAL ISLAND IS NOT A VACATION SPOT

AFTER I TURNED MYSELF IN at Terminal Island, I went through the standard sort of processing that all prisoners endure. They take your clothing and all your personal belongings (rings, watches, etc.) and give you the clothes you will wear for the duration of your sentence.

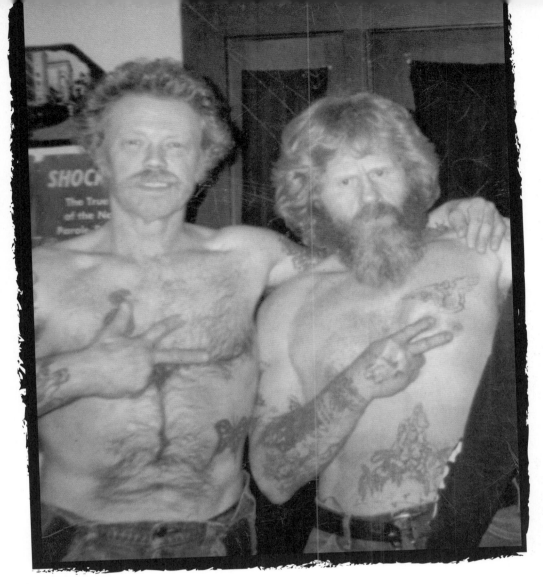

Smokey Joe and Steve Eide were Gypsy Jokers from Oregon who I met in prison.

Even though Terminal Island is a low-security prison, the new prisoners are always put in a cellblock that is set up like a penitentiary. This cellblock had three tiers of small cells, and it has a hardcore atmosphere. It was depressing, but at least you knew it was temporary.

After a while, about a month or so if you didn't screw up, you would get moved to a dormitory with seventy or eighty men in it. You would stay there for about a year. Then, if you hadn't screwed up in the dormitory, you would be moved to a section of the prison that was called Palms.

Palms was the place to be; once you were transferred to Palms, you had a lot more freedom. There were no locked doors, and the rules were much less stringent. In Palms the bedrooms were located upstairs, and it was two men to a room. There was a common room downstairs for hanging out and watching television. You could even go downstairs and watch the television if you couldn't sleep at night.

My cousin (by marriage) Joe Bonanno had done a stint at Terminal Island. He was released a couple of months before I had to go in. Joe was a great guy, and he made sure to get together with me before I went in so that he could clue me in to everything that I needed to know to make prison life work. For instance, I knew what to expect about the different stages of incarcerated living and what was expected of me to make it to Palms. I also knew that wealthy, white-collar convicts usually got there quite a bit sooner and not to let that bother me.

Terry Dodson was an old friend who got wrapped up in the same shit as me. Ben Posey was an old friend from my Joker days. Terry and Ben were both in the joint with me as well as two Gypsy Jokers, Smokey Joe and Steve Eide.

Smokey Joe, Steve, and I worked in the kitchen for a while, and we had a good time. We got our own routine going, and we would make a lot of noise banging pots and pans, just for fun. We had access to the better food and made special meals for ourselves.

Another friend who was in Terminal Island when I got there was Winston, a Hells Angel from Oakland. I had gotten one of my dogs from Winston. This dog, Duke, was the craziest and meanest German shepherd I have ever seen, or heard about for that matter. Duke was raised with Winston's other pet, an African lion named Kitty-Kitty. Once when Winston's house was raided, the cops had an easier time dealing with Kitty-Kitty than they did with Duke.

After I got into Palms, I got a job working in the garden. Being locked up in prison makes being outdoors something you really look forward to. Working in gardening was a coveted position. I worked in the back part of the prison. During World War II, Terminal Island was a naval station, so it had quarters for the officers; this is where the warden and some of the other prison personnel lived. Joe had done this very same job and told me about it. He also told me that Henry, the guy who was the supervisor, was a decent dude and easy to work for.

There was a locker out there that had a bunch of stuff stored in it, and I kept a bottle of whiskey stashed in there. I walked around all the time with a can of Pepsi that had whiskey mixed in it. That was a pretty sweet deal, going around and doing my job with a slight buzz on. I only brought the bottle into the prison once, and Henry found out about it. Everyone who worked outside was shaken down before going back inside. When Henry patted me down, he felt the bottle, tucked into my waistband. He looked up at me, shook his head a little bit, and waved me in. That was it; I didn't do that again, not for anyone. I liked working for Henry.

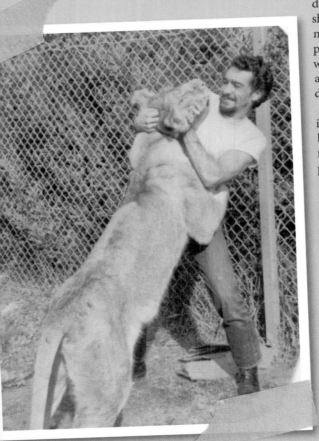

Winston, the guy I got Duke from, and his African lion, Kitty-Kitty.

He was a good guy and I didn't want to put him in jeopardy. Plus, I didn't want to risk losing my gardening job. So I just stuck to my Pepsi and whiskey when working.

One of the things that I did a lot in prison was lift weights and work out. I also helped out other guys who wanted to get in shape by putting together a lifting and exercise routine for them. That's how I met Stan and Sam, two guys who were in for committing a white-collar crime. It was a whopper too, somewhere in the neighborhood of one hundred million dollars. They had been convicted of the Equity Funding scam. Even though they were rich, white-collar dudes, we got along really great. I helped Sam put together his exercise routine, but Stan was in shape and he already had his own routine. I boxed in prison too. I even taught some of the guys how to box, and one of them got really good.

Aside from moving to the Palms faster, white-collar convicts with money got a few other perks too. Sam and Stan actually got to leave prison to go to a football game where they had seats on the fifty-yard line. Like I said, money has its privileges. Stuff like that never bothered me; it's to be expected. Stan was recognized at the game, though, and a big uproar ensued, so that put an end to that.

Palms was even more lenient when Joe was there. They even had televisions in their own rooms. Eventually, the individual televisions, along with some of the extra perks, were done away with. I guess the general population got pissed, and that kind of envy can create problems.

Even though some of the privileges were done away with, we still had it pretty good. We were even able to make our own coffee or tea. We used what was called a stinger to do it. A stinger is an electrical cord with the insulation stripped off the end. The two exposed wires are wound together, and when you plug the cord into the outlet, it gets real hot, hot enough to boil water.

When I got to Terminal Island, it was a coed prison, but in the summer of 1977, it changed to an all-male facility. There were two notable women prisoners there when it was coed: Lynette "Squeaky" Fromme, of the Manson family, and Sara Jane Moore. Both of them attempted to assassinate President Gerald Ford within seventeen days of each other. First "Squeaky" waved her gun toward the president on September 5, and then Sara Jane shot at him, and missed, on September 22.

Squeaky was a very stoic-looking gal; she always looked like she was pissed off. I only talked to her a couple of times, mostly out of curiosity. I met Sara Jane briefly too. I met some notorious people at T.I., men and women. Most of them were willing to sit around and bullshit, but not those two. Both of them were hard to talk to. I guess because they were a bit off their respective rockers.

There was a private club of guys called the Macabees at T.I. Joe Bonanno was a member when he was in, and he told me about it. They did their own cooking, and the food was good. It was a buy-in type situation, but it got shut down before I could work into it.

The guards at T.I. weren't too bad. You'd run up on the occasional dickhead, but all in all they were OK. There was this one guard who the girls hated, though, and when they'd finally had it with the guy, they got even. You have to understand that the convicts ran the prison in a sense. We did the cooking, groundskeeping, laundry, and even checked people in and out. We also did the cleaning, including the room where the guards ate their lunch.

My friend Rich Williams visiting me at Terminal Island. I had my nose broken in the navy; they fixed it at Terminal Island.

One of the girls got her hands on a bunch of LSD and doused that hated guard's coffee. I wasn't in on it, but I did see him being carried out by two other guards. He got a lot quieter after that and pretty much left people alone. He must have been a real asshole; they never would have done that otherwise.

Even though T.I. wasn't overrun with drugs, it had a fair amount. I kept a stash of Valium the whole time I was there. Once I found a way to get it in, I just kept it with my whiskey. I used it to help me deal with prison life.

After so many years of not having a driver's license, I finally got one when I was in prison. They had me driving the dump truck to the dump. I was always alone too; no guard came along for the ride. After that, it was easy for me to pick up my whiskey. I was a pretty good trustee really. I didn't cause trouble, a couple of mild fights, but nothing serious.

The visiting area at T.I. was outside, and it had a wall that was so low that you could have easily stepped over it. It could be like that because the place was pretty easygoing. Escapes were minimal, and big trouble was rare. A lot of the convicts who were there had been in other prisons for ten or more years and had been transferred to the low-risk facility to finish out their sentences. The last thing any of them wanted to do was start any trouble that would put going home at risk. There were some fights, stabbings and such, but nothing like in a penitentiary.

There is one incident that sticks out in my memory. It didn't happen to me, but to a guy I met while working out. He was a big American Indian guy, and he was always on the heavy bag. Even though he was a big guy, he was really easygoing; he never started any shit. Somehow he got on the wrong side of some of the Mexican convicts, and those guys always had knives. Sure enough, three of them came after him. He had taken the precaution of wrapping his body in layers of newspaper for protection. He got hold of one guy and killed him with his own knife. He beat the crap out of the other two. He was shipped out after that. I always thought that was unfair. He didn't start that fight; he was protecting himself. Even a convict should be able to do that.

A lot of the prison population coexisted pretty well. The distinct groups that basically stuck to their own were the Mexicans, the blacks, and the Aryans. The one group of convicts that we all shunned was the dirty cops; nobody wanted anything to do with them. They were on their own, all the time.

At the time that it was a co-ed prison, men and women were allowed to mingle in the yard. Couples always found a way to hook up, though. The most popular place was the stage they had for live performances. Couples would sneak off and go behind the curtain to get it on. They would get someone to stand watch to warn them if a guard was coming. That stuff went on all the time. It's probably one of the reasons they shut it down as co-ed.

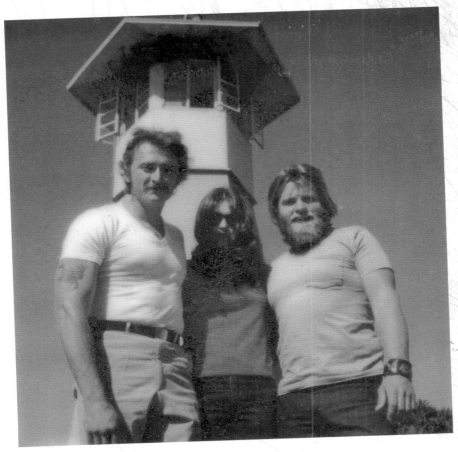

With Craig and his wife. The guard tower made a nice backdrop.

There was this one gal who sat in the same place in the yard every day. She got sick one day and went to the infirmary. While she was in there, she had a baby; she didn't even know she was pregnant. When I found out about it, I couldn't believe that anyone would screw her. Let me try to give an accurate description of her. She was black, but her skin was mottled looking. She was fat, I mean like over three hundred pounds of fat. If being fat and having bad skin weren't enough, she had only one eye, and the empty socket was sewn shut with the worst-looking stitch job ever. As ugly as she was, I was wondering who in the hell, even in prison, would want to have sex with her. Even in Terminal Island a guy had options. Damn. To each his own, I guess.

When you get a visitor, it's great. I was lucky. I had a lot of people come and visit, friends and family alike. One of the funniest visits was when Jud brought his girlfriend, who he called Fuzz-butt, along. Jud had brought a fifth of Wild Turkey with him, and we were sharing it while visiting. I guess old Fuzz-butt got super paranoid. She said she was going to the car and jumped up and tore out of the prison. From the visitor center, you could hear all the cars pull in and out of the parking lot. After Fuzz-butt had been gone about five minutes, we heard an engine rev up and Jud said, "Hey, that's my car." Then we heard the sound of the car squealing as Fuzz-butt pulled out of the parking lot. Jud looked at me and said, "I guess she doesn't like prison much." I still have no idea how he got home that day.

T.I. didn't offer a lot of educational courses, so most of the things I learned in there were my own doing, my own studies. It did have mandatory counseling classes that you had to take, and I went through all of that. In reality, though, I never felt that the counselors were very much help. They were pretty much clueless. They couldn't even figure out what someone's out date was. They just couldn't seem to calculate all the variables such as time off for good behavior.

What Terminal Island lacked in education, it made up for in Hollywood. There were episodes of some television shows filmed there. I saw Wonder Woman, Linda Carter, spin and twirl her cape in the courtyard. Everyone liked watching that. James Garner came to film an episode of his show, *The Rockford Files*. He was a good guy. He talked to everybody and really seemed to have no preconceived ideas about us at all. Every once in a while, live entertainment would be provided. Lots of times it would be "spiritual" in nature, and kind of odd, but at least it was different.

We also had a movie theater. I was told that the movie projector was the same one that was used at Alcatraz when Al Capone was there. I ran that projector for a long time. I think prison is where I developed the habit of being able to watch a movie over and over again.

One time Terry Dodson and I were in the theater watching a movie when this monstrous explosion took place. It shook that concrete theater building so hard that concrete dust and small debris were falling on our heads. My reactions were so fast in those days that I was about twenty feet from my seat before I even knew it. Then I realized that I'd left Terry behind, and he only had one leg. I had to go back in and make sure that Terry got out of the theater. Terry and I stepped out to the yard, but we couldn't see anything. We went into the middle of the yard, and there was this billowing mushroom cloud with fire in it going up at least one hundred yards. My understanding of what happened

was that some hapless guy was down inside an oil tanker welding away. Evidently, it hadn't been vented properly and there were still fumes inside. His welding ignited the fumes, and the tanker blew up. It blew into three different sections. The fore and aft sections stayed right where they were, next to the dock, but forty feet of the midsection blew right up onto the dock. They didn't find a trace of the welder; he must have been blown into atoms. Several other people were killed too. I remember thinking afterward that now I had an idea of how people in a wartime bomb attack must feel.

When you are in prison, getting a furlough is a big deal. At T.I. there was a hard-nosed guard who was responsible for handing out the furloughs. He gave most people I knew a hard time about one. It turned out that he was selling furloughs to the Mexicans. When he finally got caught, the prison system didn't do anything to him. His big punishment was to be moved to a different position.

I finally got a furlough a few months before I got out of prison. I went home to visit my dog Tramp. I had the same dream a bunch of times when I was in prison. In the dream, I was at the base of a hill made out of shale. My house was at the top of the hill. I kept trying to climb the hill, but I couldn't make it because of the shale. Tramp was at the top of the hill looking down and barking, like he was telling me: "Come on up, come on up; come home."

I was released from prison after serving two years, nine months. Jud picked me up in the same car that Fuzz-butt had taken when she stranded him. It was good to be free.

A group shot at Terminal Island. Kneeling: me, Terry Dodson, Lurch, and Ben Posey. Standing: Dirty Dave, Smokey Joe, Big John, Steve Eide, and Mort.

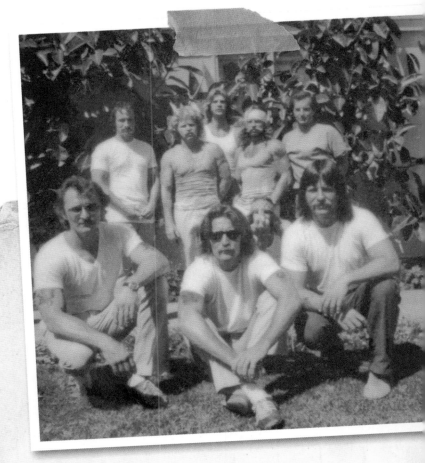

BACK HOME

FREE IS A RELATIVE TERM, even to someone who has been released from prison. After getting out, I still had a lot of rules to follow. I was going to be on regular parole uly 5, 1979, and then I had a three-year special parole that would 1, but at least I was out of prison.

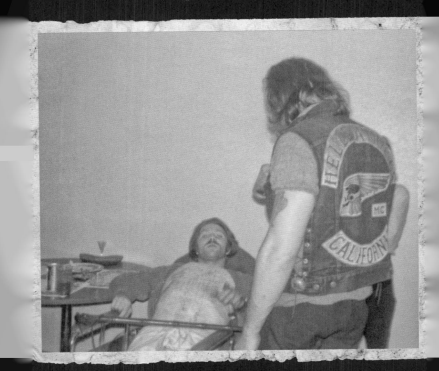

Theo after the wreck that broke his back

THE ARIZONA REPUBLIC

Valley&State

B

Wednesday, October 10, 1984

Report that 'could cost lives' disclosed in drug trial

By ALBERT J. SITTER
Arizona Republic Staff

A secret FBI report whose disclosure could place lives in "jeopardy" was used in open court Tuesday by an attorney defending an alleged Phoenix racketeer and narcotics dealer.

Attorney Frederick Creasy said the report identifies Mafia boss Joe Bonanno of Tucson and leaders of the Hell's Angels motorcycle gang

as sources of cocaine allegedly supplied to his client, Dennis Sallomi, a Phoenix resort operator.

Creasy said key portions of the report, including the names of Bonanno and the alleged bikers, Phil Cross and Don Tate, both of San Jose, Calif., had been blacked out when he received it Monday from the Maricopa County attorney's office.

But by holding the report up to a

bright light, he was able to read the censored portions, Creasy explained to Superior Court Judge Robert Gottsfield.

George Mount, head of the county attorney's organized-crime unit, said he was shocked that Creasy would deliberately reveal the contents of a confidential report that could wreck an ongoing investigation and "may cause somebody to be in serious physical jeopardy."

James Keppel, a deputy county attorney assigned to prosecute Sallomi, said he only recently received the report from the FBI and gave Creasy a copy because court rules require prosecutors to provide defense attorneys with any material pertaining to cases before trial.

The blackouts were made, Keppel said, because those portions of the report pertain to an unrelated investigation, and their disclosure

could damage the probe.

Gottsfield ordered the report filed under seal — after it had become a matter of public record.

Disclosure of the report was made during a pretrial hearing on Creasy's motion to disqualify Keppel as Sallomi's prosecutor.

The hearings have continued sporadically since Aug. 25.

Creasy he wants to keep Kepp

— Report, B

The article about Tate, my cousins, and me.

One of the great things about being a Hells Angel is that since the club is family, even if you are gone for a while, whether it's three years or twenty years, when you come home they are right there waiting for you. When you get back, it's sort of like you were never gone. You still have friends, you still have a social life, and if you need it, you have people who will help you get back on your feet. You aren't roaming around feeling lost (like so many people do); you fall right back into place.

That being said, it isn't all roses and welcome home parties when you get out. You often find that things aren't anything like they were when you left.

While I was in prison, the three things that I was most looking forward to were seeing my mom, my house, and my dog. I was really looking forward to getting back with my charter too, but that was one of the things that was definitely different than when I left.

The charter had a new president, a guy named Tony who had been a prospect when I went to prison. From the first time we met, I could tell that Tony and I were not going to get along. After I had been back for a while, it became pretty evident that he wasn't right for the club. Eventually, he decided to quit. I'll just say that it was the politically correct thing to do.

Another thing that I was really looking forward to was getting back on my bike. I didn't get to do that right away, though, because I came home to a ruined motorcycle. I'd put a lot of time and money into my bike and I wanted to make sure nothing happened to it, so I stashed it at my friend Bill's house. He had plenty of room in his garage, so I knew the bike would be out of the way, be covered, and stay safe. It almost worked too, except shortly before I got out of prison, Tony (the soon-to-be former charter president) and some of his friends showed up at Bill's house. They told Bill they came to collect my bike. Bill and I stayed in touch when I was in prison, and he knew that I would have told him about something like that. He told them that the bike was being taken care of and I had entrusted it to him, but they walked right into his garage and Tony got on the bike and rode off on it. He was seen riding my bike in Merced the following weekend. Apparently it was on that trip when the bike caught on fire from a bad battery connection, and the whole seat, tank, and

fender burned. The damage to my bike solidified my dislike of the guy. What happened to my bike really pissed me off, but I was still on parole so I really couldn't go after anyone and beat him senseless for what he had done. My vengeance would have to be discreet.

It cost me a lot of money to repair that bike. Damn, I wish I still had it; it was a beauty.

It was one of the many conditions of my parole that I get and maintain gainful employment. Naturally, I turned to my good friend Jud. Jud was the foreman for a construction company, and since I knew carpentry, he got me signed on. The owner of the company was a guy named Don, and he was somewhat of a hustler. When he bid on jobs, he would bid them really cheap; then he would make it up by cutting corners and skimping on materials.

Even though he had a good crew, there were always problems with the construction on his jobs. One time we had an irate guy come out to our job site. He was the owner of one of the condominiums in a complex that we built. He was pissed off because his roof leaked. Apparently it leaked so bad that the sheetrock on the ceiling was falling off. There were also electrical problems in the units. It was a good-looking place, all the jobs were, but they were built for shit. This irate owner was threatening to sue Don, and he wanted evidence for his case. He had a camera with him and was taking pictures of the work and Don. Then . . . big mistake, he turned the camera on me. I happened to be holding a hose with a nozzle on it when I saw him raise the camera and point it at me. I cooled that fool down right quick when I sprayed him and his Nikon too.

It wasn't just that one guy, though; there were always complaints about the work, and Don did end up having a number of lawsuits against him. He was more interested in snorting coke at the time, so I guess he needed all the money he could get his hands on. I kept out of it; I needed to keep the job until I was off parole. Don thought he was a big-time player, which finally got him in trouble with me and with my cousins, Bill and Joe Bonnano. Don had gotten involved with some stuff in Arizona and started bragging about all the people he knew. He was dropping names like crazy. Eventually, someone he'd blabbed to got popped and started spilling every name they had ever heard from him. To make matters worse, all this shit made the Arizona papers. Right there in black and white: Bonanno, Cross, and cocaine. Shit! I had to arrange a sit-down with Don, my cousins, and me so that we could set Don straight. I had already stopped working for him, and it was at that point that I cut ties with him.

Not long after I got out of prison, a really strange article hit the papers. Two investigative reporters at the *San Jose Mercury News* wrote an article entitled, "Hells Angels story revolves around mayhem, money, and narcotics." It was a crock of shit. Some investigating: they didn't know shit from shinola. In the article, they said that Sonny had designated me as his successor. They got this tidbit of fucked-up information from a book written by George Werthen, who was a piece of shit police informant. Do not believe everything you read in the newspapers.

Yet another condition of both my regular and special paroles was that

> Intelligence reports said that club president Ralph "Sonny" Barger, in prison for cocaine, heroin, barbiturate and marijuana possession, had designated San Jose chapter president Fillmore Cross as his successor, Wethern's book reports.

The crock-of-shit article stating that I was named Sonny's successor.

I couldn't associate with any Hells Angels. This meant that I couldn't go to meetings at the clubhouse. Shortly after my special parole started, one of the members, Bob, arranged for a charter meeting at a bike shop owned by another member, Barry. Bob talked me into going to the meeting, saying that nothing would happen since it wasn't at the clubhouse. Right after I got to the shop, a cop car pulled up and I was busted. The cop handcuffed me to the bumper of his car while he checked my status. He was thrilled that I was going to be violating my parole, sending me back to prison.

I contacted my attorneys, Vic and Denalee Vertner, to see what could be done to keep me from going back in. Denalee was a whiz at researching case law, and she found that special parole could not be given on the U.S. Code (conspiracy to sell drugs), on which I was convicted. We applied for my special parole to be overturned and won. Not only did my special parole get dropped, but also everyone else across the country who had a special parole for the same charges got off too. Everyone who was convicted on that charge and was doing time for violating their parole had to be released from prison. The cops and prosecutors now had yet another reason to be pissed off at me.

Since I had beaten the special parole, I could get back to real life, and in this case that meant dealing with yet another asshole who was claiming to be Phil Cross. He was seducing women and then robbing them while they were asleep.

I found out where this weasel lived and decided to pay him a visit. I took Jud with me because I didn't know what I might be facing. The weasel's place wasn't much better than a shack up in Felton, and the door was unlocked when we got there.

When I go in with another guy, I prefer for one of us to have a handgun and the other a shotgun. This time I had a 9mm automatic and Jud had the shotgun. I opened the front door quietly and we went in. We didn't turn any lights on; there was enough moonlight to guide us. There was light coming from under a closed door, and when we reached it, I kicked it in. I never knock in these situations; I like the element of surprise. Jud headed in with the shotgun held up in front of his chest at an angle. One small problem: he misjudged how narrow the door was and the shotgun got caught crosswise in the door and stopped him in his tracks. The shotgun wasn't sawed off because then it wouldn't have been any good for duck hunting, but it would have fit through the door. I scooted under Jud's weapon and drew down. Sitting in the middle of the bed was a totally startled little hippie chick with a shoebox full of weed, rolling a joint. The creep we were looking for wasn't even there. We told her that we weren't looking for her, that our visit had nothing to do with her, but we were looking for her boyfriend. After she recovered a bit, I could tell she was beginning to get pissed off at us, and she was very protective of her boyfriend, Phil Cross. When I explained that I was Phil Cross and that her boyfriend was using my name and seducing other women and then robbing them, she wasn't pissed at us anymore, but she sure was pissed at him. She told me that the "lying, cheating asshole" would never set foot in her place again. After that, there weren't any more cases of Phil Cross robbing women. I have never figured out why these dumb asses want to use my name. As my old friend Steve Tausan would say, "There ain't no future in it."

I wasn't on parole anymore, so Bill Thompson asked me to fly to Thailand with him. A kid had been arrested there for smuggling drugs, and Bill was

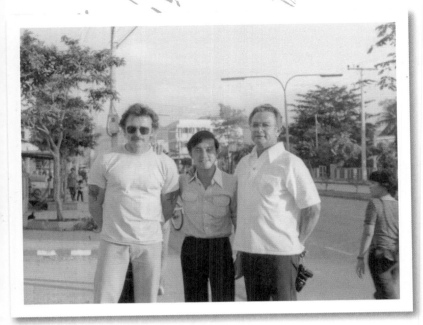

Bill Thompson and I with
his police contact in
Thailand.

hired by his family to get him out of it. The kid's family was loosely connected to the mob, and they had a connection to a Thai cop who Bill was supposed to meet with in Bangkok.

When we got there, we went straight to the prison and met with Bill's contact. The kid never went on trial, but the deal that was arranged had to be done in court. We saw other drug cases that were tried and everyone was convicted. The Thai government did not take dealing lightly. One guy was taken out and shot the morning after his conviction for selling drugs to a woman. They really hated that; you did not want to sell drugs to women in Thailand. After we got the kid off, he had to stay in prison for a short period of time, waiting on his release. After we got home, we heard that he got caught dealing drugs in prison. Bill didn't get another call to bail him out this time, and I don't know what happened to him; for all I know, he might still be there.

Heavy Evans, a member of the Soul Brothers, invited some of us to a party in San Francisco. Dirty Doug and I decided to go. Besides the Soul Brothers and the East Bay Dragons, there were a few other clubs at the party. There were also a whole bunch of independents there too. The party was 95 percent black people, and aside from the few white members of the Soul Brothers, Dirty Doug and I were the only white guys there.

When we had been at the party for about half an hour, it was time for a refill and we headed through the crowd to the bar. The party was at a bike shop, and it was crowded. Doug was walking slightly in front and to the right of me. I put my hand on Doug's back to get his attention, but before I could say anything to him, Doug bent forward. I thought he was goofing around and said, "What's happening?" Doug looked up at me, gave a little chuckle (I think in disbelief), and said, "I've been shot." I told him to quit fucking around and he said, "No, no I've been shot," and he dropped to his knees and rolled onto his back. I kneeled down next to him to check his condition, and a sea of black guys circled us.

Heavy Evans and the Soul Brothers, along with the other clubs members, came over and moved everybody away from us. They helped Doug, called for an ambulance, and tried to figure out who did it. The only thing I know for sure is that it was one of the independents. We have always been on good terms with the other clubs that were there, so there wasn't any reason for one of them to be the shooter.

When the ambulance came and I got a look at it, I couldn't believe that it was actually an ambulance. It was a big square box on the back of a flatbed truck. I thought for sure that if the gunshot wound didn't kill Doug, the ambulance ride would. That ambulance was so old and dilapidated that Doug must have felt like he was riding in a buckboard over cobblestone streets.

The white boys hadn't fared so well, so I thought it was time to go. I thanked Heavy Evans for the invite to the party, which made him laugh, and headed over to the hospital. When they let me see Doug, I discovered that the gunshot wound was in the exact same spot where I had my hand. I swear that bullet must have gone right between my fingers. Half an inch to one side or the other and the shooter would have gotten the two of us with one bullet.

Doug recovered and went on to raise hell for a long time to come.

In 1979, I met a kid named Frank Iadiano. Word was that he was pretty impressive and might be a possibility for a hang-around. I went to Frank's house and talked to him for a while. I asked if he was interested coming around. After he said he was, I told him I'd get back to him.

This was around the same time that the federal government went after Sonny Barger and others by using the RICO (Racketeer Influenced and Corrupt Organizations) Act, so we were being even more careful than usual about the guys we let come around. I checked Frank out—surreptitiously—by going to places where I'd heard he hung out, sitting in the background, and watching. As I was doing my recon on him, I knew he had the right stuff when I went to a bar where he was drinking. The place was crowded, and Frank was sitting at the bar with an empty stool on either side of him. Nobody wanted to mess with Frank. Yep, this might be the right guy. I got back to him, brought him around, and he made member in 1980. Frank retired in 2000. He was a good member and is a still a good friend.

By the way, Sonny and the rest were acquitted on those RICO charges.

In 1980, I met up with a guy I had helped out nine years earlier and we got reacquainted under odd circumstances. I first met him back in 1971 when I pulled into a hamburger joint on South First Street to grab something to eat. I noticed a few guys hassling this family in a car. They were giving them a pretty rough time. I just didn't like the situation, a man being embarrassed by some assholes in front of his wife and kids, so I got off my bike, walked over, and ran them off. They were just a bunch of punks; I didn't even have to get too rough with them. The family thanked me, and I went and got my food.

Nine years later, I was racing a guy in a Porsche down Highway 17 in my Datsun 240Z. The Porsche was a faster car, but I was a better driver and took the turns faster. I think I would have won that race except I looked in my rearview mirror and saw two highway patrol cars coming up fast. Red lights blazing and sirens blaring, one was for him and one was for me. At times like that, I usually thought, "This vehicle is capable of evading high speed pursuit," so I took the Black Road exit.

Black Road is one of those windy mountain roads that is sort of like a roller-coaster. I was driving so fast that my car kept bottoming out and I thought the mufflers were going to come off.

I was looking for a long driveway that I could pull into. I would let the highway patrol car pass and head back the way I'd come. Didn't happen, no driveway.

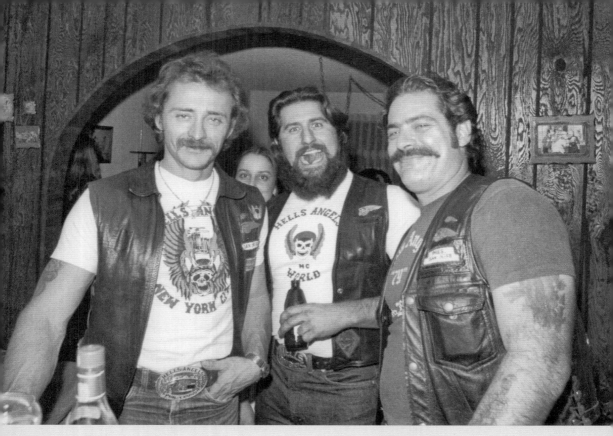

Vito, Frank, and me. It looks like we're having a good time.

When I realized that my car was going to fall apart if I kept going and that the highway patrol car was getting closer, I just pulled over and got out of my car to wait. It didn't take long; that cop was a good wheelman. When he walked over, he said, "Hi Phil, long time no see," and I thought, "Uh-oh this guy knows me. I'm definitely going to jail." Then he said, "Do you remember me from the hamburger stand? You stood up for me and my family." I didn't recognize him, but I did remember the incident. We talked for a couple of minutes, and then he said, "That was quite some race back there. Too bad I didn't catch you. Now were even."

I would run into him in town over the years (never again in a professional capacity), and he was always a decent dude.

It was time for a break, which in those days usually meant a trip to New York. I met with my friend Chuck Zito, a New York member, and he took me to a bar in upper Manhattan. Chuck knew a lot of celebrities and hung out in all the right spots for that sort of thing. I don't remember the name of the bar, but it was somewhere around 68th Street. I was wearing my patch and I felt a tap on my shoulder. This was unusual because people rarely do that if they don't know me. I turned around to see who it was, and I all I saw was a belt buckle. Then I looked up, way up, and there stood Gerry Cooney. Gerry was a great heavyweight boxer, and I caught most of his fights. He always impressed me. He said he'd never met a Hells Angel and just wanted to talk. We talked for a while and I found him to be a good guy. I'd finally met a celebrity who Chuck didn't know.

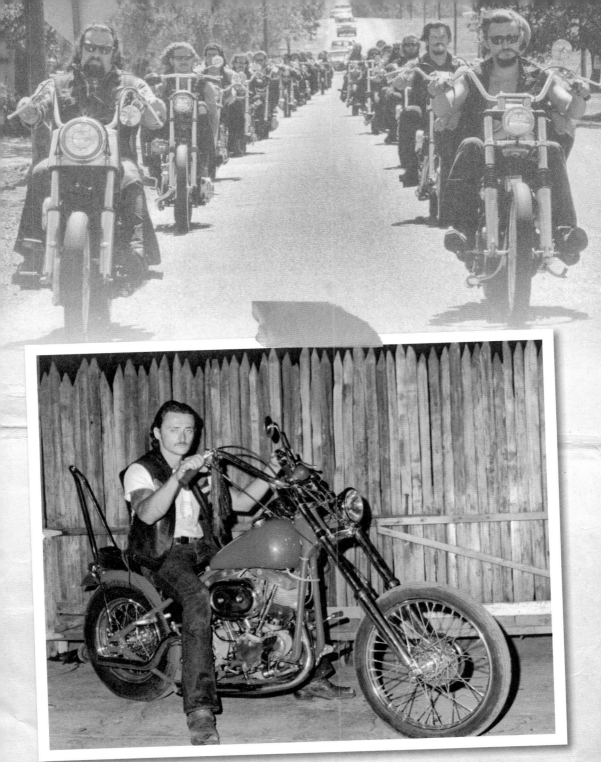

My bike before the wreck
at Lexington Dam.

Over the next year or so, I would go to that bar when I was in New York. I met Gene Simmons from Kiss there one night. He's a really tall guy too, even without his seven-inch leather heels. We sat around and bullshitted for a while. I thought he was a really good guy. I also met Robin Williams a few times at that bar. I think he's always on. By that I mean that he genuinely wants people to be entertained when he's around. The first time I met him we talked for a while, and when I left he said, "Well, I'll see you around." I said, "You probably won't even remember my name." We both laughed and I left. I went back to the bar a few days later, and when I passed through the door, I heard, "Phil, Phil, my old friend Phil; how are you?" That was Robin—quite a guy.

In 1981 and 1982, I went to New York a lot. The hot ticket in those days was Studio 54; it was the place to be and be seen. It had reopened in September of 1981, and I was at the reopening party, thanks to my good friend Chuck. Chuck knew the owners and a lot of the people who frequented the place. I met a lot of celebrities and other famous and interesting people there, and I saw a lot more.

I also hung out at the same bar where a lot of the New York Giants hung out. Craig Morton was the Giants quarterback at the time. Craig and I went to high school together and I ran into him there. I also got to know a few of the other players. They were all good guys.

Chuck was in a martial arts tournament and invited me to it. That's where I met Dan Akroyd and John Belushi, who were also invited by Chuck. We hit it off, and I spent most of my three-day visit hanging out with them and Bill Wallace. Bill was working with John on keeping his weight down and acting as his quasi bodyguard at the time.

Chuck Zito with John Belushi.

Dan Akroyd, Sugar Ray Leonard, and John Belushi

Me with John Belushi and Bill Wallace at the Gramercy Gym.

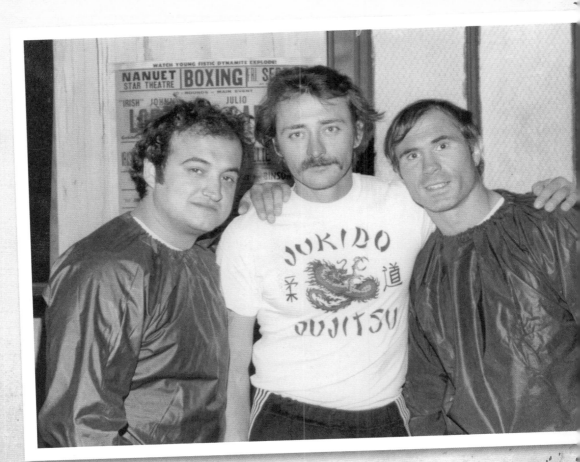

The right side of my wrecked bike.

The guys had one of the cars that had been used as the *Bluesmobile*, and we drove it all over Manhattan. We went to the Blues Bar, which Dan and John owned, to restaurants, and to the Gramercy Gym.

The only meal I distinctly remember was a lunch at a Chinese restaurant. There were six of us who went to the restaurant: Dan, John and his wife Judy, Bill, Chuck, and me. After we got there, Bill decided he wanted a hamburger and left. John and Dan told me that Bill loved hamburgers, and that was what he usually wanted to eat. John ordered a very low-calorie nuts-and-twigs sort of meal when Bill was there. After Bill left and the food arrived, John wanted nothing to do with his meal. He reached across the table and grabbed handfuls of food from two different plates (not mine). When the big, tough weight-watching guy is away, the comedian will play.

I got to spar with Bill Wallace at the Gramercy, and that was quite an honor. "Superfoot" Bill Wallace was an amazing fighter and a real champion. I'm very glad that I got to have that experience. After Bill and I sparred, he and John got in the ring. Let's just say that I fared far better that John. About halfway through the first round, John had his back to me and Bill hit him with a solid right that spun Belushi around. He grabbed the ropes that were right in front of me, and I can still see the wide-eyed, stunned look on his face. That was the end of John's sparring for that day.

John really did want to get in shape, so he, Dan, and I went jogging in lower Manhattan. Bill Wallace would have been proud of John's initiative, at least until we ended up at a bar. Lower Manhattan happened to be where the Blues Bar was located, and we ended up there. We went to the bar while it was closed, but either Dan or John had keys and opened it up and started serving.

The bar was a real hole in the wall; calling it a dive dressed it up, but it was perfect. After we left the bar, Dan had to leave town for an interview and John invited me back to his place to watch a football game. John's place in New York was nice but unassuming. His wife, Judy, who was very nice, laid out some snacks for us, and we sat back and watched the game.

I knew that John and Judy had to leave town early the next morning, so when the game was over, I got up to leave. John said, "Hey, hang on a minute." He left the room, and when he came back, he handed be a red jacket and said, "Here, take this." I thought it was pretty cool that he gave me a memento.

I shook his hand and said a simple "Hey, thanks man," and I left. That was one of my favorite trips to New York.

Once I got home, things got much more serious. I heard a rumor that there was a guy talking about me. Nobody could give me any details about what he was saying, or whom he was talking to, so I needed to check it out. I stopped by Frank's place to see if he wanted to come with me. As he was walking toward his bike, he noticed my dagger. It was strapped to my belt and it was about a foot long. He said, "Jesus Christ, Phil, what do you use that for?"

I said, "If anybody messes with us, I can stick it right through him and pin them to a wall to keep him out of the way." As it turned out, it was no big deal. They guy wasn't worth bothering with; my knife could stay sheathed.

Frank and I got to be good friends from the time he came around. He and I had a habit of mixing it up when we were drinking. These fights were never in anger, just for sport, but that didn't mean that they came without price.

Our last Lake run was in 1979, and Frank was still a prospect. Mother Nature must have been in a real bitch of a mood during that run because we

had an earthquake, a thunderstorm, and snow. Frank broke my nose on that run. We broke each other's noses a few times over the years just from horsing around.

The run lasted two days, and about one hundred people were left at the run site on the last morning. We were awakened bright and early by about sixty cops. They were yelling and kicking tents; it was an out-and-out raid. Some of the cops were strutting around like peacocks with a bad attitude; I guess they thought that was intimidating.

Nobody was arrested and they didn't bother looking for anybody with warrants; they just wanted us gone. It was time to go anyway. We just hadn't planned on leaving quite so early in the morning.

In 1982, I had a terrible bike wreck by Lexington Dam, and it was a stroke of fate that I survived. I was going about seventy miles per hour on my way to Los Gatos when my rear tire blew. Rear blowouts are tough to control as you are trying to slow down. Whichever way the tire rolls to the side of the rim, you have to steer the front tire the same way. By the time the bike went down, I was probably going about forty-five or fifty. The bike had drifted to the center of the highway, and there was no divider, just the lane markers. The bike deposited me right smack in the middle of the median and then proceeded to head back into traffic. I sat there and watched as three cars ran into my bike and kept going. The fourth car to hit it wasn't so lucky; the bike got wedged under it, so he had to stop. A Good Samaritan gave me a ride into Los Gatos, and I went to a bar called Number One Broadway to nurse my wounds, both physical (cuts and bruises all over, but no need for a hospital) and emotional (I really liked that bike).

In the spring of 1982, my dog Tramp started to lose interest in his food and he was losing weight. I took him to the vet, and they gave me bad news. Cancer. He had advanced lymphoma (the same advanced cancer that I was diagnosed with twenty-five years later). There was nothing they could do; they just gave me medication for when his pain got bad.

The immediate problem was that he wouldn't eat, so I started giving him raw hamburger. He ate that just fine. The vet told me that this could make the cancer progress faster, but I figured it was better for him to feel better and be happy for whatever time he had left.

I had Tramp for twelve years, but I lost four years with him from being on the run and being in prison. Tramp always liked the challenge of a good fight. One summer day, we went for our last walk. It was the day before he died. One of my neighbors had a weimaraner, and it ran out from their yard as we were walking by. The dog got raspy with Tramp, but Tramp had no intention of taking any shit. He whipped that dog's ass. It seemed to lift his spirits too. He died in my arms the next day. I'd lost my buddy, and it seemed like the end of an era.

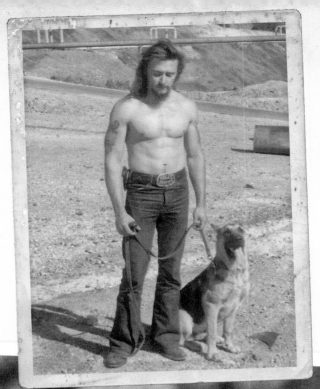

Tramp and me, both in the best of health.

My buddy Tramp, my all-time favorite dog.

CHAPTER

11

MEG

I MET MY FUTURE WIFE, MEG, in May of 1983. She worked for my accountant, and she really didn't want anything to do with me. I had actually seen her at the office the year before, but for some reason I didn't talk to her. I didn't see her again for another year because she had a private office. That May, she was covering the front desk when I came in. I had to wait for about twenty minutes to see my accountant, and she and I talked that whole time. I called later that day and asked her out. She said no and told me that the employees weren't allowed to date clients. I had to ask her out four more times before she agreed to even go to lunch with me.

Meg and me at a party when we first met.

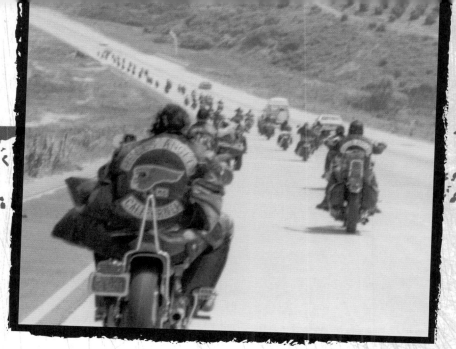

The pack riding to the run site.

I can remember the date of that first lunch because it was my mom's birthday: May 18. At lunch, she jokingly said that the reason she kept saying no was because she didn't own anything made of black leather. That, and she'd heard some scary things about the "gentlemen's club" that I belonged to. I told her not to worry, that everything she'd heard was blown way out of proportion. After lunch was over, I asked her if she was less nervous. Her reply was, "Not really." Then I asked if she wanted to get together on Saturday. Surprisingly, she agreed right away.

On Saturday afternoon, we went to my place before meeting up with some of my friends for lunch in Soquel. My house was up in the mountains, down two long, winding roads. After we got to my place, Meg said, "I hope you turn out to be a nice guy because if I have to escape from you, I'll never be able to find my way out of here." She may have been nervous, but it didn't put a damper on her sense of humor.

After a long lunch and a lot of margaritas, we headed back to my place to watch a movie. During our conversation, Meg asked me how old I was. I answered, "Forty."

She had been kicked back on the sofa, but when she heard that she sat straight up. "Oh, I had no idea you were that old," she said.

I said, "Thanks a lot." She cleaned it up by saying that she thought I looked much younger. So I asked her age.

"Twenty-five. Actually my birthday is tomorrow." A fifteen-year age difference didn't seem like that much to me, and I asked if it was going to be a problem for her. "Nope." It probably benefitted us; I still had a lot of the reckless kid in me, and she was very mature and very responsible, so we kind of evened each other out.

Meg had a series of tough times when she first started going on runs. The snow run of 1983 was the first time Meg had been on a run. One of our members owned a tow company, and he had a piece-of-shit van that the owner

never claimed. We decided that it would be a good idea to use it as a run van; that way everybody could just put all their shit into it and not have to pack up their bikes. It seemed like a good idea until we all got to the first gas stop and there was no sign of Meg and the van. I sent prospects to go back and look for her, but they came up empty.

She didn't even get one mile down the highway when the van started coughing and lurched to a stop. She knew the name of the tow company and called them. They came and got her, hooked up the van, and took Meg back to the yard and the van to a shop. The van had a clogged fuel filter that they replaced, and Meg got on the road again. The only problem was that she had no idea where the run site was; we forgot to give her one of the maps.

She knew we were going to the Tahoe area, so she decided to wing it and hit the road. When she got close to Jackson, she saw a bar with a whole lot of bikes parked in front. She told me later that when she saw death heads on some of them she said something that just a few months before she never expected to say: "Thank God, it's the Hells Angels." She walked into the bar and looked around for someone to ask for a map. She spotted a member who was just walking away from the bar and went up to him. It was Dave from Sonoma, a really great guy. She asked, "Can you tell me how to get to the run site?"

He looked her up and down and asked, "Who are you?" She told him that she was with me and about the van breaking down. Dave turned to the whole bar and announced, "Hey everybody, we got Phil Cross's old lady here. She got separated from the pack. She's gonna travel with us now to make sure she gets there safe." Meg followed the pack to the run site, and when she pulled into the parking lot, Frank and I were standing there.

Frank walked up to her before I could and said, "I'm so glad to see you." Then he picked her up and gave her a big hug. I could see that he whispered something in her ear, and she started to laugh. She told me later that he said, "My stash is in that van."

I really appreciated what Dave did and I've always been glad that I found him and told him right away. He was killed in an accident coming back to the run site from a casino that night. That sure as hell put a damper on the trip. Dave was a truly good guy, and he and Frank were really good friends.

On a run in Sonoma, we had to go up this steep, narrow, winding road to get to the run site. After partying all day, a group of us were heading back to the hotel. When we were going down the hill, I hit some gravel and couldn't correct, which caused me to swerve off the road. My bike slid sideways, and we came within millimeters of hitting this huge boulder. I guess I shouldn't have taken that Vicodin, or maybe it was the tequila. Meg's foot was actually resting up against the boulder. Steve Tausan and Jethro Pettigrew were riding behind me. They both thought that Meg's foot was trapped between the bike and the boulder. She only had on a pair of slip-on-type shoes and would have been in serious trouble if we hadn't gotten so lucky. Jethro had lost a foot in a bike wreck, so he was really relieved when he saw Meg get off that bike. While I was getting my bike out of there, Jethro and Steve gave Meg a lecture about proper footwear.

I didn't want to pack her the rest of the way and risk putting her in any further danger, so she got on Steve's bike for the rest of the ride. When we got back to the hotel, Steve made Meg promise to wear boots from now on. For

My pet sidewinder, Widow Maker.

years, he would check her feet before we headed out on runs and he always teased her about her "princess shoes," as he called them.

One of the Fourth of July runs was held at Lake Don Pedro. The nearest bar was a little joint in La Grange. A bunch of us went there one afternoon for a few beers and ended up staying, and drinking, for a long time. The bartender/owner was friendly. He made a decent drink, and he wore a western hat. He had pins in his hat, and when I said that I did that too, he suggested that I come back later with it and maybe we could do a trade.

I did go back later that afternoon, and we ended up trading pins. I gave him a Willie Nelson pin (I had a couple) for an antique U.S. Army Calvary pin.

Frank and I drank a few shots of tequila and had a few beers. Now it was time for us to start mixing it up. We had been talking about grappling techniques and thought that it would be fun to try some out. As soon as we started in, Meg advised all the patrons at our end of the bar to move to the far end. Then she and Dirty Doug cleared the empty barstools out of the way. They went to play air hockey until it was all over.

Frank and I made a hell of a racket and knocked a few things over, so Moldy Marvin, an Oakland member, tried to get us to cool it. Naturally Frank and I thought it would be more fun if Marvin joined us and he got a bit roughed up.

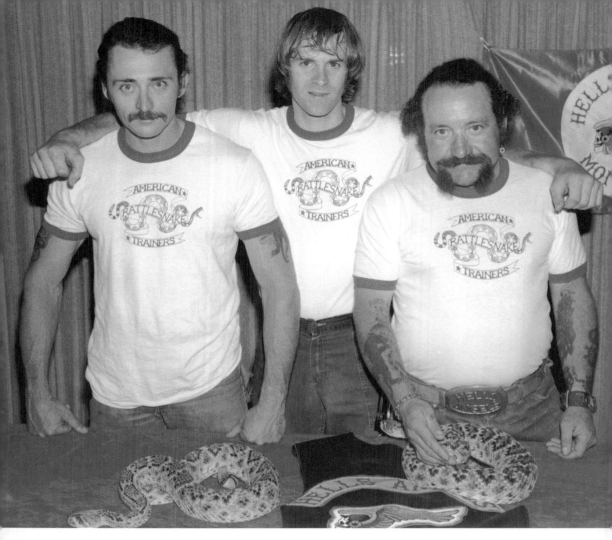

The American Rattlesnake Trainers: me, Steve Leibenberg, and Dick Snyder, a Monterey Hells Angel.

After we'd been going at it for a while, the bartender/owner reached under the bar and pulled out a gun. He yelled, "All right, nobody move," and pulled the trigger. One of those flags that says BANG popped out of the end of the gun. It was pretty funny, but it's never a good idea to pull a gun (even a fake one) on a group of Hells Angels.

On the ride back to the run site, Frank, who had been in charge of the run money, lost it. He had about two thousand dollars in his vest pocket, and it fell out when we took off on our bikes. Luckily, Marvin saw it and picked it up. He brought it back to the run site and gave it to Frank. Marvin wouldn't hold a grudge for something as simple getting roughed up when it was all in fun.

On the way to the bar and back, Meg had to hold on to my hat so she could only hold on to me with one arm. The ride out was uneventful, but the ride back was action packed (at least for her).

At the run site, the barbecue was set up on a cliff overlooking everything else. There was a dusty little squirrel trail up the hillside that would take you to it. I had ridden up there earlier in the day and it was no problem. I decided

to ride up there again and see what was cooking. What I didn't know was that the guys doing the cooking got tired of people riding up and down all day and stirring up a bunch of dust, so they put a log across the trail. I saw the log at the last minute, and the only way I could stop in time was to use the front brake. Since Meg was only holding on with one hand she flew off the bike and went over right over the cliff. She landed high up, but she slid all the way to the bottom. Dick Smith saw the whole thing and was right there when she came to a stop. He reached down to give her a hand up and said, "Don't worry; you looked very dignified during the whole thing." Meg looked up at the cliff and she saw Frank and I standing up top, laughing. What she didn't know was that we were laughing because she never let go of the hat. When I finally got down to her, she stuck the hat out to me and said, "Here's your fucking hat." Yep, she was pretty pissed at me for a few days.

For a little gal who was joking referred to as Fluffy when she first came around the club, she adjusted real well. My friend Steve Tausan used to say, "Don't let the prim and proper fool you; she is a bad ass gangster chick!"

When I met Meg, I had two pets, a bad ass German shepherd named Ajax and a sidewinder rattlesnake named Widow Maker. I gave the dog the name Ajax because he had such an abrasive personality. Widow maker is the term used to describe a detached or broken tree limb that can unexpectedly fall on and possibly kill someone. That rattler's personality was similar to that; you never quite knew what was going to happen with her. Ajax guarded the outside of the house and Widow Maker guarded the inside. They made a perfect security team. It wasn't a good idea to arrive at my house unannounced.

Getting this rattler out of my bike was slow, cautious work.

Meg didn't want anything to do with either of my pets, but I told her she had to get to know the dog. After their introduction, they quickly became friends. She drew the line at the rattler; she said she wasn't having anything to do with a creature named Widow Maker.

My mom hated Widow Maker too. She was afraid of all snakes. Mom still smoked in those days, and the only ashtray I had around the house was a ceramic one that looked like a coiled up sidewinder. I got it because it looked so much like Widow Maker. My mom came to visit one afternoon, and when she went to put her cigarette out, she saw the ashtray on the dining table. She walked over and reached down to stub it out when the ashtray started rattling. She screamed, and ran out of the room. Poor Mom; I had forgotten that I had let Widow Maker out for a walk earlier in the day.

"Out for a walk" was my terminology for when I would let Widow Maker out of her tank to bask in the sun on the dining table. I did this on a regular basis.

Meg handling rattlers at
our family Easter party.

Occasionally, she would fall off the table and roam around the house. More than once, I would wake up after dozing off in front of the television with her draped around my neck. That was a warm place for her to sleep too.

I even took her for walks in the yard. I'd put her on the ground and follow where she led. Once as we were going along, I heard an owl hooting. To me it sounded distinctly like, "Hot damn, there's dinner." I scooped her up and headed back to the house. We did fewer outdoor activities after that.

I was handling rattlers a lot in this period, which I learned how to do from my friend Steve Leiberberg. Steve started an organization called the American Rattlesnake Trainers Association, which only had about six members. I even got my friend Bill Bassett to take part, which didn't thrill his girlfriend. We were a group of guys who got together just to handle rattlers. No meetings, no dues, but we did have T-shirts.

Occasionally, we would do demonstrations at group events, but only for friends, and not for money. One of these demonstrations was at a club run. Since I had to ride with my charter, Steve transported all the rattlers to the run site. My charter was late getting there, and as soon as I got off my bike and walked up to Steve, he stuck a rattler in my arms. Preparation was not an option. Sonny told me later that Steve had a circle of members around him waiting for the show, but he wouldn't start without me. He just kept adlibbing, talking about rattlers, never showing one until I got there.

This big guy didn't seem to be offended by my hat band.

We all got together at my place one day and I had this idea for a photo op. I took one of the bigger rattlers, about six feet long, and I put his head between the frame of my bike and the rear cylinder. As the photos were being taken, he decided to keep going. He wound himself around the engine and transmission. We had a hell of a time getting him out of there. We had to be careful because it was so tight. It took Steve and I about thirty minutes to very gently work him out.

I have a beautiful five-foot-long stuffed rattler. It's stuffed in a coiled-up striking position, so it sits about two-and-a-half feet high. Steve gave it to me as a gift for my fortieth birthday. He bought it in Texas and didn't want to put it in the luggage compartment when he flew home. He planned to hold it all the way home, but the seat next to him was vacant. He put the stuffed rattler into the seat and belted it in. When the stewardess saw it, she told Steve, "OK I can handle this, but I am not serving it coffee."

I finally did get Meg to handle a couple of rattlers. She was skittish about Widow Maker, so I had Steve bring some of his over for her. Steve sat in our living room with one of his big guys on his lap and just talked to Meg about it. She started asking questions about how the scales felt and such and eventually got enough nerve up to touch it. In no time she was holding it; she even got comfortable enough to take part in a demonstration that we had one Easter.

We had about twenty people over for dinner, and Steve came over with a few of his favorite rattlers. He sat on our front deck and gave everybody a lesson. Then he brought the rattlers out and demonstrated holding them. I sat and took a turn for a while, and then Steve asked Meg if she wanted to hold one. When she said yes, both her mom and mine objected. When the rattler was put in her hands, they went into the house. They said they couldn't watch; it was too nerve-wracking. She did fine until I joked that she had been preparing the lamb for dinner and the rattler might just think it smelled better than his usual fare of rabbit.

Steve's real occupation was doing tree work. He, his dad Les, and his uncle Ray all worked together. I did a lot of the tree work at my house, but some of the really technical work I left to Steve and his dad and uncle.

One of the jobs I should have let them handle was a big redwood, about 140 feet tall, that was in my backyard. Jud was helping me, and Frank and Meg were watching. We had it all figured out; we would tie a rope around the tree and to the hooks on the front of Jud's three-quarter-ton pickup. I would make the cut and Jud would back his truck up to direct the fall of the tree into a nice, clear spot.

My brother Dave was working in Alaska at the time and his pickup truck was parked up in back, but I had moved it to a spot where it would be out of the way and I started cutting. When Jud put his truck in place, he drove over a low stump; after we hooked his truck to the tree and he started pulling on it, the truck was lowered just enough that it couldn't clear the stump. Since he got stuck on the stump, the tree didn't come down where I planned; it landed right across the bed of my brother's pickup instead. Oops!

Frank thought it was hysterical, so I suggested he take the chainsaw and get over to the truck to pose for a picture. His response was, "Hey Phil, I wasn't born yesterday." So since I couldn't put it off on someone else, I notified my brother by sending him a postcard. I didn't say a word about what happened

My brother's truck after I dropped a redwood on it.

in the card, but I used a photo of the tree-crushed truck as the postcard itself. Dave never mentioned a word, and his truck was fixed by the time he came home. The original don't ask, don't tell policy.

I always liked to go on fast rides, and I figured out a way I could go on one in a redwood tree on my property. During high winds, redwood trees will sway from side to side, and they will have a really wide arc. One night during a full moon, a big windstorm came in and I climbed up a large redwood that was at entrance of my property, just as the storm was in full swing. The tree stood off by itself, so I figured it was my best bet for both safety and a great view. The tree was a good 160 feet tall, and I put on my spikes and climbing belt and went up to about 140 feet. At this point, the tree was just about six inches around.

The tree was swaying hard, and it was going about twenty feet each direction. When the clouds weren't passing in front of the moon, the visibility was good. The rain wasn't too heavy, so I stayed up there for about half an hour and watched the storm and enjoyed an unusual, wild ride.

Bill Thompson heard a rumor that there was a small group of rogue cops on the San Jose PD who'd had it with me and they had decided to take matters into their own hands. The rumor was that they were going to come and shoot me dead. I thought about this for a long time, wondering if it could be true, and then I got another similar report. I knew that I needed to do something to head it off, so I decided to call down to the department and implicate the one cop I felt sure wouldn't be involved in something like that. His name was Scheffler, and I knew that if Scheffler got wind that he'd been implicated, he

With Jim and Molly Elrite at the *Hells Angels Forever* movie premiere.

would investigate, and he did. After some time went by, I got a phone call, and the voice on the other end said, "You had the wrong guy. It's over." Click.

Around this same time, I met Angelo Morino, who owned California Cheese Company in San Jose. I met him through some friends of my mom. Angelo wasn't quite old enough to be my parents' age, but he definitely could have been an uncle. We hit it off, and he invited me to his house for a barbecue. I developed a friendship with him and his wife that lasted until his death in 1983. Angelo had been convicted of murder in 1977, but the conviction was overturned by the time I met him. It was something we never talked about.

The California Cheese Company supplied most of the cheese in the San Jose area. Occasionally, the owner of a restaurant would piss Angelo off and he would ask me to take eight or ten guys to the restaurant and get rowdy. Nobody ever got hurt, but it might have had a negative impact on the nightly receipts. Lesson learned.

I had made some good friends when I was on the run in New York and really liked going back there to visit, so I was pretty good about making regular trips. In 1984, I made a special trip just because I wanted to get the color in one of my tattoos redone. I really liked the work of the guy who did it originally, so I wanted him to redo it.

I should have known to turn around and walk out of the tattoo parlor as soon as I walked in the door. I suppose the best way to say it is that the parlor was less than hygienic; in fact, it was downright dirty. Meg went with me on that trip thinking that she might get a little bit of ink. Not only did she not get a tat, but she wouldn't even use the bathroom. The work on my tattoo was great. I was really happy with it. It turned out, though, that I was diagnosed with hepatitis C about four years later, and I'm pretty sure I got it from that tattoo work. They didn't have individual pots of ink back then, and I really doubt they even cleaned the needles all that well. Today's tattoo standards are really good; I just wish they had been in place back then because it has played hell with my health ever since.

On October 5, 1983, the movie premiere for *Hells Angels Forever* was held in New York City, at Movieland Theater on Broadway and Fourth. I flew out for

Hells Angels Forever movie premiere ticket.

Hell's Angels Forever
Studio 54 Premiere Party
This ticket admits you and a gues[t]

After-party ticket to Studio 54.

the premiere, along with another San Jose member, Jim Elrite, and his wife. I didn't take Meg. Except for that one trip to New York, she didn't go on any of my trips. I doubt she liked it, but it's just the way I was. I did my own thing. The premiere was packed. The premiere party was held at Studio 54, and you can bet nobody wanted to miss that. That was another memorable New York trip.

During these years I went on the road with Willie Nelson quite often. My friend Larry Gorham had introduced me to Willie at the Watsonville fairgrounds years before. I got to be friends with the band, and the late Bee Spears in particular. Whenever I felt like I needed to get away, I'd call Larry and find out the band's itinerary. Then I'd meet up with them at a major city and then ride on one of the buses for about a week or so, and when they hit another major city, I'd fly home. Whenever possible I tried to arrange to go on the trips that ended up in New York. Then I would spend about a week there. Everybody in the band was friendly, and I even had a few of the members over to my house when they were in town. Mickey Rafael came over one time and brought Ali McGraw along with him. I met her one other time and she was a real classy lady.

I took a bunch of photos in those days, and I'd always give Willie a set. If I thought any of them were exceptionally good, I'd make blowups for him. I took a photo of the band, blew it up, and had it matted. Willie and the band members all signed the matting for me.

I was an avid jogger in those days and Willie was too. Whenever I was traveling with band, he and I would go jogging together. Everybody knows that Willie is a great musician. I'm lucky enough to personally know that he is also a great guy.

I was on a trip in Mexico with my friends John Hannegan and Chris Beason and about a dozen other peole when I got wind of an upcoming warrant for me back home. As if that wasn't bad enough, the Mexican police arrested me that same night.

One of the guys in our group came to my hotel room to ask me to come down to the bar because some guy was hassling one of the people in our group.

I was on this trip with a group of citizens (some of them upstanding community members). I didn't know some of these people very well, so I explained that I didn't fool around. I would go, but the way I handled things was not by negotiating. Sure enough, when we got to the bar the first thing I saw was this asshole just fucking with everybody. I walked over, and as soon as he saw me, he started mouthing off. I say "started" because he never finished the sentence; I hit him so hard he flew backward over a railing.

Now seemed like a good time for me to leave, and I was on my way out the door when one of the guys, Jim, came up and started talking to me. I told him, "I've really got to leave, Jim." He said, "Oh, sure, sure," and then he kept talking, so I started walking. Jim walked with me. At this point, I needed to be moving fast, but I really couldn't get it across to Jim that I was trying to avoid making any new friends, namely Mexican cops.

"*Alto!*" It's harder to outrun Mexican cops than you would think. You don't know the area and they have machine guns. After they caught me, they handcuffed me and put me in the back of a freaking Volkswagen.

My roommate on the trip was Bob Tobin. Bob is an attorney, so Jim went and got him. Bob speaks fluent Spanish, and when he got to the scene, I told him to do whatever was necessary to keep them from taking me to jail and running my name in a computer. The wheeling and dealing that Bob did was amazing; he talked to the cops, he talked to hotel management, he talked to the victim, and he talked to the victim's loud-mouthed girlfriend (who it turned out was the root of the whole problem). After everybody was calmed down (and suitably compensated), Bob told the cops, "See, everybody is happy, now you can let him go."

One of the cops told Bob, "Oh no, you have to talk to El Jefe first." El Jefe had been across the street watching Bob in action the whole time. He was so amused by Bob and impressed with his performance that he agreed to let me go after another donation was made at the police station. Bob made the donation, and when he came back, El Jefe gave the high sign and I was free to go. That trip was the start of a lot of great friendships, Bob, of course, being one of them. Another was my friend Rich; he's the guy who threw me a fiftieth birthday party nine years later.

While I was dealing with all of this shit in Mexico, my brother was dealing with the cops raiding my house. They treated Dave badly, and my house worse. My brother saw one cop actually close an open door just so that he could kick it in.

It seemed like a good time to leave Mexico, but I knew I couldn't fly home because I had called and found out that a warrant had been issued, so I left my luggage behind, grabbed a flight to Tijuana, and walked across the border. Next I took a small plane from San Diego to Sacramento and a friend picked me up and took me back to a motel. But as it turned out, I wouldn't be there for long.

Meg met me at the motel that night. We were watching TV and talking about the situation when the phone rang. The voice on the phone confirmed that I wasn't just wanted; they wanted me on charges that could lead to twenty years in prison. After the call ended, I hung up and told Meg we had to go. Now! That late-night call put me on the run again.

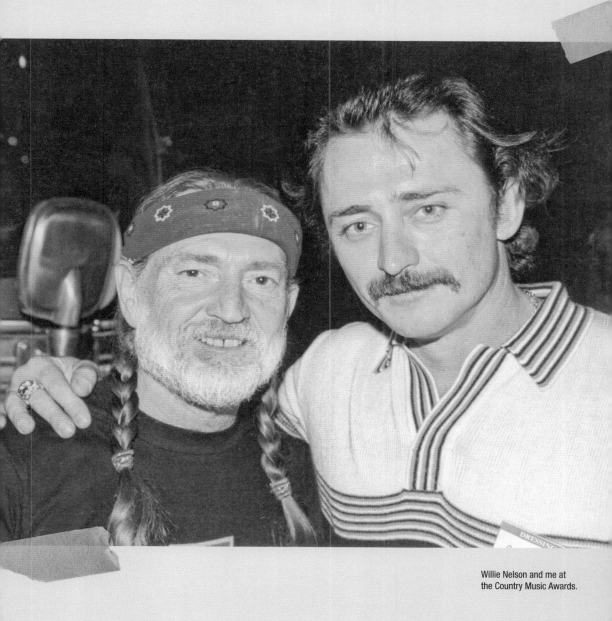

Willie Nelson and me at
the Country Music Awards.

ON THE RUN, AGAIN

I **THREW SOME CLOTHES IN A BAG**, Meg grabbed hers, and we were out the door in less than ten minutes. We took her car in case the cops were already looking for mine. I stopped at a pay phone so I could call my friend Vito. I needed a safe place to stay for the night, and I knew Vito would be just the guy. We met up with him at a restaurant in San Jose ("Meg, Vito, Vito, Meg"). Even when you're running, you still have to eat, so we went inside and had a nice steak dinner, some wine, and made plans.

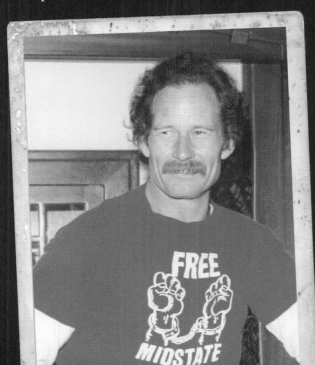

Jud was at a party at my house shortly before I went on the run.

San Jose Mercury News ■ Sunday, September 14, 1986 5B

Crime Stoppers/947-STOP

In cooperation with the San Jose Police Department and a citizen board of directors, the Mercury News is participating in Crime Stoppers, a program that features a crime of the week, offering rewards of as much as $1,000 for information leading to an arrest and prosecution. Citizens can call 947-STOP on any serious crime.

Crime Stoppers is assisting in locating these wanted persons:

Suspect No. 1: Dennis Carnahan is a wanted on a $100,000 warrant for six counts of child molestation and forcible rape. Carnahan is 6 feet 3 inches tall and weighs 300 pounds. He has brown hair and hazel eyes. He is a San Jose resident but has been seen recently in the Union City area employed as a sand and gravel truck driver.

Suspect No. 2: Luis Ponce Torres, 37, is wanted for attempted murder. When last seen, he had a mustache and beard.

 Carnahan
 Torres
 Cross

Suspect No. 3: Filmore Cross, 44, of Los Gatos. Police report he is an active member of the Hells Angels and is wanted by the Scotts Valley police. There's a million-dollar warrant out for his arrest on various charges. He is 6 feet tall and has brown hair and brown eyes. Police think he is in the Santa Cruz Mountains.

At the restaurant I made some more phone calls, three to be exact. First, I called my friend Rich. I needed a place to stay for at least a week, and it couldn't be with a known associate. Rich was someone who the cops didn't really think I associated with all that often. Rich came through like a champ. Next I called my old buddy Jud. I arranged to meet him the following day so he could take me back to Santa Cruz and drop me at Rich's place. I also wanted Jud to arrange for a clean car so he could drive me out of state when the time came. The third call was to some friends out of state. I had managed to get a fake driver's license from their state years before, for just such an occasion. It was the sort of thing a man doesn't need until he needs it, and I renewed it faithfully. I didn't want to risk losing it in a raid, so my out-of-state friends held on to it for me. It felt good to know that I had it, and that my preplanning was well founded.

I stayed with Rich for about a little over a week while I made arrangements to be gone for an extended amount of time. I also had to get enough cash together to last me for a while, and I had to wait for my ID to arrive.

When all the prep work was done, it was time for Jud to drive me to Texas where I would get a plane to New York. The one thing about Jud's driving is that he has a lead foot; this is not a great thing when you are on the run, and so I had to keep telling him to slow down.

Just outside Carlsbad, New Mexico, we were going up a hill, and Jud was speeding of course. When we crested the hill, Jud was going about eighty miles per hour and he almost hit a highway patrol car that had been stopped and was pulling back onto the highway.

I think you can imagine how unhappy this cop was with Jud. He pulled us over and took Jud's license but didn't run it. He also told Jud that he wanted to look in the trunk. Jud opened the trunk, but luckily the cop didn't thoroughly search it because Jud had two guns buried in there. He was probably looking for drugs. He gave Jud a ticket but never ran his license. After being told to slow down, we were free to go.

My warrant was $1,000,000, and the guy wanted on suspicion of molesting six children and forcible rape had a warrant for one-tenth the amount. Does that seem like justice?

After that incident, I decided that Jud should be the passenger. I figured it was less of a risk for me to drive than having old lead foot at the wheel. Two hours after Jud got that ticket, we ran up on a roadblock, a serious roadblock that covered both sides of the road. Oh great. Now we had that to deal with. They were looking for a fugitive all right, just a different one, not the one who drove right into their hands. The cop who walked up to my window leaned down and looked at me, and then he looked at Jud. I expected him to ask for my license right off the bat, but he didn't. He told us that would have to search our car; they were searching all vehicles before letting them pass. Jud leaned over and said, "Officer, our car was already searched. I got a ticket a ways back and the officer did a search." With that, Jud handed him the ticket. The cop looked at it and said that we were free to go on. Good thing neither of us fit the description of their fugitive.

Looking back on it, it's probably a good thing that Jud got that speeding ticket after all.

I stayed in New York through most of that entire winter. Let me make one thing really clear: I do not like the cold and I do not like snow, so I was not thrilled right about then. I had to make the best of things, though, and I had a pretty sweet deal going. I was staying in Greenwich Village with George, a friend of a friend, in his fifth floor walk-up. He needed help with the rent and traveled a lot, so it worked out fine. Most of the time I didn't mind the walk-up part, unless I was tired or drunk. My dad came for a short visit while I was there, and I thought he was going to croak every time he went up those steps.

I had a pretty active social life there, but I wasn't out every night. There were times when I didn't feel like going out so I'd just stay at home, light a fire, and watch TV. I had to light the fire because that apartment was freezing. I always sat really close to the fire because the place was so cold. It was freezing outside and the heat barely worked. The windows in the bedroom were arched and one of them was broken. The landlord wouldn't fix it because it cost a lot of money, and George and I weren't about to foot the bill. So the window stayed broken and the snow came right on in.

I met George Jr. on one of those nights. It was really cold and he popped out of a crack between the fireplace and the brick wall and sat on the hearth by the fire to stay warm. He was a small mouse, and he wasn't bothering me so I didn't bother him. I saw him a lot that winter. Whenever I lit the fire, he would come out. I always had some peanuts on hand for him, and eventually it got so that he sat between my feet, in front of the fire, and I would drop the peanuts down to him. Better to hang with a mouse than a rat.

Meg and I would arrange to meet every couple of weeks. She would fly under an assumed name because you could do that easily before 9/11. Sometimes she would come to New York, and sometimes she would fly some other place and I would meet her there. She had a sister who lived on Long Island, so it wasn't that odd for her to come to New York.

We talked roughly once a week by pay phone using a system I had put in place before I left. Before I left, I got the numbers of a bunch of different phone booths all over the south bay (this was in the days when there were still phone booths everywhere). I gave the number of the first phone booth to her, along with a date and time that I would call it. At the end of our talk, I would give her the location and number of a different booth, and we would set the date

and time for the next call. We changed the call days and times; set patterns can get you in trouble. If I ran low on money, she would bring me some.

After I had been on the run for a year, Meg flew out to join me for good. The separation, plus the stress of trying to meet for visits was wearing thin, and I thought it was probable that the cops would watch her more closely as time went on. I knew she was always careful about looking for tails when we met for visits, but those were always at different locations. She was coming permanently and those kinds of preparations (like giving up your apartment and quitting your job) can send up red flags, so I had to make sure she was extra careful . . . no mistakes.

I had her make arrangements to meet up with her best friend Susie at a big shopping mall. They parked their cars at opposite ends of the mall, but arranged in advance to meet in the fitting room of a specific store three hours before her flight. Meg wandered around, trying things on, making it look like a regular shopping trip. When it was time to meet Susie, she went into the fitting room, changed her clothes and her hairstyle, and the two girls swapped car keys. Meg drove the borrowed car to the airport and flew out to meet me, again under an assumed name.

She flew into JFK and got a cab into the city. No meeting at the gate for us; too risky. We met at the Plaza Hotel. She arrived at the Plaza at about 8 p.m., went to the front desk, and asked if she could leave her luggage for a bit because she was waiting for her husband and he would check them in when he got there. "Happy to oblige, Mrs. Weston." Then she went to the Oak Room for a drink and to meet me.

When Meg got to the apartment, the first thing she did was tape layers of newspaper over that broken window and then put a spare mattress in front of it. She doesn't like being cold either. It helped a lot. Why didn't George and I think of that? The next day she started cleaning and organizing. Did I mention that George was a slob? No way I was attempting to clean that place up, but she wouldn't (or couldn't) stay there, even temporarily, without fixing it up.

A night on the town before we left New York seemed like a good idea, but it didn't go quite like we expected. Meg and I were going to see Liza Minnelli in a Broadway play. Charming Chuck, a New York Hells Angel and an old friend, knew Liza and had arranged for us to meet her backstage. We got dressed up, went to an early dinner, and decided to walk to the theater.

On the way, we passed a guy who was coming out of a bar. Right after we walked by him, he hit Meg in the back of the head, real hard. When I turned around and saw that guy standing there, with a satisfied smirk on his face, I lost it. I grabbed him by the front of his shirt with one hand and pulled him up to his toes. Already knowing the answer, I asked him why he did it. The guy mumbled, "Duh, uh, well um." Wrong answer. I smacked him right in the ear. I hope he liked cauliflower, because he was getting it. I asked again. This time the dude claimed it was an accident. "Bullshit." As I once heard Bill Cosby say on stage when talking about child rearing, "Let the beatings commence." I pounded the guy; I beat him to the ground, and still holding him by the shirt, I started dragging him around. First I went left, and then I went right. I know Meg was thinking, "What the hell is he doing?" I was looking for an alley. Beating someone in public when you are a fugitive is not exactly wise. Every street in New York City has an alley, right? You see them on TV all the time,

The yard was trashed when we moved in. I spent countless hours in the hot Florida sun bringing it back to life. There wasn't much else to do.

but not this street. As I was looking, I would throw a few more punches every so often, just to let this jerk know it wasn't over.

As I was involved in the hunt and punch, a couple walked up to Meg. The dude told her they had seen the whole thing and asked if she was all right. Then he said, "I hope your husband beats the dog shit out of that guy." Meg said, "Oh, he will." They started to walk off and a gay guy came up and said, "Oh, I wish he'd stop. I think he's had enough." The man turned back to the scene and said, "He should have thought about that before he decided to hit someone, the wrong someone."

I actually did finish right about then. I couldn't find the alley, so a couple of kicks would have to suffice. Time to go to the theater; don't want to miss curtain call. We saw the play; we got to meet Liza, who was a terrific lady; and we spent some time with an old friend. Except for our little altercation and Meg's headache, it was a nice evening.

We stayed on in New York for another six weeks while preparations for our final destination were underway. I had made the contacts I needed to establish a life for us, but a house had to be rented and furnished, and a car arranged for before we moved on to Florida.

Meg called home every couple of weeks to let friends and family know that we were OK and find out what the rumor mill was saying. Before she came out to join me, I had her give the number of one of the phone booths to Susie, along with a date and time that she would call it. They used the same system

for their calls that Meg and I used for ours, and again there was no regular schedule. Those calls were a good for Meg too because they helped her to feel less cut off from the life she had known before she met me.

I have to give Susie (who had nothing whatsoever to do with the motorcycle world, or any type of outlaw stuff) a lot of credit for what she did. She helped Meg to help me, and she had never even met me. Even though she had been getting word from the cops that I was evil and that Meg was only with me under duress, she never wavered. She was smart and cautious, though, and she wanted to be sure she was doing the right thing, so during one of their talks she gave Meg a code word that she could say during any of her phone calls to signal if she needed help. But most of all, Susie trusted in Meg's belief in me. Thanks, Susie!

While we were living on the run in Florida, we really had a pretty nice lifestyle. We lived in a nice little house two doors down from the Intracoastal Waterway, which everyone there pronounced: "Inner Coastal." We drove a Mercedes; granted it was an old Mercedes, the green paint faded from the sun and the wood dash in sorry shape, but it ran. It was registered to a friend of mine from another state. We hung out with some of Palm Beach's old money families (of course they had no idea who they were hanging with). We made friends with people who hung out in the same crowd as the Pulitzers through a mutual acquaintance, Barry, who was our next-door neighbor and an art dealer who had sold pieces to all of them. They were all nice enough people, and we had a lot of fun with them. It turned out that I wasn't the only one who wasn't quite what he seemed to be, though; Barry was a big scam artist and he ripped off a whole bunch of people.

We did all the regular things a couple does while we lived in Florida. We went to the movies, out to dinner, and took care of our yard (we had a really nice big yard). We even restored the paint and interior wood on the Mercedes. When we went to the county fair, we decided that we needed a pet (other than the palmetto bugs). We found the perfect one when we went into the 4H rabbit exhibit and saw the craziest-looking rabbit either of us had ever laid eyes on. He was an English Angora with long lop ears that rotated like antenna. We named him Spot (from the Cal Worthington commercials). He was paper trained and lived in the house but went out into the back yard every day to play with the two cats that came to visit. I think they thought he was another cat because he was bigger than either of them. That rabbit was huge.

"Palmetto bug" is the fancy name that the Floridians give to cockroaches. These aren't regular little black cockroaches; these are gigantic brown cock-roaches and everybody had them. These suckers got up to four inches long, and it didn't matter if you made $500 or $500,000 a month, you had them. You had them unless you had your house and yard regularly sprayed. Meg wanted to get the service immediately. Well, I didn't want all those chemicals in our house and yard, so I didn't want to get our place sprayed at all. That turned out to be a bad decision. You see, when the neighbors on either side of you and behind you spray, those bugs got nowhere else to go. Oh, and they fly if they get startled, like when you go to swat them. After Meg found that out, she started walking around the house with a spray bottle of bug poison attached to her hip like a gun belt at all times. Any time she saw one, she'd whip out that bug-killing weapon of hers and start shooting. She panicked one day when one

flew right up at her and started spraying it in mid-air. I don't think she hit it, but I know she got me right in the face. I finally realized that she was probably dumping more chemicals in our house than a professional would, so I finally relented and got the bug service. I think she just sprayed that shit in my face to get her way.

My mom came for a visit, and she was really freaked out by the palmetto bugs too. She sided with Meg on the spray service and that may have been a mitigating factor in my change of mind too. My mom really liked Florida and we did a lot of sightseeing. I think the thing she got the biggest kick out of was looking for alligators along the highways. It was hard saying goodbye to her when it was time for her to leave.

We took up bike riding while living there. Mostly we rode to bars or restaurants when we were together. But I was more into it than Meg, so I would actually ride just for fun, with no particular destination. One day I got caught pretty far from home (about twenty-five miles) when it started to rain. I didn't think it was a really big deal because it wasn't raining too hard and it was warm, so I'd just ride it out. What I didn't take into account was how damn fast those storms come in. With every turn of the wheels, it seemed that the thunder was getting louder; then the lightening started. It was a ways off so I was pretty sure I could beat it home. I got just to the end of where our street met up with the Intracoastal. I was about thirty feet from a power pole when a bolt of lightening struck the top of the pole and took out the lines. They came down to the street and were dancing all over the place. I had no choice but to ride around them; it was a tense couple of minutes. I really needed a drink when I got home.

BELOW RIGHT: My mom was the same age that I am now when she came to visit us.

Right from the start, my mom looked on Meg as a daughter.

Just when we started to go a little stir crazy, some friends from home started to come and visit us. It's amazing that those visits didn't get us caught. I guess we enjoyed those visits so much because we could be ourselves, really let our hair down, and do some crazy stuff. We sure had fun, though.

Our first visit was from my friend Vito, who Meg had only met that one time when I first went on the run. He came to visit for about a week. Now Vito was not an innocuous-looking character. Actually, he looked like what some Hollywood casting director would want for a mafioso type: big, Italian, slicked-back dark hair, mustache, and very, very imposing. So the first night Vito was out, we decided to go into Palm Beach for dinner on Worth Avenue after having a couple of cocktails at home. When we got to the restaurant, we had to drive around the block a couple of times before we found a place to park our beater Mercedes, but we finally got a spot down the street. It was no big deal to walk a short way; after all it was a warm night and we were having a great time laughing and talking. We had a good meal, a lot of wine, dessert, and after-dinner drinks all around. We sat and talked until we realized that the place was closing. After paying the bill we walked out front, looked down the street, and saw there were only two cars left out there, a nice new Mercedes (definitely not ours) and a giant stretch limo way the hell down the road where it started to turn a corner. In disbelief Meg said, "Someone would steal our car?" (Really we were all thinking who would want a piece of shit like that, compared to all those expensive cars on the avenue?) At this point, we stepped back inside and asked our waiter to call for a cab. We were pretty buzzed so we actually found the situation kind of funny. We decided to check out the limo while we were waiting for the cab and headed down the street. As we walked up to it, parked right there in front of it is our olive-green Mercedes (yep, right where we left it). So we hot-footed it back to the restaurant to tell the waiter to cancel the cab when he informed us that he had also called the cops to report that our car was stolen. (Did I mention the excellent service at this restaurant?) I left before he completely finished the sentence! Here's a piece of advice: if you are in trouble, make sure the waiter is out of earshot before you say anything. Now Meg and Vito had to go outside to meet cops, and they had no time to come up with a story. At least the part about not seeing it because it was parked in front of the limo was true (after all it was still there).

Vito didn't look quite as intimidating when he was relaxing and having some fun.

After it was all over, Vito told me that Meg just took control of the situation. She walked over to the younger cop, smiled, and asked if she could speak to him. She told the cop, "I have a small problem. That car belongs to my boyfriend." Then she pointed to Vito, smiled at the cop again, and said, "That's not him, and I really don't want my boyfriend to find out about this. It could make

things . . . difficult for me." The cop nodded, said no problem, he understood, and then offered to drive them down the street to their car. How could they refuse? After they had been chauffeured to their car, wished a good night, and told to drive carefully, the Palm Beach police drove off. Actually, I think it shows that they were pretty good guys.

Vito told Meg to head home, that I would be OK and get there myself (and he was right), but she wanted to drive around a bit to see if she could find me. Vito convinced her that that wasn't a good idea and to just go to the next street to see if I was there. They were parked there for no more than five minutes when from the other direction, along comes that same damn cop car. Vito said he was stunned when Meg threw her arms around him and said, "Kiss me quick." After we got back to California, he gave her a gold eagle necklace because he said she really "earned her wings." So the lesson in all of this is remember where you park your fucking car.

On occasion Vito would have a little problem with speed. Basically, he would just use too fucking much of it. Then he would say and do strange things. I really had to keep a tight eye on him when he was like that. Sometimes it would just be for the night, but sometimes he would really go off for a while. Well guess what, he had one of those episodes while he was visiting. It started one night while we were having dinner at a little Italian joint that Meg and I liked. He started to act strange, getting grumpy and defensive. When we got home, it got worse and I could see that there was no way out. I told Meg to get a book or something and go to the bedroom, lock the door, and stay there. You just never knew with Vito when he was like that. He might get violent or imagine some kind of threat, and I wanted her safely out of the way. I never really did figure out what set him off, but he was definitely set for an all-nighter. So that's what I did: I talked to him and argued with him and talked to him some more, all night, until he cycled back toward normal and he was ready to sleep. He slept most of that day (I grabbed a few hours too, with Meg keeping watch, still locked in the bedroom). He was fine at dinner, like nothing had happened. His flight was the next day. Bye, Vito. Come again soon! Eventually that shit (mixed with whatever else he may have been doing) did get the better of him. Years later he was found dead of a self-inflicted gun-shot wound. Of course, some people think that he could have made someone mad enough or scared someone enough to murder him and set it up to look like suicide.

The next visitors to come and break our monotony were our friends Frank and Bridget. Meg and I had wanted to go to Key West for a while, and so the four of us decided that this was the perfect time to go there. Frank and Bridget didn't even have to unpack; we packed up our bags, loaded up the old green bomb, and headed as far south as we could go.

Meg was doing the driving, so Frank, Bridget, and I decided to have a few beers for the ride. As we were driving down, I thought Meg was screwing around or something because the car jerked when she hit the brakes and then again when she accelerated. But it turned out there really was something wrong with the car. We were in the middle of nowhere, so we pulled over and Frank and I looked under the hood but couldn't see what it was, so we just decided to keep going (actually we were pretty buzzed by then too, so we didn't much care).

Frank, in great shape back then, and in great shape now.

We were north of Homestead on a deserted stretch of Highway 1 when Frank asked Meg to pull over. He said that he needed to get into his suitcase for a snort. She pulled to the shoulder and gave Frank the trunk keys. He was back there for a while, pulling his suitcase up to the top and then getting it open. I decided to sneak around the back of the car and jump him. Let the games begin! There we were, rassling around on the edge of the highway with the trunk open and Frank's open bag of stash sitting right out in the open. To top it off the trunk light was on. We were damn lucky that a cop didn't come by. Can you imagine, a couple of cops driving down the highway see two dudes fighting and the trunk open. That's going to be a get-out-of-the-cruiser-with-weapons-drawn for sure. Then, once they see the drugs, we're all busted and we've got nowhere to go. The spot that we picked to stop is bordered by the Everglades. No way I'm going in there on foot. Besides the gators, there are rattlesnakes, dusky pigmy rattlesnakes, cottonmouths, and coral snakes, and all of them can kill you. There was no escape in that piece-of-shit chugging car either. Well, we got lucky and we had fun

By the time we hit Marathon, we had run out of beer so we decided to stop at a gas station to resupply (might as well get gas too right?). Frank and I went into the store to get the beer and prepay for the gas, while the girls waited in the car at the pump. As we were in the store, getting our beer, wine, chips, and whatever else we bought for the road, Frank told me a joke (I don't remember it), so we were busy laughing our asses off and didn't notice that a sheriff had pulled up. We opened the door to walk out and there he was, parked right smack in front. The look on that sheriff's face was not friendly. When we got to the car, Meg wanted to just split, forget about the gas, but I told her that that would be too suspicious. I mean nobody pays for gas then leaves without pumping it. So I got in the car and Frank pumped the gas. He even cleaned the windshield, real nonchalant like. Time to go! Meg started up the car, hit the gas, . . . and that piece of shit car started to jerk and shudder like it was having a seizure and was going to die right there. It didn't, though, and Meg just drove off like there was nothing wrong. I must have been break time or something because that sheriff just ignored us. Damn good thing we didn't buy all the doughnuts!

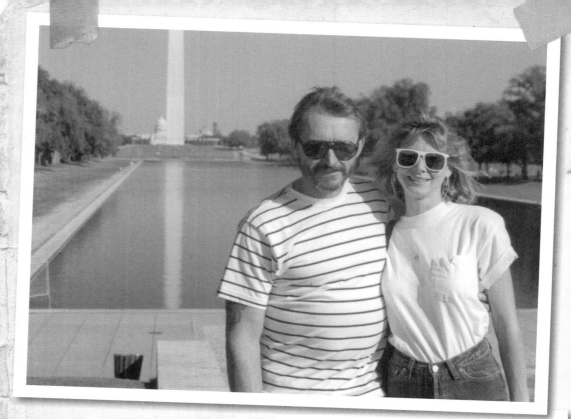

ABOVE: Meg and me at the reflecting pool in front of the Washington Monument, and we had a lot to reflect on.

RIGHT: Even as a fugitive, I still kept lifting.

BELOW: You can't see it, but we are at Mount Vernon, George Washington's home. I wouldn't lie.

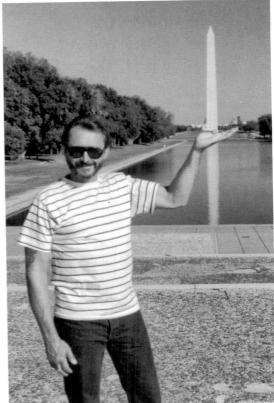

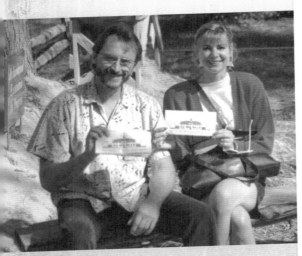

We had a lot of fun in Key West. We hung out by the pool and swam, ate good food, and drank a lot of rum drinks during the day. At night we went out for dinner and then to some bars. I remember this one restaurant the girls picked. They had passed by this small hotel that the restaurant was attached to, glanced at the menu, and thought it looked good and that the place looked nice. Frank and I wanted to go because it had a great wine list. We ate on a balcony upstairs that only had about five tables, and it overlooked the hotel pool. It was really picturesque with this big old bougainvillea hanging down over the railing and into the pool. There was only one other couple on the balcony with us, so the service was good too. As we were eating, people would come out of their rooms for a swim. After a while, Frank commented how weird it was that there were only dudes swimming in the pool. While we were waiting for the bill, Frank went to the bathroom. When he came out, he was shaking his head and laughing. When he got to the table, he said, "No fucking wonder. It's a gay joint." The men's room had photos of nude men on the walls. Then the bill came and we saw that the name of the place was something like La De Da. Even though the food was very good, we didn't stay for dessert; neither did the other couple.

South Florida is not the place to be in the summer if you aren't used to the heat, so I decided we needed a getaway. Why not go to Washington D.C. when you're on the Ten Most Wanted list? We could have spent the entire vacation right in the Smithsonian, but we managed to see a few other things too. We went to Virginia and saw Mount Vernon and Annapolis (after all, I was in the navy). The only thing we knew we couldn't do was tour the White House; that just would not have been wise. It was good to get away; even though we were living a good life on the run, it was still a pretty closed-off existence.

Carlos (the registered owner of the Mercedes) came to visit after the summer heat died down and Palm Beach's preseason to "the season" was starting. At that time, I had known Carlos for about fourteen years. Carlos is Brazilian, tall, dark, about ten years older than me, and a close friend. He's a great guy and an interesting person. He is well educated and speaks five languages fluently. Carlos is also incredibly well connected; he knows an amazing number of important, rich, or famous (or all three combined) people all over the world, and everyone who meets him likes him. He was a very close friend of the famous painter Willem (Bill) de Kooning and his family (who I got to know through Carlos). Bill and I shared a common love of movies, and we watched a lot of them on his TV. Elaine de Kooning was a talented artist in her own right and rather elegant lady whose company I enjoyed too. Carlos also introduced me to Joan Mitchell, a famous American abstract artist living outside Paris. I was lucky enough to visit her at her beautiful home a couple of times. She and I both liked German shepherds, and both of us had rather raspy ones at that time.

When Carlos came to visit, it was a good time. He knew just about every jet setter in Palm Beach, so we got to go to a lot of parties. We just had to be careful that it wasn't anything too public; a photo in the wrong place could be the end of everything. Knowing Carlos also didn't hurt our cover story of a married couple who just decided to cash it all in and get away from the rat race to lead the good life (although one much simpler than theirs).

Carlos was always impeccably dressed and ready for any occasion.

We thought it would be fun to go canoeing on the Loxahatchee River, so we packed a lunch, hopped in the car, and drove about twenty miles down to road, just a ways past Jupiter. We didn't want a guide or anything formal like that, so we chose the self-guided tour. We rented a canoe that would hold all of us and put Meg in the middle, me in the front, and Carlos in the back. We had been paddling around for about two hours, seeing some interesting wildlife, having a pleasant time when we came up on a bend in the river that led into a small inlet, maybe thirty-five-feet long. I started paddling into in with Carlos keeping pace with me. We were no more than five feet in when I spotted an alligator basking in the sun on the bank. This old gator was huge; I mean he was longer than our boat. He looked every bit of thirteen feet long to me, but what was even more amazing was that he looked to be about six feet across. I wanted to get a little bit closer for a better look, so I was paddling forward; Carlos wanted nothing to do with that old boy, so he was paddling backward. I didn't know it at the time, but Meg was on his side (she leaned back and very quietly told Carlos to paddle harder). So, of course, we're sitting there going nowhere, but probably making a hell of a racket to the gator. Meg started getting pissed at me (I thought she was overreacting) and nagging that she wanted to leave. I turned to her and said (in what they call a stage whisper), so that Carlos could hear and only because he was such a good friend, "There's nothing to worry about. If that gator comes toward us, all we have to do is throw him the nigger. I bet they really like dark meat." Carlos said, "Oh Coño, no," started laughing, and paddled even harder. I finally gave it up, and we back paddled our way out of there. When we got back to the boat rental place, we mentioned our experience to the guy who took our equipment. He said, "Oh, that just Big George. He's harmless."

Unfortunately, that didn't turn out to be true. That alligator was a killer, a known killer. It had killed a German shepherd four years earlier, and sadly it killed a little boy about seven years later. Fish and game hunted it down and killed it. Even though gator skin is pretty valuable, I'm pretty sure they wouldn't even think of making something out of that.

Not long after Carlos left, we did have a problem with a photo that came out. It was when I made the FBI's Ten Most Wanted list. It wasn't bad enough that the photo would be going up in local post offices, but it also made it into *Parade Magazine*, which was a supplement in just about every Sunday newspaper in the country. When Meg told me about that, I honestly had no idea what *Parade* was. But she showed me. She had been to every house on our block, opened their papers, taken out their copy of *Parade*, and closed up and rebanded the paper! They never knew, and I didn't know until after she was done. The next day she started going to all the post offices in the surrounding area and grabbing the wanted posters. They kept them on a ring binder so that you could flip through them. Most of the branches of the post office were small and had only one or two people manning them, so she just asked for something that they had to go to the back to get, and while they were gone she ripped me out, and that was that. One time I was even with her when she did it. She was getting pretty good at it by that point, and I think she wanted to show off a bit; plus she liked having me be the lookout.

After we had been on the run together for just under a year, Meg's grandmother and my father both got very sick. Meg was really close to her

Intelligence Report

Because of volume of mail received, Parade regrets it cannot answer queries.

"Most Wanted" List Still Going

Top, l-r: J. Edgar Hoover and Will Hutchinson, creators of the FBI's famous list, and two women who made the top 10—Angela Davis and Ruth Eisemann-Schier. Bottom, l-r, four from current list: Victor Gerena, Fillmore Cross Jr., Claude Dallas Jr. and Leo Koury.

O f all the programs crafted over the years to enhance the popularity and public-relations image of the Federal Bureau of Investigations, one of the most successful and enduring has been the FBI list of the "Ten Most Wanted Fugitives."

In the 36 years which have elapsed since March 14, 1950, when the bureau began mailing its list to post offices and the news media, 403 fugitives (including six women) have been advertised and 377 have been apprehended. Of that number, the FBI attributes 112 arrests to the cooperation of an alert citizenry.

The man who originated the Ten Most Wanted idea was the late Will Hutchinson, bureau chief of the late International News Service in Washington, D.C. One afternoon in the winter of 1949, Hutchinson phoned FBI headquarters and requested the names, descriptions and photos of the most dangerous criminals at large in the nation. The bureau supplied him with the information, and he wrote his article. It aroused so much interest and approval that, a few months later, J. Edgar Hoover adapted and implemented the basic idea, ordering that an FBI "flier" of wanted criminals be sent to news organizations and U.S. post offices on an updated basis.

Hoover was convinced that mug shots of criminals, along with details of their crimes—posted on the walls of federal buildings throughout the country—offered a near-perfect means of involving the public in the most perilous and publicized activity of the bureau. "Those notices," the late FBI director once told this reporter, "give almost everyone a rooting interest in the bureau and in some small way make them feel they belong to it."

As of August, the FBI was distributing its Ten Most Wanted flier to 33,993 U.S. post offices, 19,760 police departments and 3950 news media outlets, for a total circulation of 57,703.

BY LLOYD SHEARER © 1986

I didn't think this report seemed particularly special or intelligent when I read it back then.

SUNDAY, OCTOBER 19, 1986

San Jose Mercury News

PARADE

Wayne Thompson
Is One Of 33
Juvenile Criminals
On Death Row

Are They Too Young To Die?
By Tom Seligson

I may have been in trouble, but at least I wasn't one of the guys in the cover article.

grandmother, and I could see that it was killing her to not be there when the prognosis was not good. My dad's heart hadn't been good for a long time, and it looked like he was going to need a serious heart surgery that was risky due to his health. We decided it was time to wrap it up and started making arrangements to go home.

We decided to meet my attorney, Vic, in Boston. I had never been there and neither had Meg. We decided that Boston seemed like the right place to go to discuss one's freedom. If you've never been to Boston, you should go; it's a fun historic city. There is a lot to do, and they have great bars and great restaurants. We intentionally got there a few days before Vic so that we could see the sights. My favorite thing was the Freedom Trail. It's this yellow line that runs around the city from one historic point of interest to the next. We walked the whole thing while we were there. For us, it may have taken longer than it might for other people because we spent a lot of time at each spot talking to the guides and reading the literature they had.

INTERSTATE FLIGHT - EXTORTION; ASSAULT WITH A DANGEROUS WEAPON

Entered NCIC
I.O. 5012
7-24-86

WANTED BY FBI

FILLMORE RAYMOND CROSS, JR.

FBI No. 883 251 E

ALIASES: Fillmore Raymond Close, Fillmore Cross, Phillip Raymond Cross, Gary Greenfest, Phillip Louis Long, Walter Lee McMillen, Carl Westmore, "Fill," "Pierre," and others

NCIC: 15TT0808091408080912

15 M 1 T II 9 Ref: 1
M 1 U III 9

Photograph taken 1982

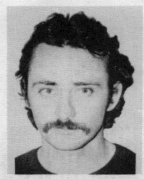

DESCRIPTION

DATE OF BIRTH: August 11, 1942
PLACE OF BIRTH: San Francisco, California
HEIGHT: 5' 11" to 6'
WEIGHT: 170 to 180 pounds
BUILD: muscular

HAIR: brown
EYES: hazel
COMPLEXION: fair
RACE: white
NATIONALITY: American

SCARS AND MARKS: Tattoos: Snake and Rose upper right arm; Snake and Panther upper left arm

OCCUPATIONS: bail bondsman, car salesman, collector, construction worker, import business owner, real estate investor, tree surgeon

REMARKS: Cross, a known member of the Hells Angels Motorcycle Club, often wears clean cut "biker"-type attire and Hells Angels identifying insignia and paraphernalia. He is an avid weightlifter with highly developed upper arms and forearms. Has worn beard and shoulder length hair in the past.

SOCIAL SECURITY NUMBER USED: ▪▪▪▪▪▪▪▪▪

CRIMINAL RECORD

Cross has been convicted of assault with a deadly weapon, battery and conspiracy to distribute and sell cocaine and amphetamines.

CAUTION

CROSS, TRAINED IN MARTIAL ARTS, IS KNOWN TO CARRY A HANDGUN, AND SHOULD BE CONSIDERED ARMED AND DANGEROUS DUE TO HIS ASSOCIATION WITH THE HELLS ANGELS MOTORCYCLE CLUB.

A Federal warrant was issued on March 6, 1986, at San Jose, California, charging Cross with Unlawful Interstate Flight to Avoid Prosecution for the crimes of Extortion and Assault with a Deadly Weapon (Title 18, U.S. Code, Section 1073).

IF YOU HAVE INFORMATION CONCERNING THIS PERSON, PLEASE CONTACT YOUR LOCAL FBI OFFICE. TELEPHONE NUMBERS AND ADDRESSES OF ALL FBI OFFICES LISTED ON BACK.

Identification Order 5012
July 24, 1986

William H. Webster
Director
Federal Bureau of Investigation
Washington, D.C. 20535

My wanted poster, from the wall of Federal Building in San Francisco. I only made it to number three.

We went to The Old North Church, where the "two if by sea" lanterns were held up in the steeple on Paul Revere's famous ride. Meg and I were the only people there, and the lady who was working was really friendly. She told us all about the church and its importance in Paul Revere's ride. The church has these huge chandeliers that line the aisle and Meg commented that it would be a beautiful place to get married (was that a hint?) and to see at night, and she asked if it was possible. The lady said that normally it was, but "the kaapet was getting rarshed" and so it would be closed. I didn't understand what she said (Bostonians have a very distinct accent) and asked her to repeat it. She told me again and I still didn't get it, so I said "One more time?" She repeated it for the third time.

I still must have looked totally confused because Meg spun around and said, "Oh for God's sake, they're washing the carpet." Meg lived on Long Island until she was ten so it's no wonder she got it on the first try.

Once we left the church, we were done for the day and headed back to our hotel. After we got back, we decided to go down to the bar for a drink. We were sitting at the bar, on our second round, when I noticed the guy sitting a couple of stools away. I kept thinking that he looked familiar, and then I realized that it was Pat Morita, the actor. I pointed him out to Meg, and she leaned toward him and said, "You know you're missing a good movie."

He said, "What?" and then she told him that *The Karate Kid* was playing on HBO right then. He laughed and said, "That's OK; I've already seen it." We talked for a little while, and then he left. He was a really nice guy.

Vic came out on our fourth day in Boston. We met him at a bar that he knew of and wanted us to see. Vic had already had a couple when we got there, but he was ready to talk business. We talked about the case, the timeline for my surrender, and everything that had to be put in play for it. We weren't planning on eating there (Meg and I wanted to try to find the bar that the TV show *Cheers* was based on), but we ordered some bar food because Vic was throwing drinks back like there was no tomorrow. He got so drunk and loud that everyone in the bar was looking at us. Finally a bouncer came over and told him to keep it down or leave. That was it; Vic started acting like Gonzo, the attorney in Hunter S. Thompson's *Fear and Loathing in Las Vegas*. Vic was just begging for trouble, and Meg and I couldn't afford to have the cops called while we were there. He started acting like he wanted to fight the bouncer, which would not have been good; he was a big kid, and sober. We tried to get Vic to leave with us so we could take him back to his hotel, but he wouldn't go. We had no choice; we had to leave, and leave him there. I told the hostess to call Vic a cab, gave her the name of his hotel and cab fare, and we left. Vic was on his own, but he made it out OK. Maybe when we left he came to his senses, or maybe he just passed out and they poured him into the cab. Vic and I had been friends for years and were really pretty close in the seventies.

When we got back to Florida, we put things in motion to go home. We found a great home for Spot. He actually wound up with a breeder in Brazil. This guy saw him and thought that Spot was so perfect that he was worth all the effort to get him to Brazil. I'm sure Spot liked his new life as a stud. We sold off or gave away our furniture and packed up some of the art and collectibles that we wanted to keep.

Meg flew home on December 20, 1986, a few days before me, and waited. I had made arrangements with Vic to turn myself in at FBI headquarters in San Francisco, which is exactly what I did three days later. On December 23, Vic (who had sobered up) and I walked into the building, up to the reception desk, and I said, "My name is Phil Cross, and I think that you're expecting me." I was waiting for them to slam the cuffs on and the long walk down the hall, but they didn't cuff me. I still had to take that walk though. As we were going down that first hallway, toward processing, we passed the posters of the Ten Most Wanted hanging on the wall. I jokingly said to one of the agents, "Hey, any chance of getting one of those?" He reached up, pulled it off the wall, and handed it to me, and said, "Why not? We won't be needing it anymore." I always thought that he was pretty decent for doing that. Either that, or he was being a wise ass.

Of course right after that happened, we got to the booking area and some other agent jumped up and said, "We got him! We got him!" The dude was acting like they actually caught me. What an asshole. I told him, "I only turned myself in now because my dad got sick. I was waiting to be number one." I actually was number three on the list at that time.

I was only at the FBI headquarters for about three hours. They did what they had to do and were finished. Nothing personal. The Santa Cruz cops that were there to transport me back so that my bail (which had been prearranged) could be posted were a whole different story. They had my hands cuffed behind my back for the entire ride to Santa Cruz. They were a far cry from the FBI. I think they took as long as they could while processing me, just to delay my getting home. A couple of cops asked me questions for a long time. They had to know I wasn't going to answer them. There was no way I would give them any information; this wasn't my first rodeo after all. So I answered all their questions with questions of my own. I was trying to figure out what they had on me. I was interrogating them while they were interrogating me. The guy in charge of the interview finally got pissed and said, "Get him out of here." I didn't even have to spend a night in jail.

It was finally time to go home.

BACK HOME, AGAIN

WE COULDN'T LET ANYONE KNOW that Meg was coming home, so there was no one to pick her up at the airport the night she got in. After her plane landed, she got a cab and went to her sister Holly's house. You can imagine the greeting she got from her sister, brother-in-law, and their combined brood of six kids. Merry Christmas! The next day she went home to wait for me.

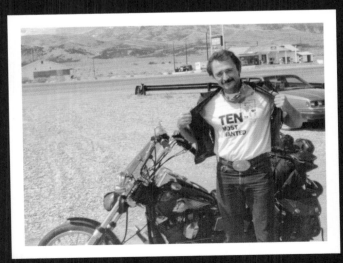

A friend gave me this shirt after I got back from being on the run. I thought it was great. I still have it.

Lee-Ann, Meg, and Steve at our pool bar.

I don't know if there have been any other Hells Angels on the Ten Most Wanted list, but if so it's been damn few. At the club New Year's Party, I had a lot of catching up to do and a lot stories to tell. Just like when I came back from prison, it was like I'd never been away.

After someone has been riding for more than a quarter of a century, you'd think that they would have come upon every type of road condition or unusual situation that could cause a wreck. Not true. I had a new one on one of our runs that year.

I decided to head home early and took off on my own. In those days, I didn't mind riding through the night, particularly when I was heading home. It was about two o'clock in the morning, and I was cruising along at about seventy-five miles per hour when I crested a hill. Just as I came over the rise, I ran into a pack of coyotes chewing on roadkill. There wasn't any time to react, so I just kept running straight on through. I sure as hell didn't want to brake and risk skidding on the blood and gore. I could feel the impact of hitting something, and I heard a bunch of yelps and cries from those coyotes. I had no intention of stopping to survey the damage. I was lucky to make it through and I still had a long ride home.

In 1987, I met Steve Price, a guy who would become a great friend. A mutual friend introduced us. Steve was one of the most go-getting guys I ever met. He was the epitome of an entrepreneur. The guy really had a knack for business.

Steve and I were both into weight training, and I suggested he come up to my place and check out my gym. He came up the next day and it turned into a regular thing.

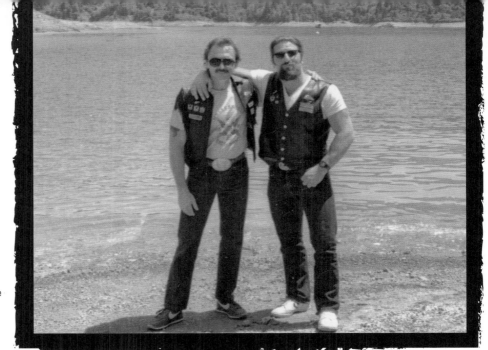

Frank and me at the Memorial Day run.

Even though Meg really liked Steve, she was resistant to meeting his fiancée, Lee-Ann. I'd met Lee-Ann and was sure the two women would hit it off, and Steve was too. He was getting the same resistance at home from Lee-Ann, though. It turned out that both women had previous bad experiences with this type of situation.

Steve and Lee-Ann knew a lot of the same people we did. Steve and Frank went to the same high school, a few years apart, and Lee-Ann and Frank's wife went to high school together too. Steve and Jim Elrite (another San Jose member) were really good friends, and Jim's wife Molly was one of Lee-Ann's best friends.

Meg finally decided that the four of us should get together for dinner, but she wanted it on her turf, so we invited Steve and Lee-Ann to our house. She also thought that we should have another couple there, so she asked Jud and his girlfriend Joey to come too.

When they came for dinner, Meg and Lee-Ann hit it off immediately. After a lot of white wine, the girls decided to go in the hot tub. Joey was a good person, but she wasn't always the sharpest tool in the shed. While they were talking in the hot tub, she spouted off with, "Hey, remember when Phil shot that girl in the head?" What a dumb ass thing to say. She was referring to the time when I was a Gypsy Joker and I was shooting at the Zig-Zag man in my house. That comment was exactly the stupid shit that Meg and Lee-Ann were trying to avoid. Luckily, Meg had heard the story before and explained it. Lee-Ann was a pretty savvy lady, and it didn't faze her at all. All four of us would go on to be great friends and have a lot of good times together.

The Christmas of 1987 was when Meg and I got engaged. Steve and Lee-Ann had been engaged for something like eight years, and I thought that sounded good. We'd already been together for four and a half years; Meg wasn't going for the long engagement thing. The wedding was set for June.

After I had been back home for a little over a year, I started having stomach problems. I went in for an exploratory surgery, and when they gave me the anesthesia, I became very jaundiced. As a result, the surgeon looked at my liver. It didn't look too healthy. That's how I found out that I had to have a liver biopsy.

They suspected that I had hepatitis C, or as they called it then Non-A, Non-B. The biopsy would give a definite answer. I had it on May 19, 1988. Since we got back home in the winter, I had to wait about five months to go on a run, and I wanted to be sure I was recovered in plenty of time to go on the Memorial Day run. I'd been stuck so many times over the years (sometimes even by doctors) that I wasn't worried about the procedure, but the doctor doing it was another matter. He was going to be using a really long needle and he had one bum arm. His aim was good, though, and he didn't puncture anything that he wasn't supposed to.

We were having a good time on the run when Meg called home to check messages. As she was listening to them, I heard her say, "Oh crap." I asked what was going on, and she told me that the doctor had left a message that he wanted to meet with us. We didn't think that sounded too good, but we didn't let it spoil our fun.

We met with the doctor on May 31 and he told us it was hepatitis, and that there was no cure. Meg asked him to be specific. He said, "You have three to five years" (he sounded like a judge giving a prison sentence). "If I were you, I'd get my affairs in order." We got that bit of happy news ten days before our wedding.

Our wedding.

We decided that three to five years was not an option and went right to our family doctor in Los Gatos. He was the first person to ever say "liver transplant" to me. He also set me up with Dr. John Lake, the medical director of the liver transplant program at the University of California, San Francisco. Dr. Lake wasn't a doomsday kind of guy, and we knew there was hope. He was my doctor until 1998, when he moved to Minneapolis. After that, we decided to move my care to Stanford Hospital.

Meg and I got married on June 11, 1988. We had the wedding at home, and about one hundred people came. We didn't worry about all the bullshit like posing for pictures. We wanted to have a good time. Frank was my best man, and just before it was time to tie the knot, he offered my one last chance to bow out. "If you don't want to do this, I'll get you out of here."

I said, "Thanks. I'm good." June 2013 will be our twenty-fifth anniversary.

My trial started on June 23 (eleven days after we got married). If you read the newspaper accounts of the trial, you got a good idea of what a crock the whole thing was. The victim had a bunch of lawsuits against him. Kyle, the prosecution's star witness, ratted on me to get out of a bunch of felonies in Hawaii, charges such as weapons and munitions importation with a bunch of other stuff. According to my attorney's research, he was facing seventy years if convicted. So the feds let a guy off who was facing seventy years in trade for one who was facing four years. The guy Kyle hired threw only one punch. I didn't make the FBI's Ten Most Wanted list for being accused of a crime that carried a maximum sentence of four years; I made it because they were afraid of what I might really do.

Since the trial got started so soon after the date we set for the wedding, we knew that a traditional honeymoon wasn't going to work for us and planned accordingly. Separate honeymoons.

SV-attack suspect surrenders to police

By MARK BERGSTROM
Sentinel Staff Writer

SANTA CRUZ — One of the FBI's 10 most wanted fugitives surrendered Tuesday in San Francisco to Scotts Valley Police, who had been hunting him since the beating of former reserve sheriff's deputy and real estate developer Jim Eberhardt in October, 1984.

Fillmore Raymond Cross Jr., 44, former president of the San Jose Hells Angels motorcycle gang, surrendered at the Federal Building and was brought back to Santa Cruz, where he was booked into County Jail and then arraigned in Municipal Court. Attorneys Tuesday afternoon were arranging a $500,000 property bond to secure Cross' release.

He had been sought on a $1 million warrant, charging him with extortion, assault with a deadly weapon and interstate flight to avoid prosecution.

According to his FBI "wanted" poster, Cross has prior convictions for asssault with a deadly weapon, battery and conspiracy to sell cocaine.

Scotts Valley Det. Donna Lind said Cross listed his current occupation as an unemployed tree trimmer. The FBI said his previous occupations included bailbondsman, car salesman and real estate investor.

Cross' surrender was negotiated by Assistant District Attorney Gary Fry, who said he had been talking with Cross' attorney for about six weeks.

Fry said Cross has refused to talk about the case, his whereabouts for the past two years or his reason for surrendering.

Fry said the motive behind the beating of Eberhardt is unclear. He said it involves money — about $100,000 — that was viewed by Eberhardt as an investment. But the money was seen as a loan by an unidentified man who allegedly hired Cross to collect that amount plus interest.

Cross, in turn, allegedly hired two thugs, Douglas Shelby and Howard Kiel, to beat Eberhardt to scare him into repaying the money.

Shelby and Kiel were arrested a

Please see back of section

At the end of this article, the assistant district attorney (ADA) stated that he was at a loss to explain why I was put on the FBI's Ten Most Wanted List when I was facing a max of four years. Maybe it was because I'm a Hells Angel.

Suspect

Continued from Page A1

month after the attack. They were convicted of battery capable of causing great bodily injury and each served a six-month jail sentence.

Police Lt. Tom Bush said Shelby and Kiel were arrested from "leads" developed by detectives. He would not elaborate, saying the information is important to the case against Cross.a

Eberhardt was struck in the head with a pipe and bound and gagged by Kiel and Shelby after one of them had made an appointment for Eberhardt to show him a house.

Police said they believed the attackers had intended to kidnap

Eberhardt but for some reason they were scared off.

After freeing himself from his bonds, Eberhardt drove to the Scotts Valley Police Department. When he arrived, he was still gagged and was bleeding from cuts and bruises on his face and head. He was treated and released at the hospital.

Fry said he was at a loss to say why Cross was on the FBI's 10 Most Wanted List.

Cross faces a maximum sentence, if convicted, of only four years, according to Fry.

An FBI spokeswoman said Cross was put on the list in August because he was considered a danger to the public.

Raymond Cross Jr.
Surrendered in San Francisco

Meg went to Hawaii for a week with a group of girlfriends about two months before the wedding. Four months after the wedding, Chris Benson, John Hannegan, Jock McCoy, and I went trekking in Tibet and Nepal for about a month. We ended the trip in Hong Kong, and Meg met up with us there.

We started the trip with a brief stop in Thailand. My friend Bill Bassett was on an extended business trip there, and he met up with us. We didn't have much time in Thailand, but we did get to go to a Thai boxing match. The guy I bet on lost. From Thailand, it was on to Nepal. As usual, I was the only one to have trouble with customs. We started out in Kathmandu. Our hotel, The Yak and Yeti, was first class, or at least as first class as Nepal could offer. The country was beautiful and the people friendly, but very poor. It made Mexico look rich by comparison. Shopping there was interesting; everything was so cheap. I could have bought a full-length tiger skin coat for four hundred dollars.

At home, Meg and I liked to sit on our deck and watch the sun set. Just after it set, but before it was dark, the bats would come out. I don't think it would have been near as charming if we had bats like you see in Nepal. They have fruit bats, and those things are huge. Their bodies average twelve to sixteen inches in length and have wingspans of up to three feet. I saw thousands of them in the trees by the king's palace.

The Pashupatinath Temple is just outside Kathmandu on the Bagmati River. It is a fantastic collection of large and small temples. The four main doors are all clad in silver. Aside from the usual Buddhist monks, you will find beggars, monkeys, and sacred cows. While we were there, they had a funeral. They had six or eight flat altars along the river, and they laid the bodies on them and cremated them. We toured the temple with several cremations taking place. The smoke has an odor that is quite its own.

At the Macan Wildlife Preserve, we had high hopes of seeing some animals other than chickens, goats, and cows. After five days, the only evidence of wildlife that we saw were prints from bison, rhinos, bears, leopards, and tigers. Big deal. Where were the animals that made them? On a last-ditch effort to see an animal, even a deer, we spent the night in the tower. It was thirty feet tall, ten feet by ten feet, and located two miles from our camp. We sat up there all night waiting and didn't even see a field mouse. When we got back to camp in the morning, we saw that a woman who was part of another group had a bandaged wrist. She injured it falling over a log while a rhino was chasing her right in camp. The next day, I finally saw some animals when I went for a walk in the jungle. I was alone on the trail when I spotted about twenty monkeys in the trees. I was elated to see anything besides bugs and I followed them. This took me off the trail. Of course, they knew I was following them and it seemed to be irritating them. Just as the thought occurred to me, a large monkey dropped down to the jungle floor. Then one after another, I could hear the whoosh and thump as the rest started coming out of the trees all around me. That changed my outlook on things. I remembered the many times I had been rat packed through the years. Not wanting it happen again, especially from a bunch of monkeys, I slowly turned and walked away.

'Protected witness' testifies

By LANE WALLACE
STAFF WRITER

A man testified in court yesterday that he was paid $5,000 in 1984 by a Hells Angel to beat up a Scotts Valley businessman "to make it look like he just played football with the 49ers."

Howard Kiel, 40, testified in Santa Cruz Municipal Court that Fillmore Cross, 45, paid him $5,000 and gave him the instructions on how severely to beat Jim Eberhardt, 44.

Cross, who Kiel said is a member of the Hells Angels, is charged with aiding and abetting assault with a deadly weapon. Kiel's testimony came during the second day of a preliminary hearing to determine if Cross will stand trial.

Cross was placed on the FBI's 10 Most Wanted List after the 1984 incident; he turned himself in 18 months ago.

After his arrest for the beating, Kiel made a deal with authorities. He pleaded guilty to assault with a deadly weapon with the understanding he would be placed in the federal witness protection program. He was sentenced to six months in jail after accepting a guarantee of a maximum four-year sentence.

Before yesterday's hearing, prosecutor Gary Fry said Cross is accused of arranging the beating for a friend, George Magnett, a Los Gatos businessman. Eberhardt allegedly owed Magnett $100,000 plus interest over a joint investment in a Colorado gold mine. Criminal charges against Magnett were filed, but later dismissed.

Kiel testified that Cross told him to beat up Eberhardt and "to give him a message to pay his bills in Los Gatos."

Kiel, who stands about 6-3 and weighs 220, said he "was afraid I might hurt the guy (Eberhardt)," and hired a friend for assistance "so the other guy could do the hittin'."

The friend, Doug Shelby, who Kiel said delivered a single punch that knocked Eberhardt out, also served a six-month jail term for the assault.

The assault, Kiel said, came in October 1984 at a house in Scotts Valley that Eberhardt, a real estate agent, was trying to sell.

Yes, rats can talk.

BACK HOME, AGAIN 171

Federally protected witness testifies

By MARK BERGSTROM
Sentinel staff writer

SANTA CRUZ — A federally protected witness testified Wednesday that reported Hell's Angels chieftain Fillmore Cross paid him $5,000 to make a Scotts Valley businessman "feel like he'd just played football with the 49ers."

Security was tight in Judge Richard McAdams' courtroom when Howard Kiel took the stand to say he was hired to beat up Jim Eberhardt in an attempt to force Eberhardt to repay a $165,000 loan.

Extra bailiffs, along with federal agents, were assigned to the courtroom and everyone entering was screened with a metal detector.

A bailiff even took apart a ballpoint pen belonging to one man in the courtroom.

Kiel has been given federal witness protection for his testimony against Cross in this case and on other matters that local authorities say they are not privy to.

Kiel has been given a new identity and relocated with a job in another part of the country.

"The federal government granted him the program after interviewing him extensively to see what Kiel might know that they would be interested in," said Scotts Valley Police Detective Donna Lind.

"Because Cross was involved, (Kiel) had no problem getting protection," added District Attorney's Inspector Dennis Clark. "What he had to offer them over and above our case, we don't know. All I can say is that Kiel told us he thought he could get into the program," said Clark.

Cross was on the FBI's 10 Most-Wanted List when he surrendered in December 1986 after Kiel had turned state's evidence.

It's obvious, local authorities say, that Cross did not make that list for an assault charge in Scotts Valley that carries a maximum four-year prison term.

Prosecutor Gary Fry concedes Cross is a "big fish on a small hook."

Kiel testified that he met with Cross several times in September and October 1984. He said Cross offered him $500 in advance and $4,500 after the beating. In addition, he said, Cross was to pay him $5,000 more if Eberhardt paid back $100,000 and $5,000 more if Eberhardt paid back the entire $165,000.

Authorities allege that Cross had been hired by a man who lost that money in a business investment with Cross. They tried, but were unable to prosecute that man because of lack of evidence.

Kiel said he engaged the services of a friend Douglas Shelby because Kiel was afraid to do the beating. "I was afraid I might really hurt the guy," said Kiel, who stands about 6 feet, three inches tall and is a solid 220 pounds.

Kiel said that he and Shelby lured Eberhardt to a house on Jolly Way that Eberhardt was advertising for sale.

As Eberhardt led them in to look around, Shelby hit him over the head with a tire iron, Kiel testified.

"Did you hear anything?" asked Fry.

"Yeah, a smack," replied Kiel, who was a man of few words on the witness stand.

Kiel said he then watched Eberhardt fall to the ground.

He said he bound Eberhardt with tape, but not as a preparation to kidnapping him as police once

suspected.

Kiel said he bent over Eberhardt and said, "Pay your bills in Los Gatos."

But, he said, he did not believe Eberhardt heard. "I don't think he was coherent," Kiel testified.

After getting the money from Cross — who shorted him a couple hundred dollars, he said — Kiel went to Hawaii.

He was picked up on the Big Island a week later on a warrant after Scotts Valley received a tip on the beating from a San Jose Police intelligence officer who had seen a bulletin about the case.

Kiel pleaded guilty to assault with force likely to produce great bodily injury. He wound up serving five months in jail after agreeing to testify against Cross. Shelby also admitted the beating and served a five-month term.

Cross' attorney, Vic Vertner, questioned Kiel at length about 10 criminal charges Kiel also faced in Hawaii. Some of those charges, Vertner asserted, involved the importation of firearms and hand grenades into the islands.

After court, Vertner said he believes Kiel had a motive to fabricate information about Cross in an attempt to save himself from the charges here and in Hawaii. The Hawaii charges could have sent Kiel to prison for 70 years, Vertner maintained.

"In my 19 years of law practice, this is the least credible witness I've ever seen," Vertner said.

Fillmore Raymond Cross Jr.

> Excellent intel, except for the fact that I wasn't there.

> He (Cross) was sighted twice in 1985 in Hawaii, once in mid-March and again over Thanksgiving weekend at a Hells Angels wedding, according to court documents.

Santa Cruz Sentinel

Thursday, June 23, 1988 Santa Cruz, Calif.

Copyright © 19
Santa Cruz Sentinel Pu

'Most-wanted' suspect in court

By MARK BERGSTROM
Sentinel staff writer

SANTA CRUZ — Extraordinary security precautions are in place for the testimony today of a federally protected witness in the preliminary hearing for a suspected Hell's Angels chieftain, charged with soliciting the 1984 beating of a Scotts Valley developer.

Fillmore Cross, 45, was on the FBI's 10 Most-Wanted list when he surrendered to federal authorities in December 1986.

The FBI's concern for Cross apparently was more for his allegedly high position with the Hell's Angels than with the relatively minor felony charge in Scotts Valley. Assistant District Attorney Gary Fry said the case here is one of "a big fish on a small hook."

If convicted, the most Cross could be sentenced to is four years in prison.

He is accused of hiring two thugs — Howard Kiel and Douglas Shelby — to beat up Jim Eberhardt for refusing to make good on a bad deal for one of Eberhardt's investors.

Eberhardt, a former reserve sheriff's deputy and onetime candidate for sheriff, at the time operated a Scotts Valley travel agency and speculated in real estate and other investments. Among these investments were a gold mine in Colorado and annuities in the Cayman Islands.

He suffered a concussion in the

attack, but did not require hospitalization.

Kiel and Shelby pleaded guilty to assault with a deadly weapon and in 1985 each received a six-month sentence.

Kiel agreed to turn state's evidence against Cross in exchange for federal witness protection.

Cross' attorney told Municipal Court Judge Richard McAdams that federal authorities paid Kiel more than $129,000 and gave him a job and a new identity.

He said Kiel also struck a deal in Hawaii, where he was arrested. Kiel was wanted on a variety of charges, ranging from extortion to smuggling firearms and grenades onto the islands, Vertner said.

Prosecutor Fry said federal marshals have accompanied Kiel to Santa Cruz and that exceptional security measures have been taken in anticipation of Kiel's testimony.

Even without Kiel's presence in court Tuesday, bailiffs used metal detectors to search those entering the courtroom.

Eberhardt was the first witness in the case, testifying he was beaten by two men posing as potential buyers for a house he was offering for sale on Jolly Way in Scotts Valley.

Eberhardt said he was struck over the head as he led the two men into the house. Kiel and Shelby then bound and gagged him, apparently considering kidnapping him.

Scotts Valley Detective Donna

Lind testified that police learned of the attack when Eberhardt drove up to the station, bleeding and still partially bound by silver duct tape.

She said she put out a bulletin to other police agencies and received a response from a San Jose Police narcotics and intelligence officer.

Fry said after court that the San Jose officer said Kiel and Shelby were known associates of the Hell's Angels.

Fry said the investor supposedly burned in a deal with Eberhardt originally was charged in the case but could not be prosecuted because of insufficient evidence. Fry believes that investor solicited Cross who, in turn, solicited Kiel and Shelby to administer the beating.

The investor, Fry said, had put $100,000 into the Cripple Creek gold mine in Colorado. Fry said the investor considered the deal a loan and Eberhardt considered it an investment. When the deal fell through, Eberhardt refused to pay the $100,000 back.

Eberhardt testified that he named that investor among other disgruntled associates to police as investigators searched for suspects until being led to Kiel and Shelby.

On cross-examination, Cross' attorney pointed out there were a number of civil lawsuits pending against Eberhardt in several states in 1984. Eberhardt said he was unaware of some of the suits that Vertner read from a list.

> Why not cut the guy facing seventy years loose just so you can get the guy facing four years? It's cop math.

> The ADA said they had "a big fish on a small hook." Don't those usually get away?

One afternoon I went to a bar that looked a lot like the one Indiana Jones went to in *The Temple of Doom*. It had a small entry door, and the ceiling was low. You had to walk through three dimly lit rooms with earthen floors and a clientele that many would describe as dubious. There was no bar, just an old woman pouring rice wine from a kettle. The place smelled of kerosene and urine, and it had a low cloud of cigarette smoke. The final door opened to a courtyard with about twenty Tibetan sherpas, all with long knives called gurkhas. They were sitting on mats drinking rice wine. Ah, home at last, a place I could relate to. I thought about the assholes at home that I continually ran across who started shit and then ran to the cops or sued, or both. They would never survive, literally, in that bar.

We took a helicopter to Tengboche, at the base of Mount Everest. We slept in tents and we shared the space with Buddhist monks and climbers wanting to conquer Everest. No sign of a yeti. Using the outhouse up there was a little bit nerve-wracking. It was built on the edge of a cliff so that the hole in the seat was hanging out over a one thousand foot drop. Talk about scaring the shit out of someone. We toured the monastery and took a trek up toward the base camp of Mount Everest. We crossed a rope bridge that spanned a steep canyon, and it was only about two feet wide. That was another thing that made me think of Indiana Jones.

Next we went to Pokhara on a private bus, and we got a good look at the countryside. The roads are bad in Kathmandu but manage to get worse when you leave the city. It is one land with huge potholes. There are goats, pigs, chickens, donkeys, water buffalo, and occasionally herds of cows in the road all the time. The buses and trucks there are all brightly painted with tassels and written prayers on them. Many had a picture of the king on the cab. The public buses are always full; people even ride on the roof, and some people had chickens or goats with them.

From Pokhara, we trekked to a camp with a terrific view of Annapurna. The trek started with a steep trail that was about the equivalent of climbing up to Yosemite Falls. That took about three hours, but after that, it was easier going. The trail was lush with mango trees, ferns, giant bamboo, moss, and creeks and streams with cascades. And leeches. When we arrived at camp, the ground was damp and there were literally millions of leeches so we moved to a drier area nearby. Our new camp had a beautiful view of the Himalayas, but as it turned out, it was not a leech-free zone. I found them in the tent attached to my legs and feet happily drawing blood.

On our way back to Pokhara, we were supposed to cross Lake Pehwa in two boats. After waiting a long time and enduring the nonstop chatter of two women who were also making the crossing, the boats arrived. They were glorified canoes and each one had an ore man who was old and slow. In our canoe, Jock finally got so irritated that he grabbed the paddle and rowed us to the other side. No tip for the captain, free drinks for the mutineer!

We flew to from Kathmandu to Tibet and stayed in Lhasa for five days and Chengdu, China, for two. I really liked the Tibetan people quite a lot.

We ended the trip in Hong Kong. All of us were scarred from the leeches, sick, and exhausted. Chris had the perfect definition of exhausted: "You know you are exhausted when you're about to step into a pile of yak shit, but you just can't stop yourself."

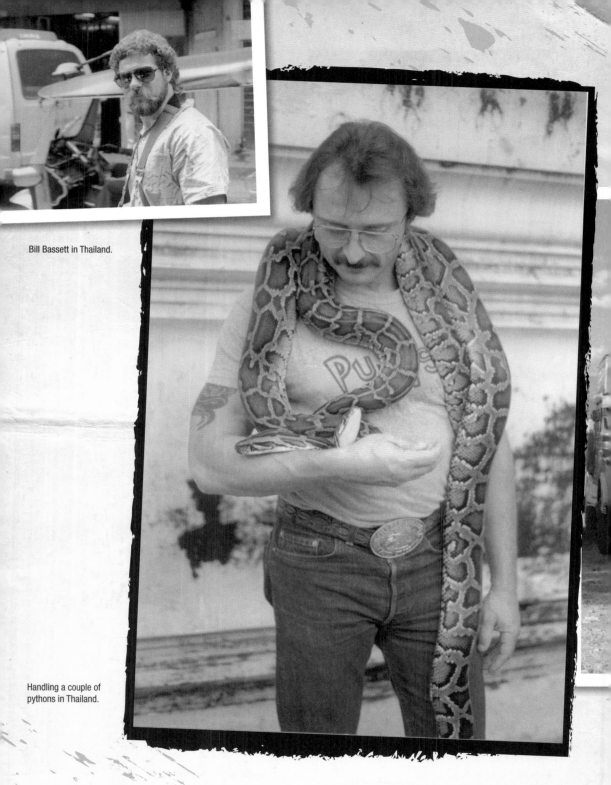

Bill Bassett in Thailand.

Handling a couple of
pythons in Thailand.

A decorated truck in Nepal.

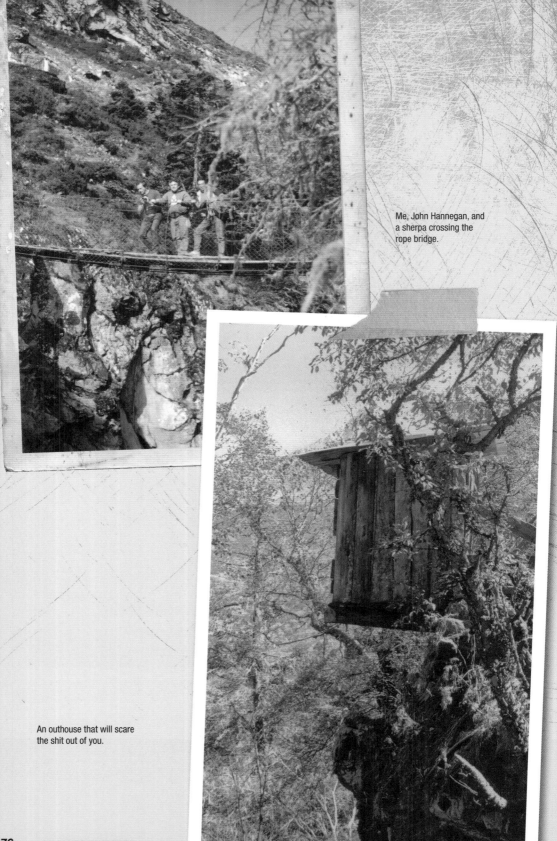

Me, John Hannegan, and a sherpa crossing the rope bridge.

An outhouse that will scare the shit out of you.

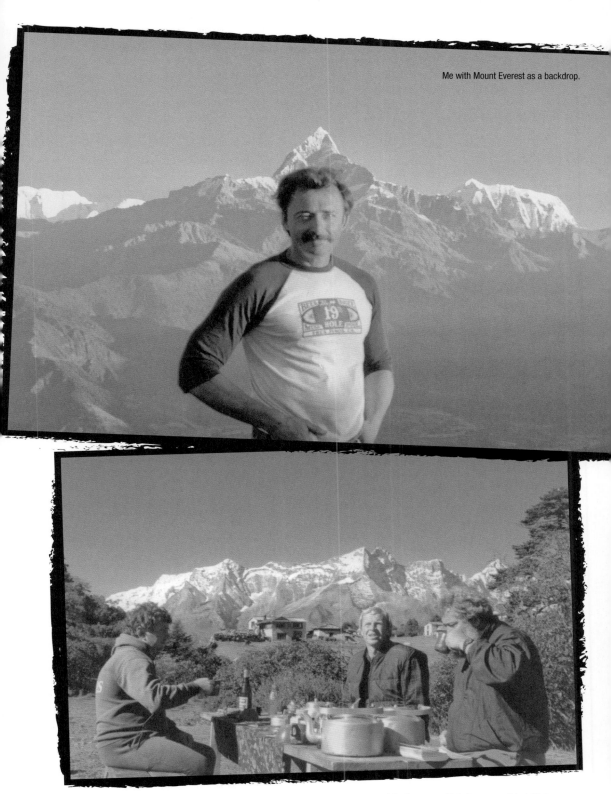

Me with Mount Everest as a backdrop.

John Hannegan, Chris Benson, and Jock McCoy.

The bike I shipped to Amsterdam for the world run.

When Frank and I went to the world run in Zurich, we decided that since Harleys were so hard to get there we would buy a couple of bikes to ship over. We'd ride them around Europe and sell them for a profit before we came home. We wouldn't have to rent or borrow bikes, and if we made the profit we hoped for, it would help offset the cost of the trip. It seemed like a win-win idea.

We went to the Harley-Davidson dealer in San Jose and got a couple of shipping crates from them. After the fuel and oil were drained from the bikes, they were packed up and ready to go. And then there was customs in San Francisco. When I go on a trip, I can't go through customs without being put through the wringer, and back then I usually ended up being shackled to a wall, missing flights, and being generally fucked with. You can imagine how customs treated us when we went to ship those bikes. The customs guy was a rude, disrespectful piece of shit. He was a total asshole, but we got the bike through.

We flew to Amsterdam and picked up our bikes. We didn't have any problem with customs there. From Amsterdam, there was a pack of twenty-five or thirty bikes that rode through Belgium and France to the run site in Switzerland.

On the way to the run site, we came upon a little bar in the French countryside at about one o'clock in the morning. We were really surprised to find it open at that late hour. They were happy to wait on our group of thirty people, and that surprised us even more.

After we left the bar, my headlight went out. The pack was riding fast, so I couldn't keep up and got left behind. I took a wrong turn and wasted at least an

The bike Frank shipped ran much better than mine.

hour. I could only creep along at about five or ten miles per hour, so I had to be careful of cars too. I didn't want to get rear ended by someone who didn't realize that I was going so slow, so I had to pull far off the road when a car came up from behind. If that wasn't bad enough, it started to rain. By the time I got to the hotel where everyone was staying, there were no rooms. The hotel wasn't just for our group; it was a rendezvous for about sixty other members as well. There were about eighty guys who needed rooms and the hotel had twenty rooms. I was so tired I just didn't give a shit. I went outside and went to sleep under a tree. Since it was raining, I slept in my foul weather suit and helmet to keep dry. What a night. I continued to have a lot of problems with that bike for the rest of the trip. I couldn't wait to get to Zurich so that I could sell it. I hated that piece of shit.

We had a good time at the run and even managed to take a short side trip to have lunch in a castle courtyard in Austria. In spite of my bike, the ride was a lot of fun. After the run was over, we sold the bikes. We didn't make the profit we wanted, but we did break even.

We took a train to Paris and saw the sights: Notre Dame, the Louvre, the Eiffel Tower, and a lot of bars and restaurants. We even went by train to the Palace of Versailles. I like going to Europe and have been there a lot, but being able to see some of it on motorcycle was really special.

In August, I celebrated my twentieth anniversary in the club. My charter had a party for me at our clubhouse, and I got my twenty-year buckle. I also turned forty-seven. I had great friends, a beautiful home, a good dog, and a wife who always stood by me. Life was good. What could go wrong now?

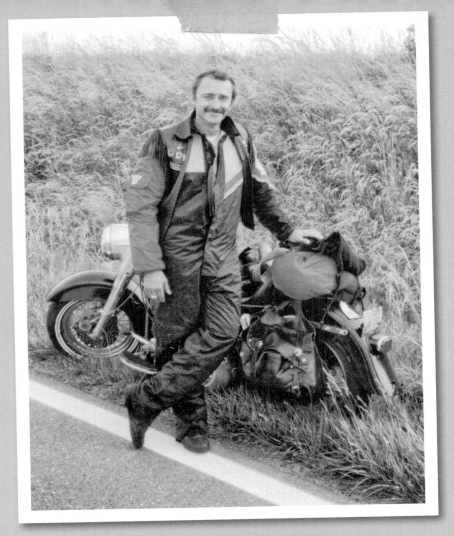

I slept in the hotel garden, in the rain, wearing my foul weather suit and helmet.

October 17, 1989, the Loma Prieta earthquake hit. That was the start of one really terrible month.

My home was about only about two miles from the epicenter, and luckily nobody was home when it hit. Meg had gone to the vet on Summit Road to pick up our dog, Ace. Ace had been acting strange for a couple of days. He was whining, not eating well, and following me around even more than usual, so we took him in for a checkup. Meg was in the exam room with Ace and the vet, and he had just told her that the dog was fine. Suddenly the dog (a ninety-five pound German shepherd) started whining and jumped in her lap. Meg never even had time to comment when the noise and shaking started. Ace must have sensed that something was going to happen and that's why he was acting so weird. It's a good thing that Meg wasn't home; every bit of glass in the house broke and flew everywhere. If she had been in there, she would have been cut to ribbons.

Meg couldn't get home; the road to our house was closed because of a fire. She thought I wouldn't be able to get home, so she decided to go over the hill and check on our families. The only problem with that plan was the five-foot-wide, very deep fissure running across Summit Road. She was on the high side

of the fissure, so she went back about a hundred yards and floored it. She sailed right on over the fissure. When she got to town, she found that everyone was OK, including me. I had found a working phone and already checked in by the time she got there.

I had been in Oakland that day visiting friends. I wasn't supposed to be home until about eight o'clock that night, but one of guys I was going to see had to cancel. I was on my road, no more than a quarter of a mile from the house when the quake hit. The first thing I saw was the all of the trees starting to shake. Almost instantly they became one big blur. The hillside on my left was very steep, and stone and dirt started coming off of it. As it was landing on the car, it sounded like a hailstorm from hell. I looked out the windshield and saw that a fissure had opened and was snaking its way toward me down the center of the road. I started backing up as soon as I saw it, but it caught up with me. More debris from the hillside came down and blacked out all the windows. I had slam on the brakes so that I didn't drive off the cliff to my right. For a moment I wondered if my car had been completely buried. After the shaking stopped, I got out of my car to assess the damage. The fissure wasn't very wide or deep. It did make the road about six inches higher on the driver's side, but I thought it was passable. I figured that if I was careful, I could straddle the fissure and hopefully make it to my house.

On the way down the road, I saw a neighbor standing in her driveway with her arm raised up in front of her and blood pouring off of her. She had cuts everywhere (I knew that is exactly what Meg would have looked like if she had been home). She was in shock and was losing a lot of blood from a terrible cut on her arm. I made a tourniquet, got her in my car, and headed for the hospital. When we got to the fissure at Summit Road, I got her across with the help of a guy on the other side. When I told him he had to take her to the hospital, he did it reluctantly. Let's just say I made him an offer he couldn't refuse.

Does not play well with others.

BELOW: Inside the Zurich clubhouse.

I made a beeline back to my house, and the first thing I saw was the broken supply line on the propane tank. I shut that off right away and went to look for Meg. Once I found that her car was gone, it was time to check the rest of the property.

The house looked OK from the outside. There were redwood limbs everywhere, but the roof didn't sustain any damage and all the windows were intact.

I went to check on all of our neighbors. I wanted to shut off gas, electrical, and water supplies and check to see if anyone else was hurt.

Another neighbor's house fell off the foundation and completely collapsed. The owners were Filipino and grandpa, who didn't speak any English, was in the driveway when I got there. As soon as he saw me, he started waving

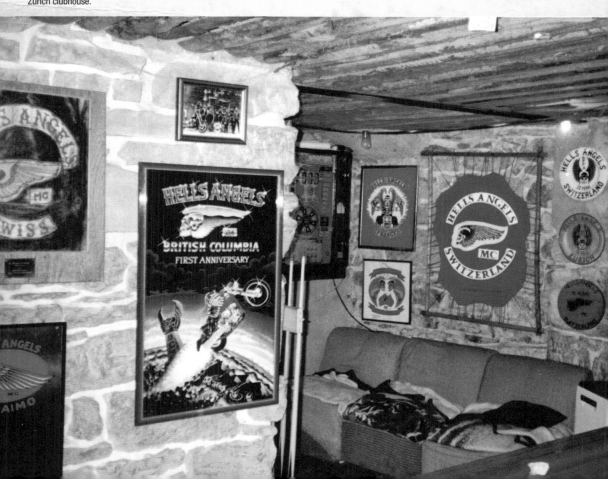

his hands and pointing at the house. Their female German shepherd was trapped under the collapsed house. I could hear her barking, but couldn't get to her. I went home and got my chainsaw and carefully cut a hole through the floor. I didn't give a shit about further damage to the house; I had to be careful because the space she was trapped in was only about eighteen inches deep. She looked completely spooked when I opened up that floor. I called to her and she came out, tail between her legs. Amazingly, she didn't have a scratch on her. I took her to my place and put her in our pen. Since their home was completely destroyed, the neighbors asked if I would be willing to adopt her. I thought, "Why not? It will give Ace some company." Ace was thrilled because she went into heat a week later.

In the grand scheme of things, we got pretty lucky; our house had a lot of damage, but nothing structural. We had an in-ground pool with a swim-up bar about fifty feet from the house. It was destroyed. The pool itself wasn't too bad, but the deck and bar were totaled. My dad made it up to the house to check on us the next day. I went to my wine cellar and got a bottle of 1978 Chateau Lafite Rothschild. We sat by the remnants of my pool and drank the whole thing. What the hell? I was lucky that I still had it. I'm certain that God appreciates good wine. I say this because I had a two thousand-bottle wine cellar and only the cheap, drink-now stuff broke. The fine wine that I had been collecting and aging for years—Lafites, Moutons Margeaux, and Haute Brions—rode out the quake like the champions they were.

My twentieth anniversary.

The Loma Prieta ruined all of our crystal, and the booze.

We ate on paper plates for a while.

November 11 was a sunny day and unseasonably warm. Things weren't back to normal, but the aftershocks had stopped and people were getting on with life. Frank, Steve, and a few other guys went for a ride. Meg and I were still working on putting our house back together so we were at home that day. When the phone rang, Meg answered it. I heard her say, "When?" "How bad?" and, "OK." Then she hung up and started to cry. The word she got was that Steve had been hit on Highway 1 by a hit-and-run driver, and it was bad. He had a head injury and might not make it.

We went straight to the hospital and waited. Lee-Ann was holding up really well, and asking all the right questions; the doctors just didn't have many answers. Steve was in a coma; wait and see. I don't remember how long he was in the coma, but it was quite a while. When he woke up, his life and Lee-Ann's were drastically changed. Everybody's had been. Steve had a brain-stem injury, and he was never going to be the same again.

My friend Steve Price sitting
at our damaged pool.

Tina (black and tan shepherd), the dog I rescued after the earthquake with Ace (my second favorite dog).

Meg was at the hospital with Lee-Ann pretty much round the clock for four days. I wanted her to take a break and relax a little, so I stopped at a restaurant that my friends own and called her to come and join me. That was November 17. We had a late dinner and ran into our friend John, who was one of the owners. We sat around shooting the shit with him for a long time. It got late and I was tired, so I said it was time to go. Meg still had her drink to finish so she said, "Go ahead. I'll be right behind you." When she wasn't home in half an hour, I figured that maybe she decided to have another drink and keep visiting. When she wasn't home in an hour, I called the restaurant. John said she had been gone for a long time. I got in my car and drove all the way back to Los Gatos looking for her car. Nothing. I called her sister. I thought maybe she decided to spend the night there instead of driving home. No. I even called Lee-Ann. Maybe she decided to go to the hospital. No again. I couldn't do anything else but wait for morning and go looking again.

At about seven o'clock in the morning, I was in my driveway when Meg walked up. Her clothes were torn and dirty, her hands were scratched and bloody, and she had a goose egg on her head. She said, "I was so close, but I couldn't make it home." The whole night she was less than a quarter of a mile away. She had been run off our road by a small pickup truck that was driving fast in the middle of the road. When she swerved, she hit gravel and started to slide. She couldn't correct fast enough and hit a big tree. As usual, she had taken her seat belt off when she got to our road. When she hit the tree, she broke the windshield with her head. After that, she thought she could limp the car home. She must have passed out or the concussion she had made her confused because she doesn't remember driving over the cliff. It was a small cliff, but big enough to hide the car at night.

I took her to the doctor right away. She did have a concussion, but other than that and the scrapes and bruises, she was OK.

Meg ended up getting a new car out of the deal. She never really liked her old one anyway.

In 1990, the USA run was held at Sturgis, South Dakota. It was the fiftieth anniversary of the event, and we'd heard that the Outlaws were going to make a showing, so we rode out there too, just to see what was going to happen.

On the ride out there, I had a series of unfortunate events in Nevada. It started with losing my sleeping bag shortly after we crossed the border. Frank saw it come off my bike and signaled to me. I pulled over, saw it was missing, and went back for it. It had been hit by so many cars that there was no point in stopping for it. I knew I didn't have any chance of buying one in Sturgis (I got a hotel room instead).

I had a rear tire flat about an hour later. I was working on holding steady and slowing down, so I didn't notice that there was a big rig coming up fast behind me. Frank told me that when the driver jammed on the brakes, his elbows were locked and he had a grimace of concentration on his face. Flattening a Hells Angel like a pancake would not be a good thing. When we both came to a stop, he was about a foot off my rear fender.

We were heading into Wells, Nevada, and I got separated from the pack at a gas station. I was riding alone, heading to the hotel, when I hit a piece of steel that fell off a truck. It was dusk and I had a helmet on with a smoked visor. As I was lifting the visor so that I could see the road better, I suddenly took a hit to the chest that was so intense I really thought that I had been shot by a .45. When I hit the steel, it turned my front tire hard to the left. It was my left handlebar grip that hit my chest. The bike and I flipped up into the air together. In the middle of a 360-degree flip, we separated. The bike landed on its wheels and I landed on my feet. That's when all hell broke loose. The bike went into a slide and I went into one of my own. I did a half roll forward and ended up sliding on my back for about fifty feet. Some members came up just about that time and helped me out. They trucked my bike to the hotel. One of the guys was a motorcycle mechanic and used a crowbar to straighten the front end and handlebar. The bike and I both had a bad case of road rash, but we were both up and running in the morning.

While we were riding on a side road just outside Yellowstone National Park in Wyoming, we saw a large herd of buffalo. The herd was grazing close to the side of the road, and we were going at a pretty good clip so I slowed down to look at them. The guys riding in front of me didn't bother. As I was watching the buffalo, the road started to feel strange, a little bit slick. I looked down and I was right in the middle of thousands of huge furry spiders. It was a tarantula migration and they were all crossing the road. The buffalo weren't all that interesting anymore. I was now more concerned with staying upright. The last thing I wanted to do was go sliding through the middle of all those big-ass spiders.

The cops were aware that both the Hells Angels and the Outlaws were going to be in Sturgis and had prepared for it with extra police presence. They came out in force when it looked like we were going to get into a confrontation. Things had gotten tense. I even gave my friend Jimbo my video camera, just in case, and told him to be sure to film what ever happened. Nothing did.

My bike getting emergency
repairs on the way to
Sturgis, 1990.

I went to Sturgis again the following year with my friend Chris Benson. Chris has a huge barbeque rig and arranged for a prime spot in Sturgis to set up The Bodacious BBQ. We had a huge moving van with all the gear and my bike on board.

Nevada got to us on this trip too. The truck Chris was pulling the barbeque with broke down. Chris talked the driver of an empty big rig into loading up the truck and barbecue and taking it all the way to Sturgis. The trucker was heading back east anyhow, and on the way out one of the gals who was going to work serving the BBQ hopped in the truck with him. He made the run for nothing.

While we were there, Chris wanted to go for a ride on my bike. Chris is a big guy and I'm sure we looked pretty strange riding around the event. After a bit, I noticed that the fender started hitting the tire. The shock was broken. Like I said, Chris was a big guy.

When it was time to head home and everything was being loaded into the van, I thought about it and decided I wanted to ride. I made home it in two days. I rode 700 miles the first day and 810 the second. It was a long, fast ride, and nothing bad happened.

In the spring of 1992, I drove by a piece of property that I knew I had to make mine. It was twenty-three acres and had seven houses on it. The property was actually an old logging community from the 1880s. It had a log beam lodge, an old saloon, and two whore houses that had all been turned into dwellings. It also had a new house, an apartment over the garage, and another small one-bedroom house.

I went to the door of the newly constructed house and knocked. The owners were easygoing, but they weren't interested in selling. They hadn't owned the property all that long and had gone through a lot to get it.

In March 1993, I contacted the owners again after hearing a rumor that they wanted to sell. This time they were receptive and negotiations ensued. I was excited about the prospect of getting the property and took Meg by to see it. She was not thrilled. The property was very rundown and still recovering from the earthquake. Except for the newly constructed house that had replaced one destroyed in the quake, all of the houses needed work, a lot of work. There was a huge pool, sixty feet by seventy feet, that was totally polluted; the lawns were all dead; and every fence was dilapidated. Where I saw great potential, she saw great expense.

In June 1993 Meg was pregnant, and we sold our house on Comstock Mill Road. We were still in negotiations for the property, and now she was worried that we wouldn't get it. Her opinion had changed from not wanting the property to not wanting to be pregnant and homeless.

The sale went through and we were set to close escrow in mid-August. Every time I went to the property there were loads of deer in the field, so I named the property Deerfield. At the end of July, we moved to Deerfield and stayed in one of the rentals until escrow closed. Meg and I were going to the world run in France and we had to wait to move into our new home until we got back, so we didn't unpack anything. We left for the world run five days after moving.

DEERFIELD

WE DIDN'T PLAN ON MEG being two months pregnant for the trip to France. There we were in one of the greatest wine-making countries in the world and I had to drink the wine for both of us. It was a tough job, but I rose to the challenge.

Meg pregnant.

We rented a car at the airport and drove straight to the run site. The French brothers did a good job of putting the run together. It was held in Tours, in the Loir region, about 150 miles from France, on the grounds of an old castle. The owners rented the barn to us and we used it for a dining, drinking, and entertainment area. I'd seen a lot of barns in my time, but nothing like this one. It was huge, about ten thousand square feet, and built of stone and wood. It was around eight or nine hundred years old. The beams were so hard they were practically stone. You could not get a knife into them—I know, because I tried. I remember thinking that it would make a really nice clubhouse. There was a big lake on the property that appeared to be man-made. That was the place to go for some downtime.

We stayed in a hotel not far from the run site. When we checked in, the management was friendly to their American guests, but they treated our German members like crap. Depending on who was at the desk, the attitude ranged from curt to downright rude. The guys couldn't even get fresh towels. In spite of everything, the German members were surprisingly tolerant, and as far I know, nobody got their ass beat.

There was one sad event that put a damper on the run. One of the members from England was killed in a head-on collision on the road to town. Another English member had a bad accident in just about the same area, but he survived.

After the run ended, Meg and I drove back to Paris and visited a lot of smaller towns on the way. One town that we were truly impressed with was Amboise. The town is beautiful and it has a chateau that overlooks it. It is also where Leonardo da Vinci's home is located. If you go there, just don't touch the fruit at the fruit stands. Meg picked up a peach to buy it, and the lady running the stand came out and started yelling at her. Shoppers are supposed to point to what they want, and then she would get it for them. That is, if they pass inspection.

It was at a little patisserie across the street from our hotel in Paris where I saw a side of Meg that was completely new to me. One morning she was ready before me and decided to go and get her decaf while I was in the shower. There were quite a few people in line, and she had to wait awhile until it was her turn. As I walked in the door, I heard Meg yell, "Hey, I want my decaf and I want it now!" I had never heard her growl at anyone like that. The barista had evidently passed right over the pregnant American woman in favor of the Parisians in line. Meg is an avid coffee drinker, and even though she was pregnant and couldn't have caffeine, she still needed her decaf. I asked Meg what was wrong and she told me that she couldn't get waited on. Then she turned to the barista and yelled, "If that little coffee bitch doesn't get me a dee-caff-a right now, I will climb over that counter and rip her heart out." Oh yeah, this pregnancy thing was going to be fun.

Meg had her blowup at a French waitperson; now it was my turn. We had been walking around Paris for hours, shopping and sightseeing, and it was getting to be dinnertime. You can get dinner in Paris as late as midnight, but being pregnant, Meg couldn't stay up that late. At about eight o'clock, we found an interesting little restaurant down a side street. We were glad to see that they had menus posted outside. One was written in French and one in English. The food sounded good, so we headed in. The place was small, only a dozen or so

tables, and four of them were occupied. The waiter was a young guy, about six feet tall and pretty well built. He pointed to a table as we came through the door and we sat down. When the waiter finally came over to us, he handed us menus written in French. I asked if we could get an English menu and that asshole said, "This is a French restaurant." The way he said it came across as extremely rude and challenging. We had run up on a lot of people with attitudes like that in Paris, but this guy was way too chesty.

This time I snapped. I said, "Who the fuck do you think you are?" He got wide-eyed and nervously looked toward the kitchen. As I jumped up and threw my chair backward, I yelled, "I'll kick your ass you son of a bitch." I don't think he heard the kick your ass part because he was already running. I chased him through the kitchen and out the back door. The cook looked stunned, but didn't interfere.

Meg got up from the table, picked up her stuff, and headed for the door. As she was leaving, she told the other diners, "I don't think we'll be staying after all. Enjoy your meal, that is, if the waiter comes back." As she was heading around to the back of the restaurant, she met up with me heading toward the front. I couldn't catch that piece-of-shit waiter. He may not have been so tough after all, but he sure was fast.

Some of the Parisians may have been rude, but the people in the countryside were much friendlier. One afternoon as we were driving around, we saw a small wooden sign that was pointed down a dirt road. All it said was "Champagne." We decided to see where it went. It was a long driveway that stopped at a small family-owned vineyard. When we stopped the car and got out, a short elderly man wearing a beret came out from an old wooden building that looked like it might be a barn. He smiled, bowed, and waved to us to come in. It was the tasting room. The bar was an old wooden plank on top a couple of barrels. Half barrels were stacked one on top of another behind the bar and they were filled with bottles. There were two other old men inside who looked like clones of the first. One of them started speaking to us in French. I said one word: "American." All three of them smiled and nodded, and five glasses appeared on the bar along with cheese and bread. The rest of the visit was conducted with improvised sign language, which consisted of a lot of pointing and smiling. When they started pouring, Meg put her hand over her glass. One of the little vintners said, "No?" Meg patted her tummy and then cradled her arms and made like she was rocking a baby. The response was, "Oh," and the vintner pinched his fingers together to indicate just a little bit. Meg shook her head and made a gesture like throwing up. The men all laughed and poured her some water. In spite of the language barrier, we spent a long time at the vineyard and bought champagne to take home. Those old dudes treated us to one of the best afternoons we'd had.

Our daughter Amanda was born on February 17, 1994. She was a breach baby so we had an appointment scheduled for her delivery, and it was at the decent time of 10 a.m. True to her personality from the start, she decided to do things her own way and come into the world three weeks early, in the wee hours of the morning, during the worst storm of that winter.

At 1:00 a.m., Meg woke me and said it was time to go to the hospital. I grabbed her suitcase, put it in the car, got her settled, and at 1:30 we headed out for the twenty-mile drive, over mountain roads and a nasty highway, to the

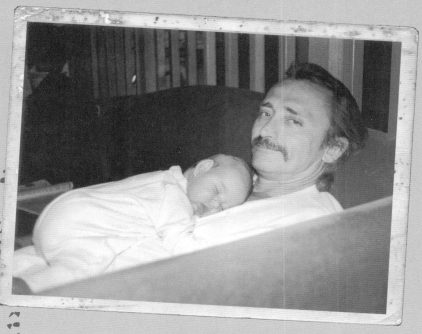

Nap time.

With my baby daughter.

Hey Dad, I'm ready to roll.

hospital in Los Gatos. The drive normally took about thirty-five minutes, but we expected it to take longer due to the horrible weather. As we set out, Meg said, "Don't rush. I'm fine, and they say first babies always take forever." She would do the Lamaze breathing during the contractions and seemed really in control. It didn't take long, though, until the breathing was way more frequent and I could tell that she was having a tough time. At this point, she said, "You might want to drive faster now." It seemed like the contractions were nonstop now, and I had a horrible feeling I might be delivering the baby on the side of the road. As soon as I thought it, she said it. "If you want this baby born at the hospital . . . DRIVE FASTER!" When we got to town, we only had one stoplight to deal with, and, of course, it was red. As we were approaching it, Meg yelled, "RUN IT!" I had to slow down to make the turn and make sure that no cars were coming. When I started to slow, she growled, "RUUUN IT!" I swear her voice sounded like something you would hear from a movie character who was demonically possessed.

We got to the hospital just after two o'clock. We were ushered right into a room so they could prep Meg for surgery. It was the busiest night for births that the hospital had seen in many years, and the prep room was still being cleaned from the last patient. There was even a guy in there mopping the floor. The minute Meg walked in that room she started ripping her clothes off. On her way to the bathroom, she walked past the guy with the mop. Without breaking stride, and in that same demonic tone, she told him, "GET OUT!" That poor dude probably thought the spawn of Satan was coming. Instead, our baby daughter arrived one hour later, and Meg went back to being fully human.

In August 1996, I decided to hold a ride for friends who weren't in the club. I called it the Phil Cross Summer Run and held it for four years. I invited friends who were regular supporters of the club and guys who were interested in coming around. It was a good way to check them out and possibly pick up membership for the club while having a good time. The first year we went to Jackson, California, which is up in the gold country.

RIGHT: Getting ready to head out on one of my summer runs.

BELOW: The last stop on one of our summer runs, C. B. Hannegan's Bar.

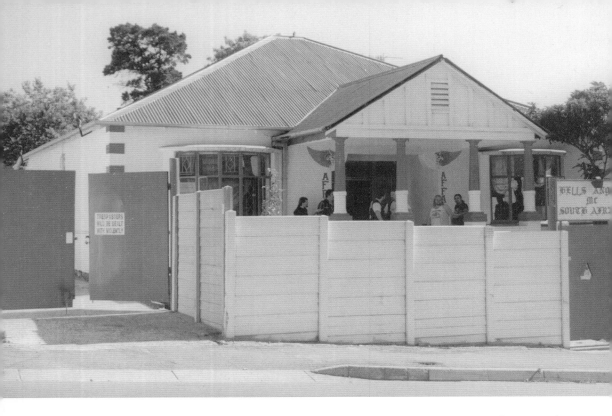

The clubhouse
in Johannesburg.

For the following three years, the runs were in Calistoga, Nevada City, and the last one was held in Jackson again. After that, I wasn't feeling well enough to host the runs anymore. We had a lot of laughs on those runs and I picked up a few members.

On October 1, 1997, my friend, and fellow San Jose member, Steve was arrested for murder. The management of The Pink Poodle (a strip club in San Jose) called Steve because a patron had gotten out of hand. When he got to the club, he went to the guy causing the problem and told him to leave. The dude got raspy and started swinging. Steve hit him in return. The guy died as a result of the punch and Steve was charged with first-degree murder. The prosecution contended that Steve knew ahead of time that he was going to take the guy out. It would be over a year before he came to trial.

In November 1997, I went on the world run in South Africa. I was eager to get there and see the sights. The plane ride was over sixteen hours, but it felt like days. After we landed at the airport, we went straight to the clubhouse in Johannesburg. It took me a while to notice that the clubhouse was nice because when I walked in the door the first thing I saw was a totally naked girl sitting by a group of guys playing poker. Evidently the guys were more interested in their game than her because they were completely ignoring her. With AIDS on everybody's mind, none of the visitors were interested either. So the naked, pretty girl just watched the card game.

Three other guys from California and I wanted to go to Cape Town, so after a couple of days in Johannesburg, we rented a car and headed out. Before we left, the Johannesburg brothers warned us not to get into a cab in Cape Town. The cab drivers would take you to a remote area where you would be mugged. The cabbies would then get a cut of the take.

I took the risk and rolled down the window to take this photo.

This little guy had some sharp teeth.

We made a bunch of stops along the way to Cape Town. One of the best ones was at Ukhahlamba Drakensberg Park, a wildlife reserve on the road to the coast. We drove through the park and saw all kinds of animals. We weren't supposed to get out of the car, but of course we did. We got pretty close to zebras and rhinos, and we were able to get real close to a herd of ostriches. They were curious and would walk right up to you. We saw lions too, but we didn't get out of the car around them. My favorites were the lions. They would come right up to the car and rub against it and chew on the mirror. One of them came and stuck his head right up to my window, and he and I were sitting there staring at each other with only the window separating us. I put my hand against the window at the spot where his muzzle was, and I could almost feel his breath. It was pretty awesome. After he walked away, I rolled down my window and took his picture.

The ostriches were curious, and funny.

We stumbled on this huge bone pile in the game reserve.

They had a section of the park where you could get out of the car and see young animals up close. I held a baby lion and he was a feisty little sucker.

The biggest park is Kruger National Park, but it was to the north and we were heading south. I wasn't interested in going there anyhow. We had been told that refugees from the north headed through the park and were met by a group of machete-wielding tribesmen who raped, pillaged, and plundered them and then hacked them to bits as well as attacking some tourist camps.

We were also told that there was a pair of lions running around that had developed a taste for refugee. No point in finding out if they liked white meat.

We stopped at a town called Durban on the coast and stayed in a nice hotel. Prices in South Africa were cheap—the hotel cost about half what you would pay here. Our steak dinner, with wine, cost about twelve dollars each. I was used to travelling where the euro was used, so this was a nice change. In the morning, I went for a walk on the beach. I filled an empty water bottle with sea water from the Indian Ocean and put it in my koi pond when I got back home.

The next day we headed farther down the coast, but we never made it to Cape Town. Two of the guys had earlier return flights and didn't want to reschedule. I tried to talk them into it; I really wanted to see Cape Town. I suppose I'll just have to go back some day.

Steve's arrest led to a charter-wide raid. Every member had his home and business (if he had one) raided on January 21, 1998. The cops said that The Pink Poodle had a video camera and the tape was missing. Owners of the club told the cops that the video hadn't worked in a while and there was no tape. I doubt that the cops shared this piece of information with the judge who signed the warrants.

In the early morning of January 21, 1998, there was pounding on the front door, the sliding glass door of my bedroom, and basically every other door and window in my home. Along with the pounding was a voice saying, "Are you gonna let us in Phil, or do we have to break down the door?" Once again my house was being raided.

The raid on our house was a coordinated attack. At the same time they hit our place, they were hitting the homes of every San Jose Hells Angel.

I told Meg to grab a robe because once they came in they wouldn't let her put one on. We went together to the front door and as soon as we opened it, the cops grabbed us both and pulled us outside, and we were both cuffed behind our backs.

Meg told them that we had a three-year-old sleeping in the other downstairs bedroom. They didn't even know we had a kid, which I thought was pretty funny considering that they were supposed to have expert intelligence on the club. A cop with an assault rifle went inside the house. Right away he saw the photos of our daughter on the wall and told the others that it was true. They asked me where her room was and I nodded toward the door. I couldn't believe it when they went in to her bedroom and pointed that fucking rifle at her. After that, they let Meg go in and be with her. One of the younger cops wanted to take the cuffs off Meg. He said, "Her daughter shouldn't see her like this."

The asshole in charge wouldn't let him. His words were, "She stays like that." The young cop didn't like it, though, and he moved her hands to the front.

While Meg was in the bedroom with Amanda and one cop as a guard, I was in the living room with four other cops. They were looking for anything that

had to do with Steve's murder charges. They used a missing tape from The Pink Poodle as an excuse to get the warrants.

Meg had never been in a raid, and she was surprisingly calm. The only time she got upset was when some chick cop went into Amanda's room and said to her, "Do you want to see your daddy? You can go out and see him." That set Meg off, and she got right in that cop's face and said, "My daughter will never see her father in handcuffs. I don't want you to speak to my daughter ever again."

As they were searching our house, they were also banging on the doors of all of the tenants on our property. The tenants were amazingly cool with the whole thing. Every one of them vouched for us and told the cops that they were way off base. They were. Jud, one of our tenants, turned out to have a warrant for a $300 ticket that he didn't even know about, and they arrested him right on the spot.

Their warrant only allowed them to search our house, gym, and garage. When they started the search, some of them were ripping through things and dumping stuff all over. One of the cops didn't like it and he told them to be careful. He actually apologized to Meg and told her that he had never seen a neater, more organized home.

They were at our place for most of the day, and the upshot of their search was to take all my club memorabilia and our VHS tapes. They even took Amanda's Disney movies. Her favorite Barney (the purple dinosaur) tape was never returned. Evidently Barney got life.

We fared a lot better than most of the other members; many of them had their homes torn apart and damaged, and some even had their dogs killed. For a long time after that raid, my little girl would ask if the bad men were going to come back. Since she had never seen one, she also wanted to know why people had guns in our house.

On January 12, 1999, and after spending one year and three months in jail, Steve was acquitted of all charges.

The club filed a lawsuit against the San Jose Police Department for violation of our civil rights the same day as Steve was acquitted. It was a long time for the suit to get to court and get a decision. Frank Iadiano was president of the charter at the time, and he was the guy in charge of handling the entire suit for all of the San Jose members. The suit was complicated, not only by the very nature of it, but also by all the parties involved.

After a couple of years, the case came to trial and the club was victorious. The San Jose Police Department was found to have violated the civil rights of the members of the San Jose Hells Angels and was ordered to pay damages.

During the time of the lawsuit, my health started getting worse. I was on a downhill ride, and I felt it was necessary to start making plans for Meg and Amanda in case I didn't make it.

It was starting to look like I might not get my liver transplant, and I didn't think that a twenty-three acre property with seven houses on it was something that Meg should handle alone. This was the height of the real estate boom, and I talked to a realtor who told me that the property had quadrupled in value since we bought it. Now was the time to sell.

We had put in almost seven straight years of work in the property and did most of it ourselves. We did everything: landscaping, resurfacing of the

Hells Angels take the cops to court

Members say their rights were trampled during murder investigation

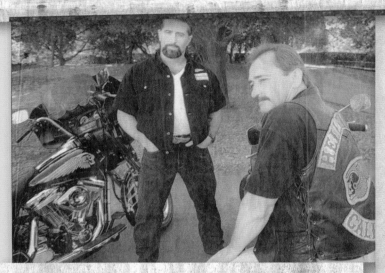

SOQUEL — It was 6 a.m. on Jan. 21, 1998, and Meg and Phil Cross were asleep in their Olive Springs Road home. In the next room, their 3-year-old daughter was tucked in bed, cuddled up with her favorite stuffed bunny.

The Crosses were unaware that a platoon of federal, state and local law enforcement agents — some dressed in camouflage gear — had surrounded their house until they heard pounding on every window and door.

Within minutes, Phil, a 30-year member of the Hells Angels, and Meg were in handcuffs on their front porch. They say agents with guns drawn swarmed their home, including the room where their daughter slept.

"I could hear her waking up and calling, 'Mommy,' " said Meg,

We sued, and we won.

Hells Angels

Continued from Page A1

who, still shackled, was allowed to comfort the girl while two armed officers stood guard. "Later on, my daughter started asking me if those bad men were coming back and why the people had guns in our home."

The Crosses say they were the lucky ones.

On the other side of the hill, as many as 200 police officers, sheriff's deputies, narcotics agents and FBI agents simultaneously stormed the properties of dozens of other San Jose Hells Angels, along with the homes of their friends and lovers from Santa Cruz to Contra Costa counties.

Members say their homes were ransacked, their families terrorized and pets shot dead in their driveways.

"These guys think they can do whatever they want and they need to know they can't," said Soquel contractor Frank Iadiano, president of the San Jose Hells Angels charter, which has filed a federal civil-rights lawsuit against the involved law enforcement agencies.

Hells Angels say the raids were part of a desperate attempt to link the notorious motorcycle club to the 1997 beating death of a patron at the Pink Poodle, a San Jose strip joint. In their zeal to bring the Hells Angels to trial, agents overstepped their legal authority, trampling not only Angels' property but their civil rights as well, members allege in the lawsuit now proceeding toward trial in San Jose.

"They are not a criminal street gang, and don't want their civil liberties violated by being labeled as such," said San Francisco lawyer Karen Snell, who represents the club.

Hells Angel and Pink Poodle bouncer Steve Tausan, 39, and strip club manager David Kuzinich were ultimately charged with the Aug. 24, 1997, slaying of 38-year-old customer Kevin Sullivan.

Both were acquitted Jan. 12 after a two-month trial. They also were cleared of conspiracy to commit assault, conspiracy to obstruct justice and a gang enhancement

The day of the verdict, the Hells Angels threw a counterpunch, suing for damages and to clear their name as a criminal street gang.

Dan Coyro/Sentinel photos

A San Jose murder investigation drifted over the hill to Soquel, Santa Cruz and Capitola where police raided the property of local Hells Angels members. Soquel residents Frank Iadiano, left, president of the San Jose Hells Angels, and Phill Cross, a 30-year member, say police have not returned all of their property.

swimming pool, hanging sheetrock, setting tile, replacing decking, doing concrete work, building rock walls, plumbing, painting, and much more.

The work I was proudest of was the renovation of the old lodge. Meg and I decided that we wanted to move into it in 1996 and set to work. It was an impressive structure but needed serious updating. Jud was instrumental in the renovation; it would have taken a lot longer and a lot more money without his help. It took about six months to finish, and it was worth it. It was amazing when it was done.

The decision to sell was hard, but I knew we had to let the property go. It was good business. In August 2000, we sold Deerfield. We bought a newly remodeled house in Aptos (which, of course, we ended up remodeling again) as well as an apartment complex in Soquel that had twenty-two units.

Being the landlord of the apartment complex was a challenge for me at times. I couldn't just beat the shit out of someone who didn't pay their rent or left their place filthy when they moved. There were three incidents were I came close, though.

The first time was when an eighty-five-year-old tenant named George went into a convalescent home after having a stroke. George had a guy named Arnie who was supposed to be helping him out when he needed it. I had to let Arnie into the apartment to get some things for George. When I opened the front door, I saw a maze of newspapers stacked about three feet high. George had a tight little path that led from the front door into the living room where it branched to the refrigerator and the bedroom. Every surface was stacked with newspapers, even the stove, heater, and bathtub. George was sleeping on a cot and cooking on a hotplate that sat on a stack of newspapers. When I saw that apartment, I told the Arnie that I couldn't believe that he let George live like that and to clean the place out. Hell, I was lucky the entire complex hadn't burned to the ground. Arnie got chesty with me and said it wasn't my business how George lived. I calmly explained to Arnie that if he didn't do it and continued to let that old man live like that, I would happily smack the shit out of him. Arnie hauled the newspapers off, but the rest of the cleanup was on us. We ended up gutting the unit.

Another guy who came real close to getting stomped was a dude who was drunk and throwing knives into his front door. I got a call from another tenant who was pretty freaked out about it. She really was afraid because there were kids who were playing outside in the courtyard area. When I showed up at the complex, there he was, drunk off his ass, yelling about something and still throwing knives at the now-ruined front door. I waited until all the knives were in the door until I approached him. When I first started talking to him, he got really angry that I was interfering with his fun. I pulled the knives out of the door, grabbed the front of his shirt, and told him that there was no way he was touching those knives again. I opened the door, and he stumbled inside and promptly passed out on the sofa. He moved out a couple of days later.

The last guy was a loser who had skipped out because he was two months behind on his rent. When he skipped, he left piles of trash in the carport. I had to load it all up and take it to the dump. About a month later, this asshole called me and said that I had thrown his grandmothers ashes out and he was going to sue me. Evidently, he had put dear old granny into a potted plant that he let die. Then he put the pot in with the piles of trash. I told him to go ahead

The pool was so big it took us five hours to paint it.

and sue; nobody was going to give him shit when they found out that he put granny out with the trash.

In hopes of curing the hepatitis C, I started on interferon therapy. It had been around for a while and was being used more and more. At that time, you had to go to the doctor's office for the shots. It did not work out for me. After the first treatment, I broke out in a bad rash that covered my entire body. The rash was so bad that I looked like a burn victim. It wasn't the kind of rash that itched; it burned. I felt like my skin was on fire. Either I was allergic to it or I was too sick to be able to handle it. It really didn't matter which, because I wasn't going to be able to do the treatment.

It was during this time that things started to get really tense between the Hells Angels and the Mongols. There was a continual threat of war, so appropriate security was put in place. Personally, I never had any altercations with them, but then I was pretty sick and not getting out much. We had other members who did get into it with them, but that is their story to tell.

September 11, 2001. There is nothing that I can say about that date that every other American doesn't already know. There are no feelings that I can describe that weren't felt by an entire nation.

Waiting for a liver transplant was a strange position to be in. I was waiting and hoping that I would get that phone call that said they have an organ for me, but I also had to accept that someone else needed to die in order for me to live.

My condition had been steadily declining, but luckily I was at the top of the transplant list. It was just a matter of waiting for a liver with my blood type to come available.

On May 1, 2002, Meg and I went to Stanford for a regular checkup with my liver doctor. He told me that there was some bad news. The criteria for getting a transplant was changing and those changes would bump me from the top of the list. He didn't know how far down the list I would go, but he made it clear that it was a very real possibly that I might not get one now.

In spite of the news, life had to go on. Meg and I had planned on going to Home Depot to pick up a bunch of materials that we needed for our apartment complex. We went ahead with the plan. Avoiding Home Depot wasn't going to change anything. It took us well over an hour to get the two flatbed carts full of items, and we had to wait in a really long checkout line. While we were in line to check out, Meg's cellphone rang. She stepped outside to take the call. It was Stanford calling to tell me to come back to the hospital; they had a liver for me.

The San Jose charter of the Hells Angels.

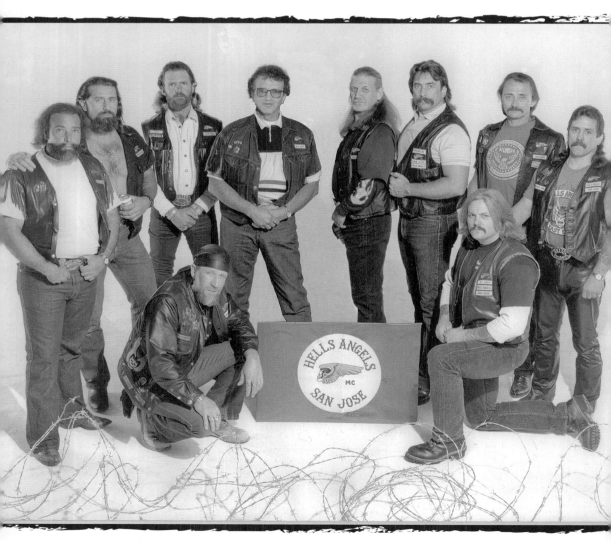

When you get a transplant, you don't get to know the name of your donor (unless it's a family member or friend). I did know that my donor was a man and that he had been in an accident on one of the local highways. They wouldn't say if it was motorcycle or car, or what highway it was. They did say that he was on life support and the hospital was waiting for family members to come and say their goodbyes, so I spent the night in the hospital and waited. The nurses pulled another bed into my room so that Meg could stay the night with me. I don't think either of us slept very well. A priest came in and offered me the last rights, just in case, but Meg told him it wasn't necessary because I wasn't going anywhere.

I had my transplant the next day, and even though it is a long, difficult surgery, I had no complications. I didn't even need any blood transfusions. The doctor said it was textbook perfect. We had been told to expect my body to try to reject the new liver. The doctors said it was common to have to adjust the immuno-supressive medications after surgery. Meg has a theory that if my donor and I had met, we probably would have been good friends. His liver was not only the right blood type, but it was so compatible that I never experienced even the slightest rejection. I also didn't have to take as many different types of medication as some people do.

Aside from being very weak, the most difficult thing about the immediate aftermath of the surgery was the pain. I had terrible pain in my back and my ribs. A couple of ribs had been broken when they did the surgery. The problem wasn't so much the pain; it was that after you have a liver transplant, you get very little in the way of pain medication. Any kind of pain medication is hard for the newly transplanted liver to process, so you just have to tough it out. That sucked.

Post-transplant, I had to stay close to the hospital for about six weeks. Meg's sister Holly managed a large apartment complex that was about seven miles from the hospital, and she arranged to put us up in the one-bedroom model apartment. Meg was my designated caregiver. You can't leave the hospital without one. That meant she was responsible for keeping track of everything I ate, giving me medication when I needed it, monitoring my temperature and blood pressure, cleaning and dressing the incision, and making sure that I got some exercise, but not doing too much.

Amanda was staying with friends because she was still in school, so Meg drove about two hours a day pick her up from school and spend time with her. Amanda was getting upset because she couldn't see me and she was always so sad when Meg had to leave, so Meg finally pulled her out of school when there was only one week left. Amanda loved being at the apartment. She thought it was like being on a vacation. Even though we couldn't wait to get home, it worked out really well, and it was good to have the family back together again.

Friends would come and visit, and we would go out for lunch or dinner. That helped break the monotony. Steve came to my apartment a lot. So did Larry Ficarra, one of the guys who rode on my summer runs. Another frequent visitor that I had was James. He was a member from Monterey, and we had briefly talked about the possibility of starting a Santa Cruz chapter on a couple of different occasions. It was in that apartment that the real discussions about making the charter a reality took place and the wheels to do so were put in motion. Now that I was going to live, I was intent on making the new charter a reality.

HELLS ANGELS SANTA CRUZ

IT TOOK THIRTEEN YEARS to make it happen, but with the help of Chris Hecht, Hector Chavez, Randy Healey, Big Mike Hult, and James Gonzales, the Santa Cruz Charter of the Hells Angels became a reality. James was the president of the charter and we held our first meeting at his house on June 24, 2002, fifty-three days after my liver transplant. It was a proud day for me.

Obviously the cops weren't thrilled to hear that the club was starting a charter in Santa Cruz. They added additional cops to the force when the charter was first started. But overall things didn't go badly.

The people in the community seemed to take it all in stride. Overall, we've had a lot of support from the community. We did have a couple of restaurant owners who didn't want us coming in wearing our patches, but you know what we said to that: "Fuck you." Other motorcycle clubs and locals who are into motorcycles have always been very supportive of our events and fundraisers.

Six months after my transplant, I went to Stanford to see my doctor for one of my regular follow-up visits. I always got my blood work done a few days before my appointments so he would have the results when we met. The latest results weren't good. He told me that the hepatitis C had come back. The doctors wanted me to try the interferon therapy again. It had changed, gotten better, they said. They felt that between the improvement in the therapy and my healthy new liver I wouldn't have such a bad reaction. It's not like I had much choice; I had to do it. I didn't get the rash, but the treatment made me so sick that I couldn't do anything more physical than get up from bed in the morning and head straight to the couch in my office. I had a hard time eating because of the constant nausea, and I didn't have the strength to do anything but lift the channel changer while I was watching television. I was like that for an entire year; it never got better. I have been through an awful lot of shit with my health, and I can honestly say that this was the worst. A lot of people compared the side effects of the treatment to how cancer patients feel during chemotherapy. I've done both, and for me it was definitely true.

This photo was taken shortly after the Santa Cruz charter was started. We are at Brookdale Lodge. I'm in the foreground with Chris and John and my good friend Cisco is behind me.

After I was finished with the interferon therapy, it didn't take long before I felt healthy again. The treatment worked, the hepatitis C virus was gone, and it has never come back.

A month or so later, Meg was offered the job of administrator at our daughter's school. She had been managing the apartments, but now that I was better, I would take over. She was worried that after having been in charge of pretty much everything for almost a year we might rub each other the wrong way if we worked together. After all, there can only be one boss. She decided to take the job with the school.

Somewhere around this time I became president of the charter and Chris became vice president. Things were going good. The charter was taking off, I was finally healthy, and things were good at home. For a long time, I'd had a design in mind for a bike I wanted to build, but all the health shit kept me from doing it. Now it seemed like a perfect time to do it. I had it built by a friend of mine, Jeremy Casson. He helped me out by getting the parts at cost, and he built the bike that I designed. It was a beauty. It was an old-style bike with 3.5-gallon tanks from a 1950 Harley-Davidson. Everything else on it was new, but it was designed to look like it came from the 1960s. It was a rigid frame, with a wide-glide front end and a twenty-one-inch wheel. The paint job was fire engine red with gold flames. It had a stock Evolution motor when I had it built, but I did a motor exchange with Joe Delnegro at Cycle Imagery in Santa Cruz and he put a 116-inch Evolution motor in it. It was plenty fast. Steve was

My good friend (and great club supporter) Ron Oliviera did the barbecue at this party. The Werewolves are a club that makes a lot of our events.

an excellent rider and I had no qualms loaning him the bike one day when his car broke down at my house. He took off and rode away so hard and fast that I figured he would probably make the forty-mile drive back to his place in twenty minutes.

It's always good to see other clubs like the Henchmen at our events.

The day the bike was delivered, I parked it sideways in the two-car garage that Meg used. I called her at work and told her that we were going to go out for dinner so she should just leave her car in the driveway. I didn't want her whipping into the garage and hitting the bike. I knew she would see the bike as she came though the garage to get into the house. When she got inside, she saw me said, "Honey, you got me a bike. I love it." For an instant I thought she was serious. I also thought she might be upset about the money I spent on the bike, but she wasn't. She said that after all I had been through I deserved it.

In April 2006, we had a poker run, followed by Hector's twentieth anniversary party. The run started at Callahan's Bar in Santa Cruz and rode through Moss Landing and back to Watsonville. Amanda came on this run and she rode with me. Chris was going to pack Meg for me so she could film the ride. Chris is the Don Juan of our charter so it was amazing that he didn't have a girl with him that day. Chris was riding Hector's new bike so he could deliver it to him. The charter had bought Hector a new bagger and it was going to be presented to him at the last stop, where he was overseeing the cooking.

After the pack took off and Meg was done filming it, she went over to the bike and put the camera away. Then she put her helmet on and tried to zip up her jacket. It wouldn't zip. As she was working on it, Chris was getting more and more concerned about the pack. She and Chris both agreed that they were probably only five minutes behind the pack, but it felt like thirty-five.

Talking with my good friends Dave Lanham and Billy Miner.

Rick, Steve, and Meg at one of our fundraisers.

RIGHT: Brian and a Ghost Mountain Rider.

BELOW: Rick and Lyle Fleming (founder and former president for twenty-five years of the Ghost Mountain Riders). Lyle explains a bit about his club: "The Ghost Mountain Riders MC name came up in the winter of 1978. High on a ridge in the Santa Cruz Mountains, two bikers were sitting around a campfire outside their cabin, listening to the wind whispering through the branches of the redwoods. Whether it was what they were drinking or smoking doesn't matter. They heard the voices of the Indians that are buried on that ridge and knew they were riding and living on a ghost mountain. From that quiet winter's evening came the name, and the pride of the club that came from that name. The 'Ghosties' were officially recognized in 1985, and the colors, as they are seen today, came into being in 1987. We enjoy a very good relationship with the local Santa Cruz chapter of the red and white, and the other chapters statewide. If the chips are down, they can count on us."

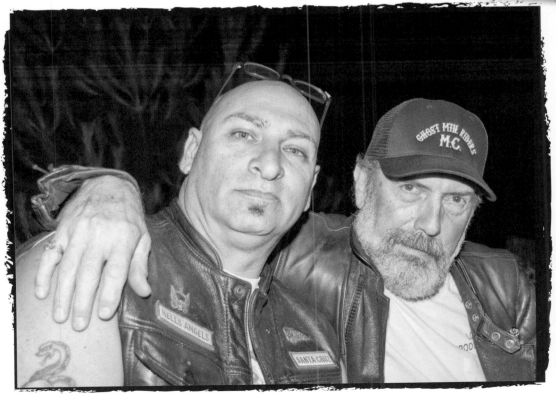

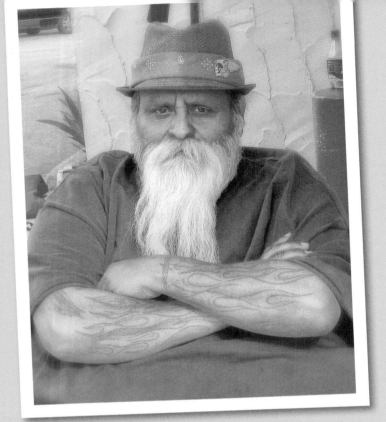

Hector taking a much-
needed break from selling
support gear.

Rick is a great musician.
Here he is with a death-
head guitar.

Chris said that when they took off to catch the pack, he was going about one hundred miles per hour when they hit the freeway. The traffic was solid and going about sixty to sixty-five miles per hour. As Chris put it, "I was tearing through traffic at about one hundred miles per hour, and splitting lanes." They came up on a big panel truck that was in front of them and a pickup truck in the lane next to it. Chris wasn't real used to riding baggers, but Meg was used to being on mine. Hector's bike had a front fairing similar to mine and Meg said that when she saw that Chris was going to go between the panel truck and the pickup, she thought, "Oh holy mother of God! He is not going to go through there?" Oh yes he was. Meg is not timid on the bike. She does shit like standing up and filming the pack at high speeds, or riding backward so that she can film them behind us. She likes riding fast, but she doesn't like taking chances. She didn't think there was enough room to make it through those trucks so she squealed, pulled her arms and legs in tight, and dropped her head. Chris said that when she squealed and locked up like that, his asshole puckered. He was sure he had just made a terrible mistake. Heart pounding and sweating bullets, he rode through, and it was close. They caught up with the pack, and when we got to the first stop, they were bickering like little kids as they got off the bike. "You scared me when you locked down like that!"

"Well you scared me. I like my knees and elbows and didn't want to lose them."

"There was plenty of room."

"There wasn't even room for air." She and Chris both agreed that they bonded that day, and that the stupid jacket needed to go. She threw it away when she got home.

The new bike I designed in a 1960 style. It has a 116-inch Evolution motor. It's quick.

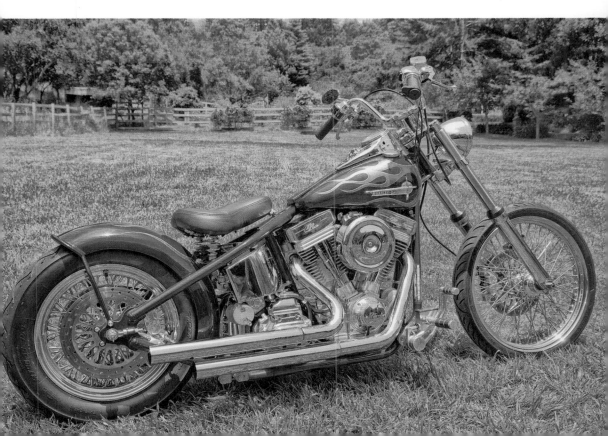

John is normally behind the camera taking photos of all our events. In the summer of 2005 Meg and I and John and Michele went on the world run in Prague. We had a good time at the run and on our extended trip to Italy, Switzerland, and Lichtenstein. We saw all the sights, ate a lot, drank a lot, and laughed our asses off. It was a really good trip.

John and I are at the top of a tower that overlooks Lucca, Italy.

In the summer of 2006, Meg and I decided that it was time for Amanda to go to Europe. She was twelve years old. We went to Italy and showed her all the important historical sights. Then we went to the coast, to the town of Sorrento. We stayed at Hotel La Badia, a converted convent sitting on a hill above town. Our room had a view of Mount Vesuvius. We usually walked down the hill to town and the beach and taxied back after dinner. A few days into the stay, my leg started bothering me and grew progressively worse. It got to the point that the pain was so bad I could hardly walk. The hotel called a doctor who diagnosed a pulled muscle, but Meg didn't think so. She called home to our doctor and told him she thought it was a blood clot. After hearing the symptoms, he said it sounded very possible. We were scheduled to make the short flight to London in two days and Meg wanted me to be treated there so she loaded me up with aspirin to thin my blood and arranged for a doctor to come to our London hotel.

The doctor in London came and checked my leg. He said he thought it was a blood clot and that normally he would admit me to the hospital. He didn't for two reasons. The first was that Meg had elevated the end of the bed with dresser drawers, she had packed my leg in ice, and she had kept giving me aspirin. The other reason was that if I were treated as an outpatient, their socialized medicine would pick up the cost.

We were supposed to be in London for four days, so we decided to splurge on a suite. We ended up having to stay for an additional nineteen days. I sure as hell was glad we didn't have to pay for the hospital costs; twenty-three days in the hotel suite was expensive enough. Plus one of the maids stole my wallet.

While I was club president, I had to have my left shoulder replaced. That run-in with the Volkswagen thirty years earlier had finally worn it out. I know a lot of people who have had the surgery and come out the other side in great shape. I wasn't one of them. The constant pain was less, but not gone, and it really did a number on my strength.

I went to see Dr. Mow (the surgeon) three times about the pain. Each time he would grab my arm and yank it up over my head (which hurt like a son of a bitch) and say, "It's fine. You're doing great." It wasn't fine and I felt like shit. The pain finally did go away, but it took five years and another injury for it to happen.

Six months after the surgery I started experiencing pain in my hip and rib, and it was spreading. I went from doctor to doctor to try to find out what was wrong, but none of them could figure out what was going. One even said some shit like it was because I was straining my back because of the pain from the shoulder replacement. As time went on, the pain got worse and I started feeling sick. Finally I went to a new general practitioner and he said what nobody wants to hear: "I think you should be checked for cancer."

It was really hot in Lucca so Michelle and Meg found a shady place to cool off.

Sitting backstage at a Willie Nelson concert with my daughter. This was taken not long before my cancer diagnosis.

I didn't tell Meg because I didn't want her to freak out. It was when we were having dinner at our friends Rich and Katy's house that she overheard me tell Rich. Shit. She was so mad at me for not telling her. Even though she was mad, it didn't keep her from getting on the phone with my doctors. Now we started going to the doctors together and Meg got really frustrated by their inability to get to the bottom of what was going on with me. She finally got so pissed that she called one of my doctors, a good guy who we both knew, and told him, "My husband is dying. All anyone has to do is look at him to know it. He's lost twenty pounds, can't eat, and is in terrible pain. Somebody has to do something, so start making calls." I had an appointment scheduled for a PET scan three days later.

The scan came back and it confirmed that I had cancer. Post-transplant lymphoproliferative disorder, also known as PTLD, was caused because the same immuno-suppressive drugs that kept me from rejecting the liver also opened me up to lymphoma. I was stage four by the time I got a diagnosis.

My sixty-fifth birthday party took place during my cancer treatment. We're laughing because Steve ended his toast to me with: "Do Not Die!" I responded with: "I'm trying not to. That's why I look like shit."

I was still president of the charter while I was sick and waiting for a diagnosis, but our vice president, Chris, was really the one handling things. He came to me if he wanted to discuss something, or wanted another opinion, but he was doing a great job on his own. It was time for me to step down, and Chris became our new president.

In June, Meg retired from the school so that she could be my full-time caregiver. She took no prisoners as far as the doctors, nurses, or anybody else involved in my treatment were concerned.

I finally got an appointment with an oncologist at Stanford, but I was going to have to wait three weeks.

One of my other doctors suggested that Meg take me to Stanford's emergency room. He said they would almost certainly admit me to the hospital and the necessary treatment could start right away. It worked like a charm.

Meg called Chris and our friend Steve Tausan and her sister to let them know that I had been admitted. Holly, Steve, and all the members of the Santa Cruz Hells Angels were waiting for me when I finally got to my room. The orderly who wheeled me from emergency to my room was new to the hospital and didn't know his way around too well yet. Meg knew Stanford inside and out from my transplant and had to show him how to get to oncology.

After I was taken to my room, I got some morphine and was pretty out of it. I don't remember a nurse coming in and telling Meg that the doctor would be in to discuss my test results in the morning. The guys told me later that Meg stood up, pointed to Chris, Brian, and Steve, and said, "You, you, and you, come with me." They followed the nurse out into the hall and Meg told her,

"The doctor won't see us in the morning. He'll come in tonight. You can tell him we are all waiting for him." They say that the doctor showed up in record time. That was the first time Steve made that "gangster chick" comment about her. Meg made a health-care binder for me and she insisted on being copied on every form, test result, and communication, which she filed in it. She also kept her own notes in it to give the doctors when we saw them. She could find things in her book before the doctor or nurse could find it in my chart. She became known at Stanford as the lady with the binder, and doctors from other parts of the hospital came to my room to see her book. She made a couple of them for friends who needed them. She has since written *A Caregiver's Organizer*, a binder that has everything that someone needs to know to help someone else who is ill.

Zee Barger, Meg, and Amanda at a run in Jackson, California.

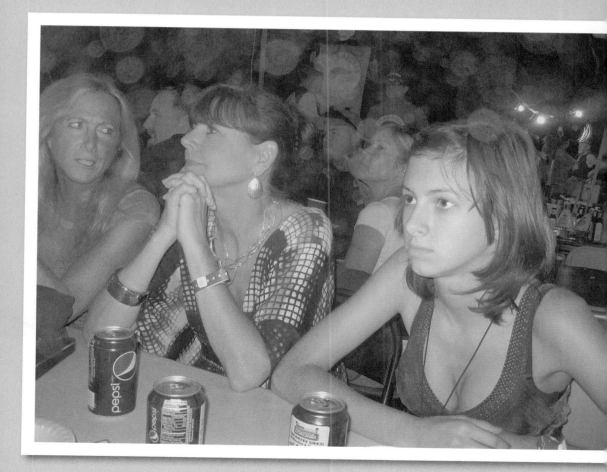

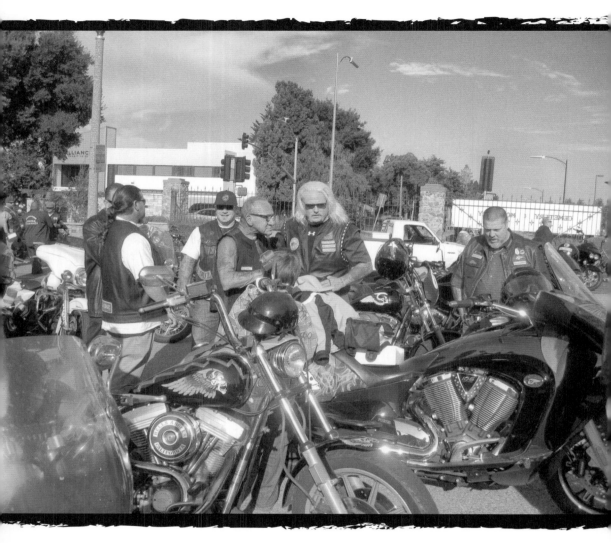

Sonny, Steve, Brian,
and my friend Frank
Oliviera at one of Sonny's
book signings.

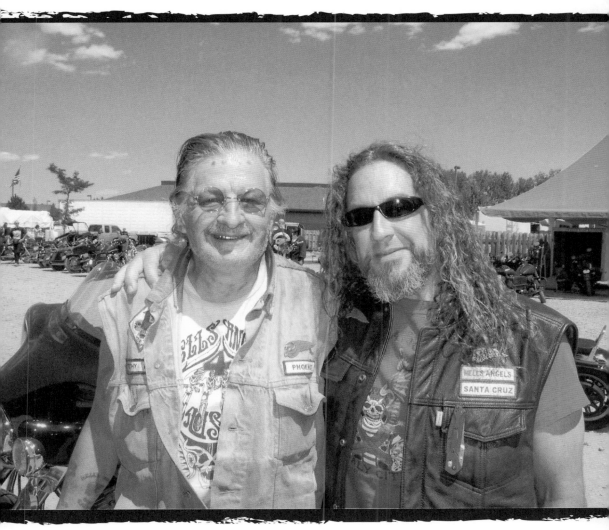

Boomer and John at
Sonny's book signing.

Steve's Victory motorcycle had a great death head on the saddlebag.

I like that the death head on this tank is all done in shades of red.

A Santa Cruz member's motorcycle with another great death head.

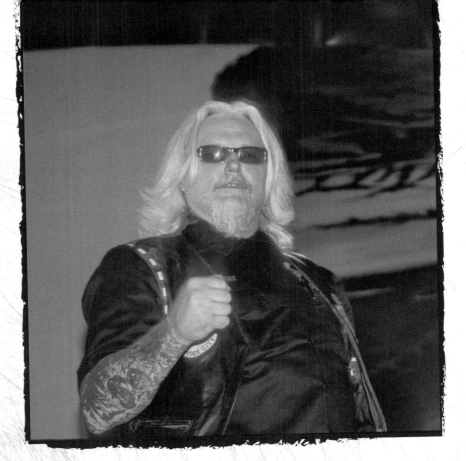

Steve Tausan, a Hells Angel . . . again.

While I was going through treatment, the whole charter was supportive—not only of me, but of Meg too. They were good about visiting me in the hospital and at home, and they helped Meg with whatever she needed.

Aside from Meg, Steve was the person who visited me the most when I was in the hospital. He came almost every day. And he always told me, "Phil Cross, you can't die! I plan to stand side by side with you as a Hells Angel again." Steve had been a member in San Jose with me, and even after he quit the club, he was a great supporter. As a bail bondsman, he helped any brother who needed it.

Steve was strong shoulder for Meg too. She once jokingly told me that she thought he might have a tracking device on her car because he always seemed to know when she had left the hospital and would call her to give her a pep talk when she was on the way home from the hospital.

The cancer was tough, so the treatment had to be tougher. When I had my first round of chemo, it did nothing so they talked to Meg about changing the treatment. She had already thoroughly researched the treatments and medications so she told them to pull out the big guns, that I could take it. When I was getting the chemo treatments, I was hooked up to it twenty-four hours a day for four days. I got to go home on the fifth day. Then I would have three weeks off, where I would give myself shots at home and have outpatient therapy. I went through that cycle six times. In October 2007, I was done with treatment. My PET scans were clear; there was no sign of the cancer. Last month, I had my five-year checkup and I am now officially cured.

On the first run I went on after I finished my treatment, the roads were narrow and winding. I signaled to Chris that we should ride single file and he signaled the rest of the pack. I figured everybody was good now and took off. Chris kept up with me, but we pretty much lost everybody else. When we got to the first stop, Chris said, "What are you doing? You just practically got off your death bed. Are you trying to kill yourself now?" I guess I didn't realize how fast I was going; I just knew that it felt good.

Billy and Chris at one of our functions at the Veteran's Hall.

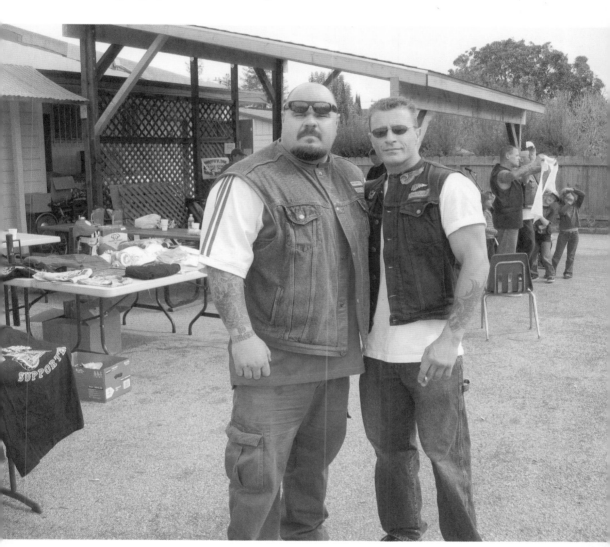

To celebrate my recovery, we went to China in January with our friends Bob and Kathy and seven other people. It was not the best time of year. It gets cold in China in the winter, and that winter was the worst the country had seen in sixty years.

We went to Beijing and Shanghai and a few smaller cities in between. In Beijing we climbed the Great Wall. I still hadn't gotten all my strength back so that was a rough one.

We took a train to Shanghai and got stuck in the snow. That was an interesting experience. We were on a train with no food. Luckily, we had a kid with us. Meg had packed a bunch of snacks in case Amanda had trouble with the food. When we crept into a station, our tour guide jumped off the train and grabbed a bunch of packaged ramen noodles. We heated water on a little burner in our cabin and devoured it.

The hotels we stayed in were nice, except for the beds. The mattresses were rock hard. They were sheets of plywood a one-inch pieces of foam, wrapped up to look like mattresses. At every hotel we called for extra blankets and used them for extra padding. They also didn't let you control the heat and it went off at about ten o'clock at night. The rooms were very cold, as were all the restaurants. China was an interesting experience. I'm glad I went, but I don't have any plans on going back.

I had been looking for a larger piece of property, but Meg was hesitant about leaving the home we had fixed to suit us so well. Our friend Katy is also our realtor, and she ran across a property that she insisted we look at. It had the land for me, and a house that Meg loved. So in November 2008, we moved again. One afternoon I was working on the property, and when I lifted half sack of cement, the muscle in my replacement shoulder tore loose. The muscle slid down my arm and settled just above the elbow. That bad shoulder replacement cost me dearly. After the initial pain from the muscle tearing loose went away, I didn't have pain anymore; of course, my strength in that arm decreased even more.

Steve became a Santa Cruz member in July 2009. He was a great addition to our charter. He was instrumental in bringing guys around the charter, and three of them—Billy, Gordon, and Jeremy—ended up becoming members.

Billy has been sitting in jail for two years. He's a good guy and we are all hoping that his case comes to a good resolution.

I celebrated my fortieth anniversary in the club on August 11, 2009. The charter threw a great party for me at the Brookdale Lodge, and Steve made a terrific-looking banner for me. Steve celebrated being back in the club for one month the same night. It was a special night for both of us.

My fortieth anniversary cake with an image of my club buckle.

Steve and I at the cake cutting. He had a one-month anniversary cake.

Sonny and I at my cake. Steve made the banner on the wall.

My friend Johnny Angel
and I on one of my visits to
the Cave Creek charter.

Me with Sonny and
Deacon at Sonny's
book signing.

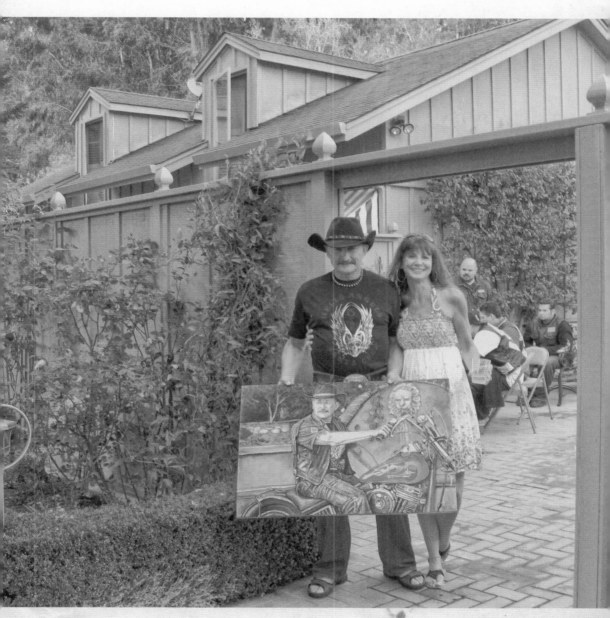

Meg and I with a painting
that my charter had done
of me.

Big Mike from Richmond
and I getting ready to act
as two of Steve's
pall bearers.

On September 24, 2011, my friend Jethro Pettigrew, a member of the San Jose charter, was killed in Reno, Nevada. A member of the Vagos motorcycle club shot him in the back. Jethro was a natural leader; he was a charismatic guy with a good personality. He should still be with us.

My good friend Steve was shot and killed on October 15, 2011, while attending Jethro's funeral. Aside from being a great Hells Angel, Steve was a great friend and a great father. His two older kids are grown, but he had two young children who he was raising as a single dad. He, too, should still be with us. He is greatly missed, never forgotten.

The Santa Cruz charter had grown in both strength and numbers since we started it ten years prior and I know that regardless of what happens to any individual member, it will continue to do so.

Taking our brother Steve to his final resting place.

The Santa Cruz members visiting Steve's grave on his birthday are (standing): Mikki, Craig, Justin, (a friend), me, Jeremy, Chris, Rick, Brian, Vince (a Merced member), Shane, Randy; (kneeling): Stuart, John, A.J., and Gordon.

EPILOGUE

In my life I have seen a lot, done so many unique and interesting things, and had a lot of fun.

I have had one wife. Meg and I have been together for almost thirty years. It is the second longest commitment I have made in my life.

I have one daughter. Amanda is the best parts of her mother and me.

I have had seventeen motorcycles, and countless wrecks, but only some of them were worth relating to you.

I have been hospitalized at least twenty times and had ten surgeries (most of them from fights or accidents).

I have been in so many hundreds of fights that I couldn't even begin to guess the number.

I have been arrested fourteen times (that I can count), but I was always innocent . . . honest.

I have been a fugitive twice. It is not the way I recommend seeing the world.

I've had thirteen dogs, of different breeds, but I'm partial to German shepherds:

Corky: Mutt. Our dog when I was a kid.

Dog: Mutt. I had him in Texas for three weeks.

Tramp: German shepherd. The best dog I ever had.

Duke: German shepherd. The crazy dog I got from Winston.

Ajax: German shepherd. My abrasive perimeter-trained dog.

Ace: German shepherd. A great dog and close runnerup to Tramp; Meg's favorite dog (but she didn't know Tramp).

Tina: German shepherd. I rescued her right after the quake.

Clancy: Border collie. A good dog, but he wouldn't stop chasing cars. The third time he got hit was not a charm.

Cash: Shepherd mix. He scared people when he smiled.

Boswell: Lab mix. He nipped Steve Tausan's daughter and was lucky to live until I could give him away the next day.

Scooter: Cocker/Springer Spaniel. The little dog I didn't want, but Meg and Amanda insisted. She turned out to be a good girl.

Now we have Buddy, a one hundred pound German shepherd that we rescued and Dash, a nine-pound Cocker/Bichon mix (yep, Meg again).

I have traveled all over the United Stated as well as to thirty countries and territories, including the following:

Austria	Italy
Canada	Lichtenstein
China	Japan
Costa Rica	Malaysia
Czech Republic	Macao (as a Portuguese territory)
England	Mexico
Egypt	Nepal
France	The Netherlands
Germany	The Philippines
Greece	Switzerland
Guam	Thailand
Hungary	Tibet
India	Turkey
Ireland	U.S. Virgin Islands
Israel	Wake Island

I have been a member of the Hells Angels motorcycle club for forty-three years, and I'm damned proud of it.

The fifty-two years that I have been riding motorcycles have been a wild ride. I have seen and done a lot, and most of it has been a blast. Not many people get to live a life like this, and as time goes on, it seems that fewer and fewer will be free to do so.

I have had an interesting, colorful, sometimes dangerous life, and I wouldn't change a bit of it.

Now you know my story (at least the parts I could tell) and I swear it's all true . . . give or take a lie or two.

ACKNOWLEDGMENTS

To John "Fuki" Fukushima, H.A.M.C., Oakland, for his help and advice on the process of making this book happen, and because he said he won't mention me in his book if he's not in mine.

To Sonny Barger, H.A.M.C., Cave Creek, for his invaluable advice on the business of book publishing.

To Mark Shubin for all his work of making old photos look so much better.

To Catherine McMurray, daughter of Wino Joe Zachnich, for the use of his photos.

To John Guadamuz, H.A.M.C., Santa Cruz, for the photos of our charter.

To all the members of the Santa Cruz Hell's Angels, for supporting me during all my trials and tribulations.

To all the friends who met with me to recount the good old days. You know who you are.

IN
MEMORIAM

OVER THE YEARS
I HAVE LOST
FAR TOO MANY
FRIENDS AND BROTHERS.
I MISS THEM ALL.

LISTED ARE THOSE I WAS CLOSEST TO.

HELLS ANGELS MC

Steve Tausen, Santa Cruz
Jethro Pettigrew, San Jose
Dick Smith, San Jose
Ron Segali, San Jose
Jack Nye, San Jose
Lurch Burkett, Oakland
Deakon, Oakland
Big Albert Perryman, Oakland
Irish O'Ferrell, Oakland
Gary Popkin, Oakland

"Pi" White, Oakland
"Fu," Oakland
Mark Perry, Oakland
Dirty Doug Bontempe, Oakland
Dave Cooper, Sonoma County
Norm Greene, Sonoma County
Mike Sheeley, Vallejo
Rooster, Richmond
Guinea Colucci, Nevada Nomads
Dee Mecham, Frisco

GYPSY JOKERS MC

Wino Joe Zachnich
Big John
Mike Gimelli

OTHER FRIENDS

Armond Bletcher
Rich Pileggi
Bob Brancato
Larry Ficarra
Lloyd Schallich